2007

Ryan,

May the wave
always be behind you
and may your board
never break -

Merry Christmas

Love,
Michelle Mike Bonn

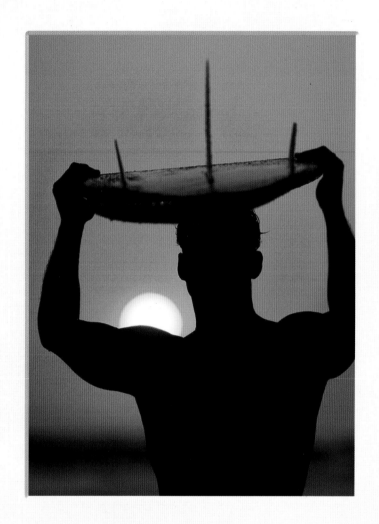

Surfboards

Guy Motil

FALCONGUIDES ®

GUILFORD, CONNECTICUT
HELENA, MONTANA
AN IMPRINT OF THE GLOBE PEQUOT PRESS

FALCONGUIDES®

Copyright © 2007 Guy Motil
Produced by *Longboard Magazine*

Edited and photographed by Guy Motil
Book design by John Bass and Rick Simmons
Front cover illustration by John Bass
Back cover photo by Guy Motil

Library of Congress Catalog-in-Publishing Data is available.
ISBN 978-0-7627-4621-7

Printed in China
First Edition/First Printing

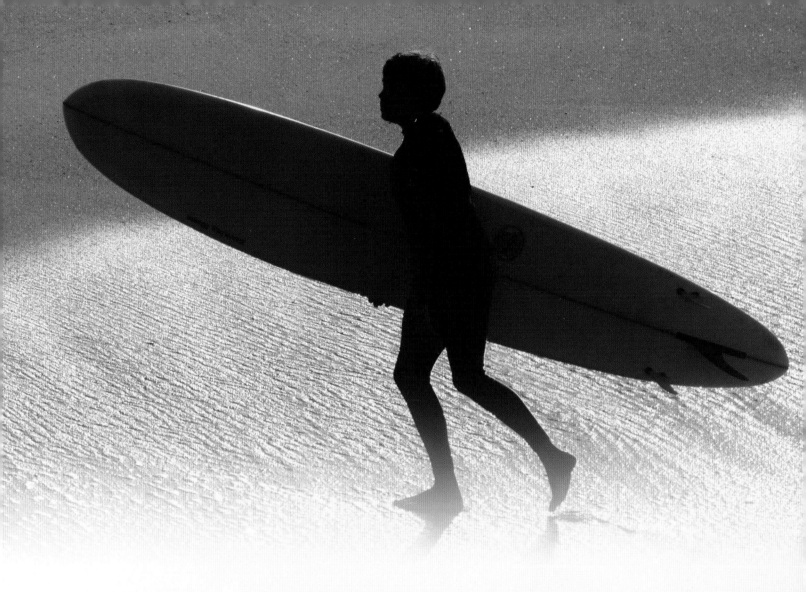

This book is dedicated to my Mom,

June Motil,

my first sponsor and surfing's biggest fan.

A special thanks to Bob and Linda Pruitt
and to Jack and Gwen Pruitt.

Over the years several people have shown themselves to be true friends. A special mahalo to Gary Sirota, Nat Young, Craig Aurness, Terry McCann, Patty Edwards, Phil and Mary Edwards, Al and Esther Shillman, Dewey Weber, Allan Seymour, John Severson, Randy Rarick, Jim Russi, Kevin Kinnear, Jim Clement, Bill Stewart, Herbie Fletcher, Joe Beason, Gary Linden and my all-time best surf buddy, my brother, Gary Motil.

Table of Contents

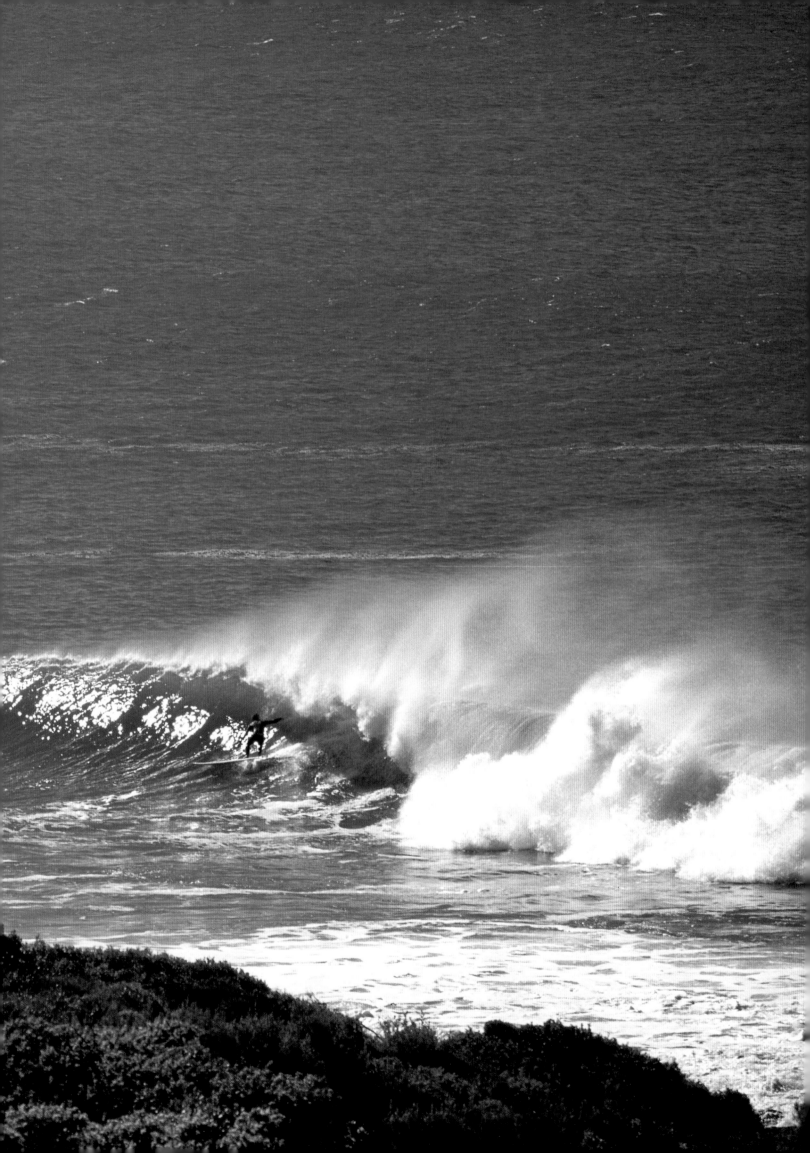

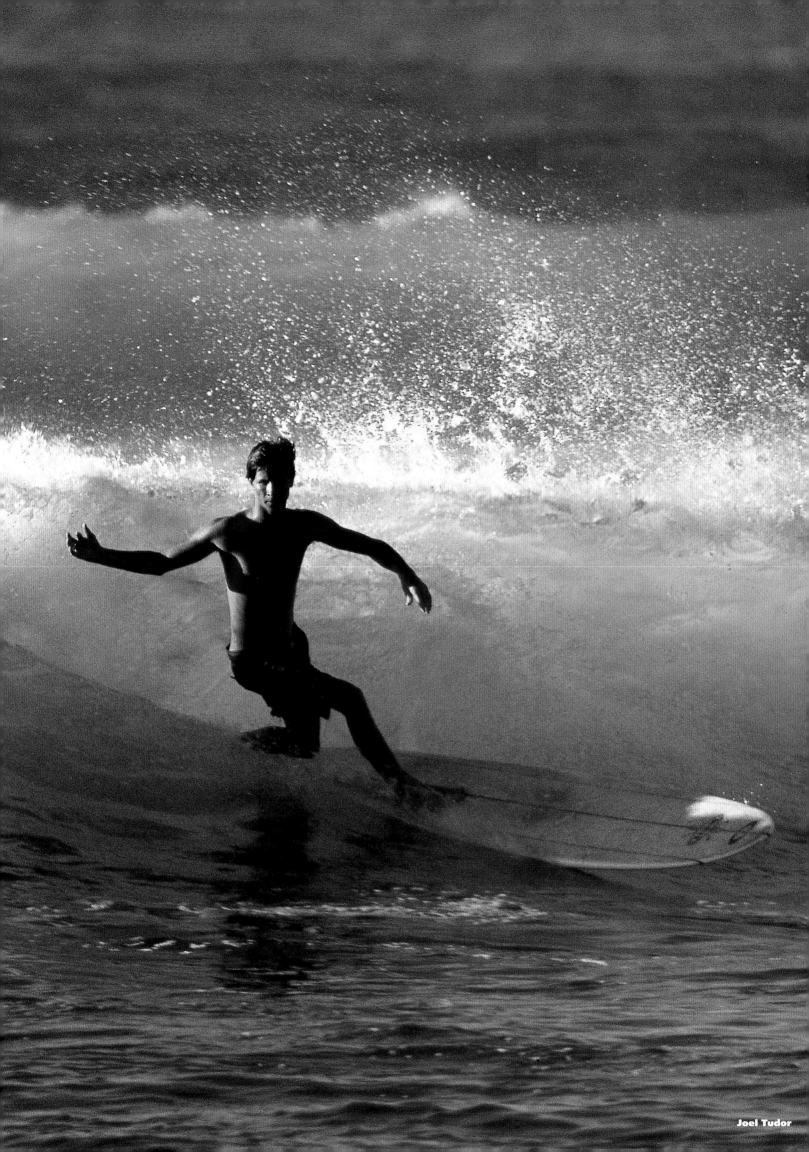

Joel Tudor

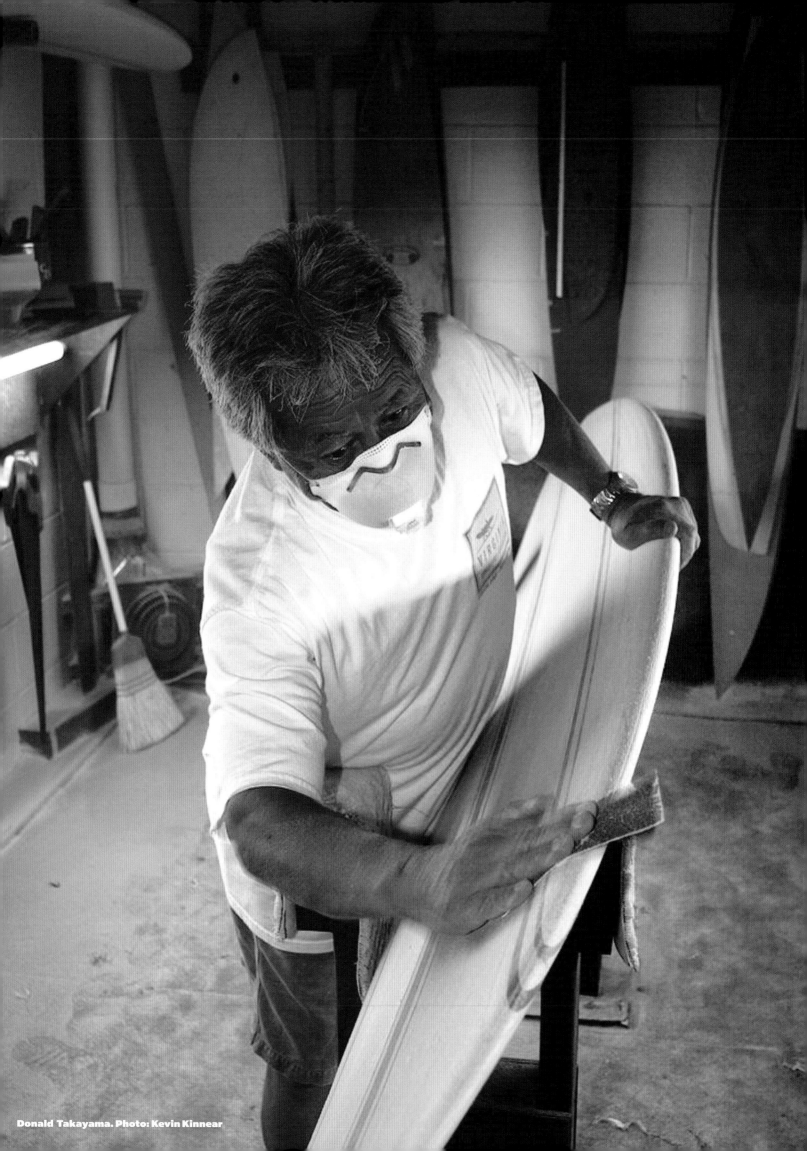

Donald Takayama. Photo: Kevin Kinnear

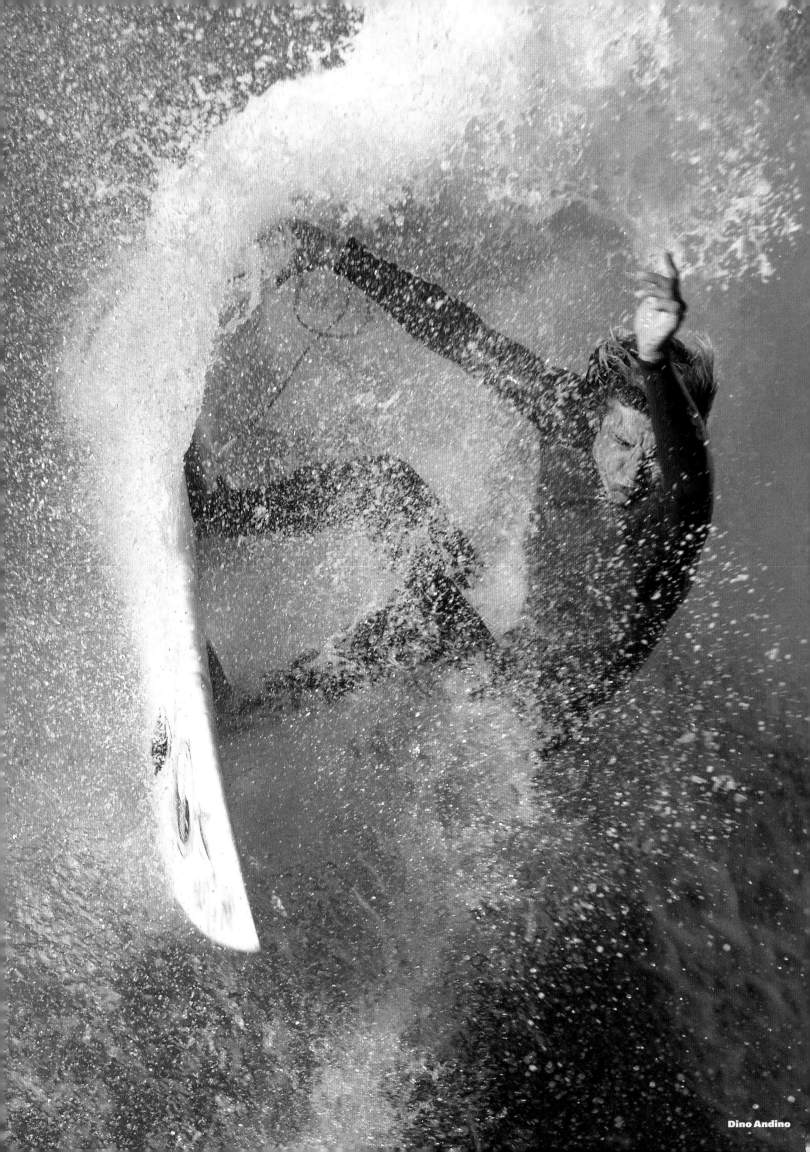

Dino Andino

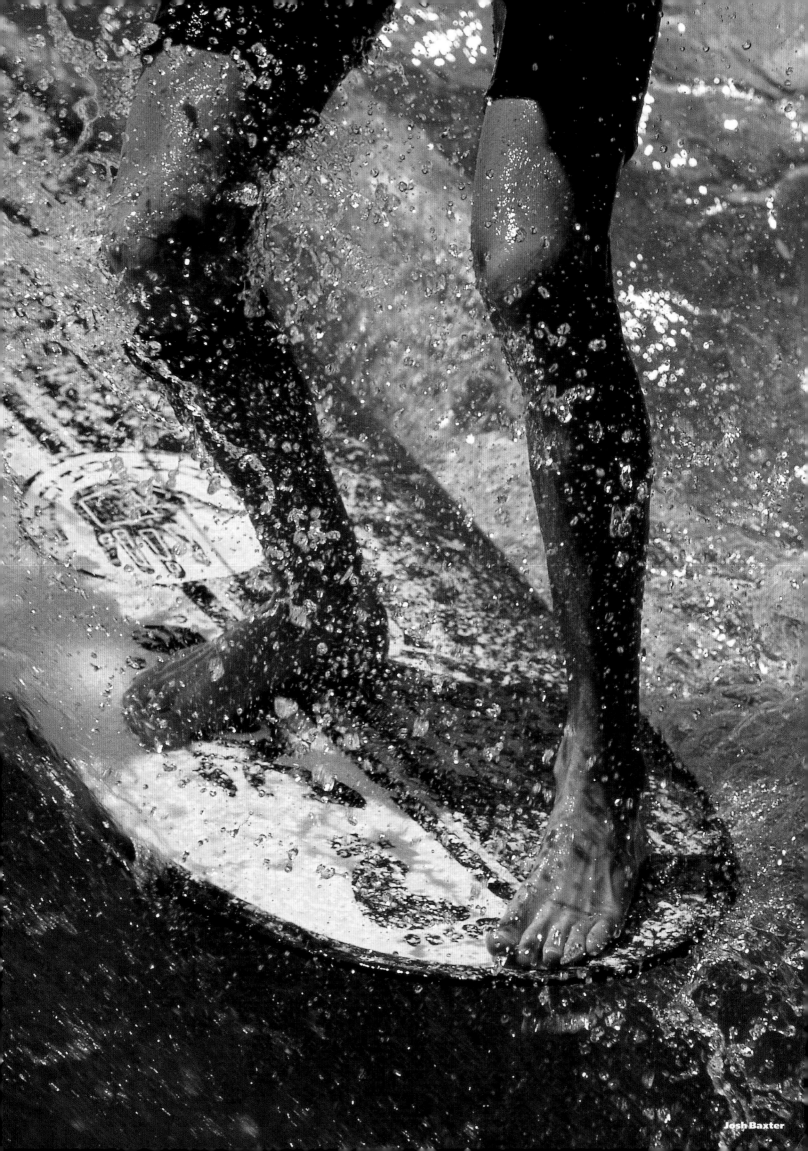

Josh Baxter

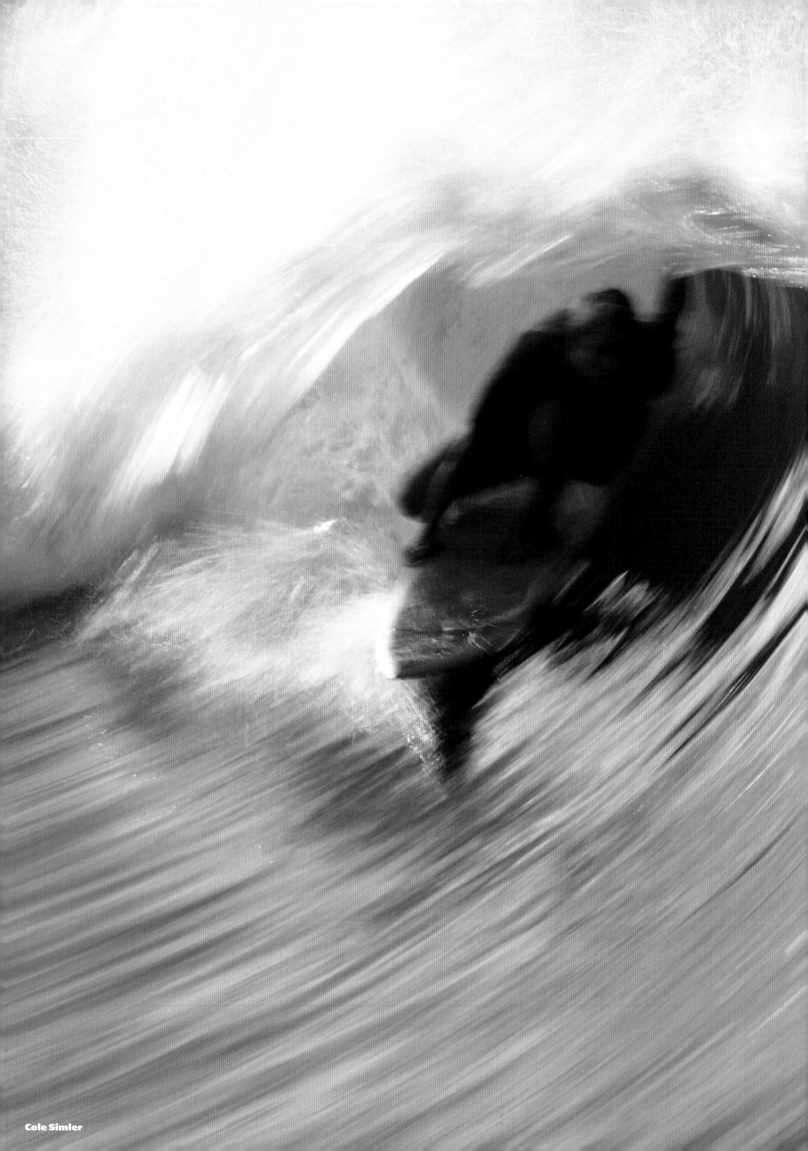
Cole Simler

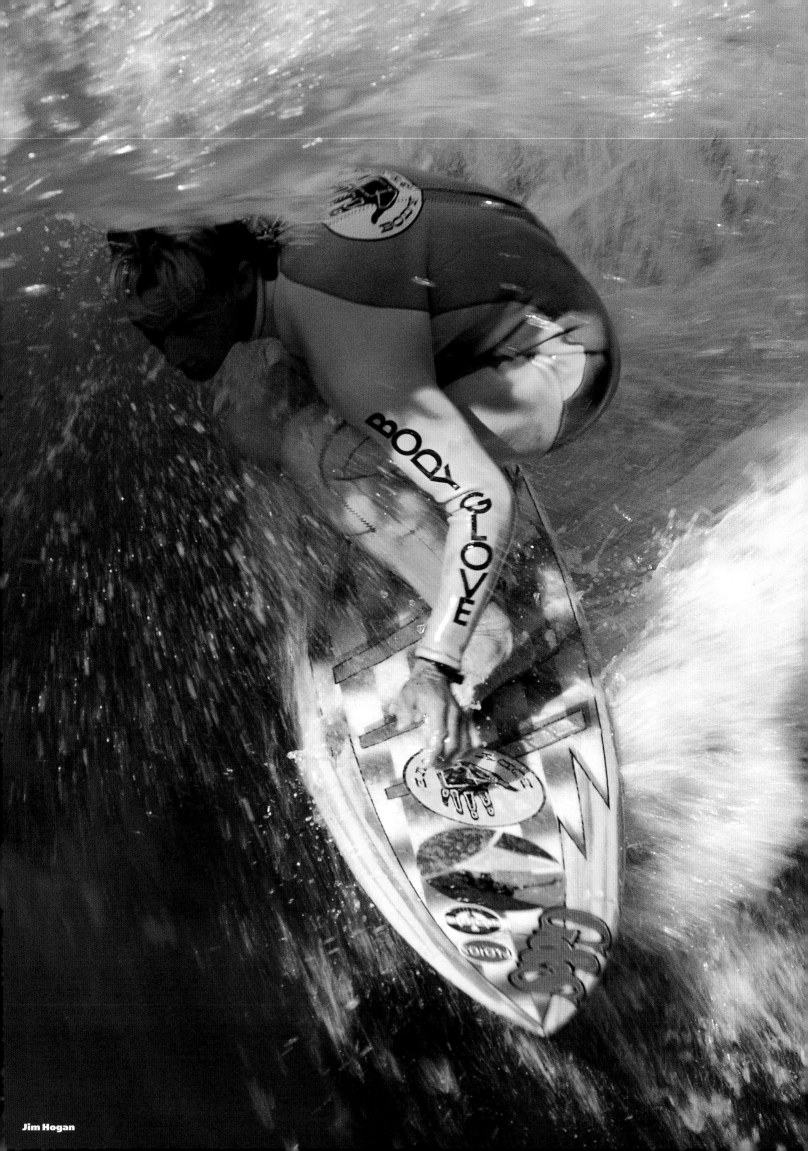
Jim Hogan

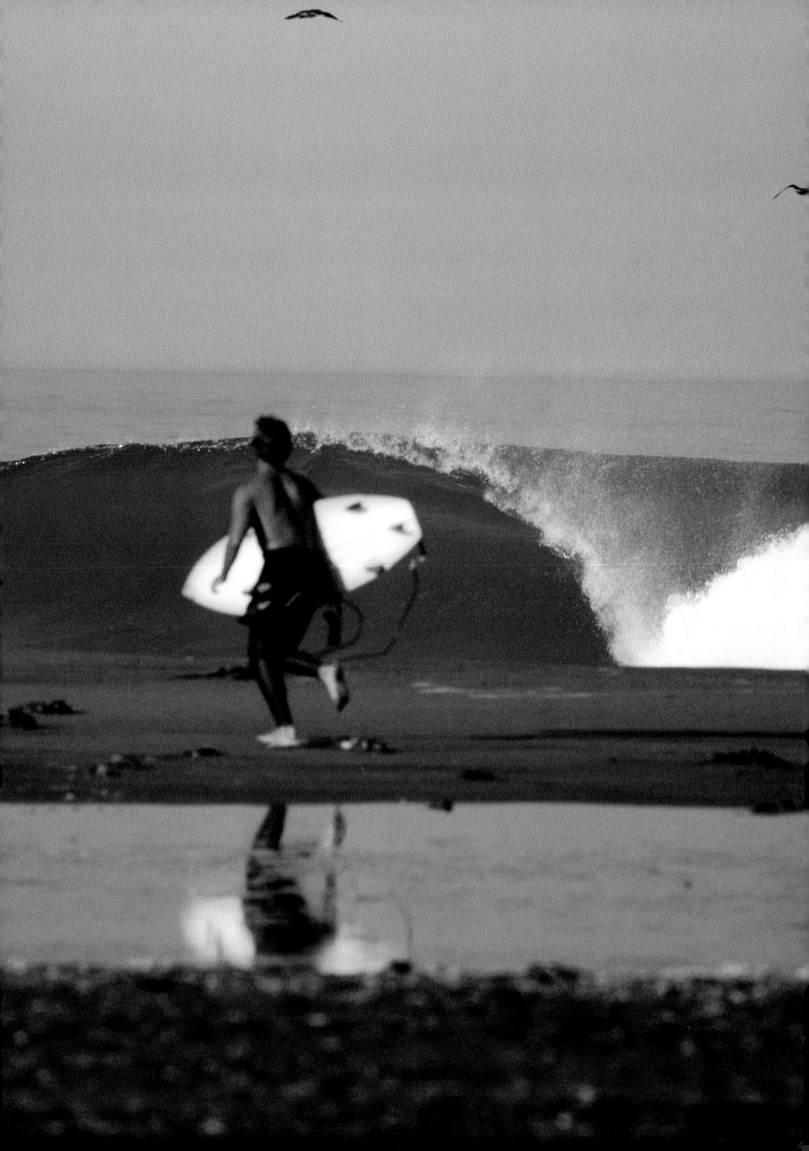

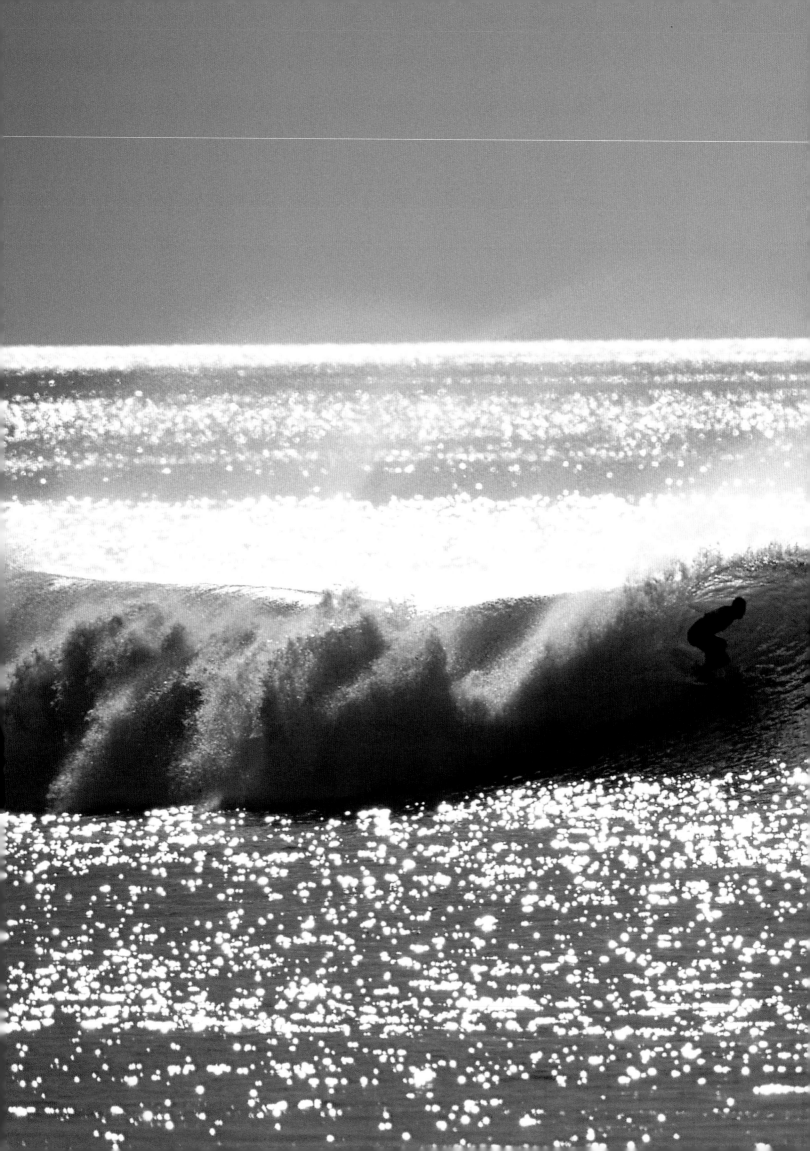

Introduction

I was first introduced to the sport of surfing on a family spring vacation to Daytona Beach, Fla., in the early 1960s. For a young boy, surfing had it all: excitement, adventure, exotic travel, physical challenge, individualism and a fresh "cool factor" that all my peers instantly recognized. With the help of family, relatives, friends and sometimes even strangers, I managed to spend an inordinate amount of time that first summer at the beach learning the nuances of riding waves.

It quickly became apparent that the surfboard was a major factor in how well a surfer could ride a wave. Having ridden two or three boards by then, I knew what would

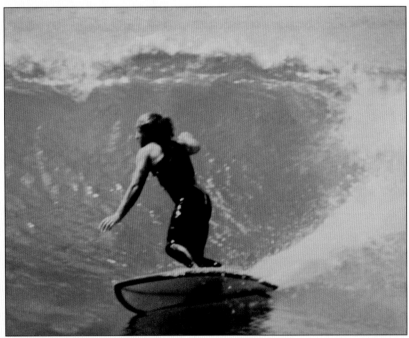

Guy Motil during an early 1970 test ride.

work best for me. I set about trying to talk Mom and Dad into buying a new surfboard. I was lucky, my parents were pretty cool by early '60s standards and soon my brother Gary and I were the proud owners of a surfboard and a belly-board. That first day my dad took me aside and expressed the hope, quite strongly, that this "surfboard thing" not be a short-term interest now that the family had "invested" almost $150 in this activity. Little did any of us know at the time how little he needed to worry about surfing being a passing fad. For almost a half-century now, surfing has been the focal point of my brother's and my life.

After acquiring that first surfboard, the next decade saw Gary and I embrace anything that had to do with wave riding. The Beach Boys' music, Bruce Brown's films and John Severson's Surfer Magazine were major parts of our lives. By the end of that first 10 years, we had become quite proficient at surfing, joining the Dewey Weber Surf Team and enjoying some competitive success with a few contest wins and numerous podium finishes.

It was at Weber Surfboards that I really began to understand the complexities of how a surfboard works. Dewey would have several similar surfboards made, each with specific variations to the base model and he, I and the other team members would spend the next couple of weeks trying them out at various surf spots along the coast. This trial and error R&D process was repeated every several weeks and improvements on the Weber boards were made on a regular basis. The functional beauty of a well-designed surfboard was obvious to all involved in the process. For me, a lifelong interest in surfboard design was established.

During this period I also became fascinated with photography and publishing. With Dewey's help I got a movie and still-camera with a complement of lenses and we shot our surf trips and anything else to do with surfing. With time my

photography was noticed, and I was offered a job in the photo department at *Surfer* magazine, culminating in a brief stint as the photo editor for the publication.

In the early 1980s, with the help of my wife, Gail, I began to aggressively pursue my photography career, forming Guy Motil Photography and Design. For the next 15 years our business worked on commercial and editorial assignments around the world, concentrating on surfing and other water-related activities. We also participated in several magazine redesigns and start-ups, the most notable being a two-man startup of *Transworld Snowboarding Magazine* with editor/writer Kevin Kinnear. We took TWS from concept to commercial and critical success and indeed it remains the industry leader to this day.

By the early 1990s my desire to get back into surfing caused us to look into creating our own surf magazine. In 1993 *Longboard Magazine* was created and our first issue rolled off the presses in July of that year. Originally designed as a quarterly, our frequency quickly expanded and now, some 15 years later, we produce seven issues a year.

From the first issue of *Longboard Magazine* our business plan included videos and books with the key project being a book on surfboards. Having already photographed hundreds of surfboards in the '70s and '80s, I began to seek out private collections, museums and anyone who had "special" boards hanging in their house or stored in the rafters. I can't begin to thank the many people who have made their surfboards available and shared their stories of living the surf lifestyle with me. This book stands as a testimony to the passion and creativity of a global tribe of watermen and women. Keep surfing.

Aloha,

Guy Motil

Guy Motil

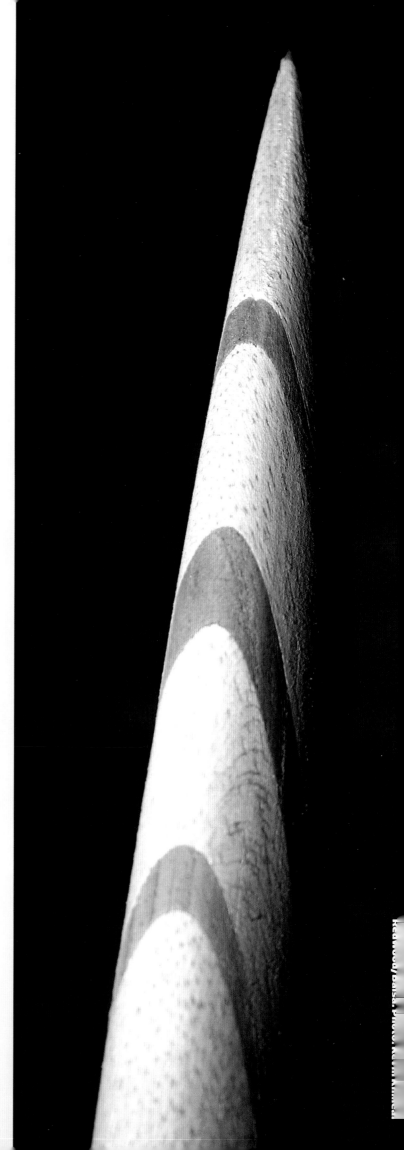

Foreword

When Guy Motil asked me to write the foreword for this book, I was both honored and scared about the job assignment.

Even with over four decades of surfing and an intense relationship with the ocean, I wasn't sure I could put in written words the deep feelings for surfing that I have had since my first day out in the waves with my brother, Santiago. Surfing saved my life. Surfing kept me close to my brother. Surfing helped me grow up. Let me explain this a bit.

I owe my life to surfing. This is something I've known and felt since my early childhood. My love for surfing kept me away from becoming involved in the deadly political world of my native Argentina under a military dictatorship. While I was in college the military mayor of the city banned surfing. Furious, I led the Argentinian surfers into a long fight for the lifting of the ban. I succeeded a year later, and in the process I founded the first national surfing federation. Santiago always told me, "Since you were busy dealing with the politics of surfing's legalization, you did not get dragged into the deadlier world of government politics." That struggle for our rights to surf and enjoy our waves and beaches became a part of who I am.

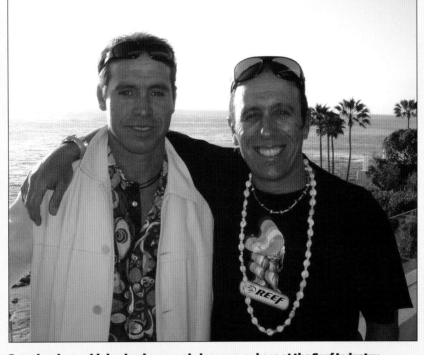

Seamlessly combining business and pleasure, as here at the Surf Industry Manufacturers annual conference at Baja's Los Cabos, is what Santiago (left) and Fernando Aguerre do best.

Eventually, both Santiago and I moved to California, and from La Jolla, near Windansea, we started our next relationship with surfing as owners of Reef, a swell we rode as brothers and partners for the next 20 years.

Our success with Reef eventually took a toll on the amount of hours spent in the waves. With families, a successful business and our charitable commitments, we realized that something needed to give in order to recover our water time.

Of course, family and the ocean were to stay. Reef had to go. We sold the company and regained the quality time needed for our other two passions: family and surfing.

After expressing to Guy my fears about writing the foreword, he simply laid out what he hoped for: "Fernando, just write about your feelings for surfing and for this book."

So, aware of my limitations, I decided to give it my best shot.

Any proper book about the history of any topic should have the subjects of the book interviewed by the authors. In this case, the surfboards themselves should have been interviewed by the authors of each story.

Fernando sets up for a bottom turn on an adventure surf trip in Indonesia.

Wood was the original material used to make boards. It's no surprise that most of those wooden boards are long gone; after providing countless hours of entertainment to their builders and owners, they could not withstand the destruction by the weather or termites.

Some newer boards were covered with oil or varnish. Eventually fiberglass and resin came to the rescue of the shapes. A good portion of those newer boards are also gone, but many of those great later boards were preserved and are still with us.

The common thread among all surfboards is that they have all provided plenty of lasting memories to their owners. In the process they have allowed us an easy way out from our day-to-day world of obligations, work and other times we'd rather forget.

After all, for the last 100 years surfboards have been nothing less than a recreational form of entertainment. These were boards that we loved, cared for, and in turn paid us back with way more fun times than we would have ever expected.

Once our lives are touched by a surfboard, they change forever.

From that moment on, we start a lifelong love affair that survives all our ups and downs,

That would have been proper journalism.

If that would have been possible, it's very likely that the boards would have talked about *their* hopes and dreams, and about the hopes and dreams of their shapers and riders they enjoyed the waves with.

But we all know that boards can't talk, hence the very difficult job confronted by the writers of the stories in this book.

Instead, they went back to the shapers and riders in the search of the souls of the boards selected for the book.

Thousands of boards were reviewed for inclusion. There are probably several hundred boards worthy of inclusion that did not make it into the book. This is only normal since most boards have lived great lives along with their owners.

The boards that made it into this book are extraordinary; most of them are legendary. Some were made over a 100 years ago, as a joint effort of a family or clan. While most of the "civilized world" was busy promoting the industrialization of their economies, the Hawaiians continued to hand build boards, their "water toys," in the search for that vehicle that would allow them to have the most fun while surfing.

Santiago locked in the barrel. Note the booties—protection from the razor-sharp reef.

eventually turning us into surfers, not just of the waves, but surfers of our lives.

Most of us were kids when that memorable moment happened—we all had that first night when we slept alone, just us and our board, waiting for that first opportunity to get wet.

Deeply in love with our board and our waves, we cheated the whole societal system. We skipped school, we went out after long nights of fun and little or no sleep. We left girlfriends and families waiting for hours while we were making out with the ocean waves and our board. We called in sick to our bosses. We spent our savings not on better cars or larger houses, but on long trips to remote destinations, where we met other surfers, other cheaters of the system, in search of that very brief, yet fully satisfying moment with the waves.

Eventually, some of us found girlfriends and wives who agreed with the sort of polygamy that we wanted in order to be true to our needs.

And then we had children, and our most important dream, our hope, was that they would fall in love with surfing and the waves ... even before they could walk, we were already wondering if they were going to be regular- or goofy-footed, if they were going to stick with surfing, just like we did.

I was lucky enough, very lucky indeed, to continue to surf in my adult years while working to promote our credo: There is nothing that a good day of surfing won't cure.

The proverbial fountain of youth is not some magic or any yet-to-be-created drug. It's right here, right now, in the riding of the waves.

You don't stop surfing because you grow old, you grow old because you stop surfing.

Viva el Surfing!!!

Fernando Aguerre

Fernando Aguerre

Fernando Aguerre's passion for surfing and surfboards has led him to put together a world-class collection of historic boards that rivals any in museums.

Equip-volution 100 Years of Surfboard Design

The first modern improvement of the Hawaiian wooden surfboard came at the hands of Tom Blake. While studying the royal *olos* in Honolulu during the mid-1920s, Blake copied their dimensions to begin building his own version of the ancient planks. After purchasing a 16-foot, 150-pound piece of redwood, Blake shaped it into a surfboard and then bored nearly 100 four-inch-long holes through the deck and hung it to dry for a month. He later covered the top and bottom with thin sheets of plywood to seal the holes. The finished product cut the weight to only 100 pounds—it resembled a cigar—and carried Blake to several paddle racing and surfing championships.

Inspired, Blake began developing a new way of making surfboards and, in 1930, he received a patent for his "Hawaiian Hollow Surfboard," and designed the first commercially produced boards—"Tom Blake Approved" paddle and surfboards—with the help of Roger's Manufacturing of Venice Beach, Calif., a year later.

Pacific Ready Cut Homes, Inc.—a Los Angeles-based home-building company owned by Meyers Butte, which would later be known as Pacific System Homes—introduced their commercially manufactured surfboards in 1932. The "Swastika" model was 10-feet long and built from a series of redwood, pine or balsa strips stuck together by waterproof glue and tongue-in-groove joints, and was coated with marine varnish. These boards were sold until the late '30s—when it was realized that the swastika was a symbol of Adolph Hitler's German national-socialist regime—at which point the name was changed to the "Waikiki" model.

Over in Hawaii, the "Empty Lot Boys"—which included Wally Froiseth, Fran Heath and John Kelly—were inventing new ways to keep the bulky, flat boards from "sliding ass" in large surf, and would enable them to gather more speed and outrun the onslaught of whitewater. Accounts differ slightly, but either Froiseth or Kelly first took the hatchet to his 12- to 14-inch wide squaretail and cut it down to a mere four inches, making the first modern gun shape (even though the term "gun" would not be used until 1956). Later, the crew added beveled bottoms (or vee) to the last quarter of the boards, and "Hot Curl" surfboards helped them attack waves like never before.

In 1935, consummate innovator Tom Blake became the first surfer to attach a fixed fin to a surfriding board. As the skeg gained popularity, the foot-dragging turn would become ancient history.

After World War II, new advanced materials became available to the U.S. public, and change came quickly to the surfboard. Preston "Pete" Peterson, often considered the best mainland surfer of his era, built the first fiberglass surfboard in June of 1946 with the help (and materials) of Brant Goldsworthy and a Los Angeles aircraft plastics company. Peterson's board was made of two hollow, molded halves connected with a redwood stringer and sealed with fiberglass tape.

Soon after, California Institute of Technology student Bob Simmons covered an all-balsa surfboard with glass fabric and polyester resin in the garage of his Pasadena, Calif., home.

Another Southern Californian, Joe Quigg, had a breakthrough year in 1947. After building an all-foam, lightweight surfboard prototype glassed with four-ounce cloth, he made the first fiberglass fin

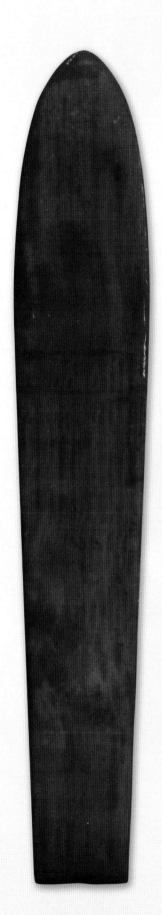

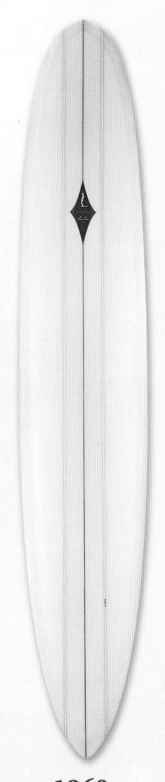

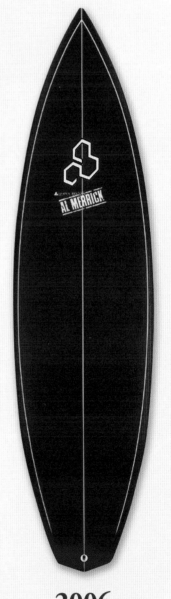

EARLY
HAWAIIAN
STYLE PLANK

1960s

JACOBS
"LANCE CARSON"
MODEL

2006

AL MERRICK
"K-SMALL"

1778

• Captain James Cook's fleet, composed of the HMS *Resolution* and the HMS *Discovery*, spot the Sandwich Islands (later renamed Hawaii). A written account of the experience is the first recorded testament of board-surfing.

Pre-Contact

• In Polynesia, Hawaiian Islanders use several types of wood, from the heavy koa trees to the lighter *wiliwili* and *ula*, to construct their *alaia* (shorter board for commoners) and *olo* (longer board for royalty) surfboards. It's believed that fire is used to rough out the shape, while crushed coral and rough stones smooth out the surface. The board is then rubbed with *hili*, a pounded bark, to give it a glossy black finish and waterproofed with kukui nut oil.

1850s

• Surfing on the Hawaiian Islands is reduced to almost non-existent by Calvinist missionaries.

1885

• Three young Hawaiian princes surf near the chilly San Lorenzo rivermouth in Santa Cruz while attending school in Northern California. They mill the boards from local redwood.

1890

• Duke Kahanamoku is born.

1898

• Duke Kahanamoku starts surfing at Waikiki at the age of eight. The sport is all but dead at the time, so there is almost nobody from whom to learn.

1907

• George Freeth is invited by Los Angeles industrialist Henry E. Huntington to Southern California to help promote a new rail service. Thousands turn out to watch Freeth surf Redondo Beach on a chopped-down version of a 16-foot *alaia*. Surfing is formally introduced to Southern California.

1910

• Surfers in Hawaii begin using imported redwood (and some pine) from California, which proves to be lighter, easier to shape and more buoyant. Boards are shaped with adz and drawknife.

• In response to the mostly *haole* Outrigger Canoe Club, local Hawaiians like the Kahanamoku brothers helped form the Hui Nalu. Their club is composed of swimmers, canoeists and surfers. The two clubs go head to head in competitions at Waikiki.

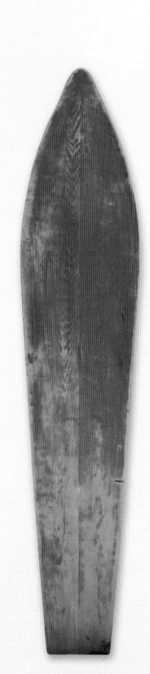

TURN OF
THE CENTURY
HAWAIIAN PLANK

CIRCA 1905

MODERN
ALAIA

1910-1920

REDWOOD PLANK

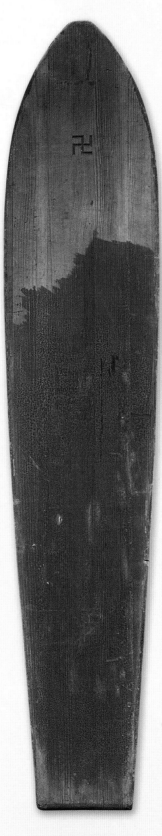

CIRCA 1930S

REDWOOD PLANK

1911
- An untrained Duke Kahanamoku breaks the 50-yard and 100-yard freestyle records at Hawaii's first Amateur Athletic Union-sanctioned swim meet. He goes on to become a three-time Olympic gold medalist later in life.

1912
- Duke Kahanamoku rides waves near Atlantic City, N.J., and so introduces surfing to the U.S. East Coast.

1914
- Duke Kahanamoku paddles out at Freshwater Beach (near Sydney, Australia) atop a 90-pound surfboard he fashioned from local sugar pine, and surfs waves for the first time in the country's history. The event was a part of a series of exhibitions in Australia to promote swimming and surfing; the event triggers national interest in the newfound sport of surfing.

1917
- According to legend, Duke Kahanamoku rides a wave from outside Castle's to Cunha on Oahu during a huge south swell, a distance of over half a mile.

1923
- Surfboard riding makes its debut appearance in a Hollywood feature in *The White Flower*.

1924
- Tom Blake moves to Hawaii from Wisconsin after meeting Duke while he passes through town on his way home from the Olympic Games in Antwerp. Blake is probably the first surfer to travel via the newly launched passenger ships of the Matson Line to Hawaii. Once settled in, he begins to experiment with surf equipment. After copying an old *olo* board from the Bishop Museum, he ends up revolutionizing surfboard design with his "hollow" boards.

1927
- Tom Blake and Sam Reid make a summertime hike into Rindge Ranch and discover the points at Malibu. Blake takes the first wave at the famed righthander.

1928
- The inaugural Pacific Coast Surfriding Championships are held at Corona del Mar. Tom Blake wins the contest on one of his hollow boards. Some believe it is the first time a surfboard is turned.

1934
- John Kelly, Fran Heath and Wally Froiseth experiment with a new board design at Brown's Surf, a break on the other side of Diamond Head from Waikiki, after experiencing problems with the boards "sliding ass"— the birth of the "Hot Curl" surfboard is soon to follow.

1935
- Tom Blake introduces the sport's first stabilizing fin, thus changing the way waves can be ridden from that point forward.

Circa 1935
- Pine and balsa wood strips are laminated into redwood planks to make them lighter. A division emerges between those who prefer Blake's thick-railed, hollow board technology and those who like the sleeker (but heavier) solid plank construction.

1943
- On Dec. 23, Dickie Cross and Woody Brown paddle out at Sunset Beach in Hawaii on a big day. The swell jumps to 30 feet and they're forced to attempt to paddle in at Waimea Bay because everywhere else is closing out. Brown barely makes it to shore, but Cross is never seen again. Surfers stay away from Waimea Bay for over a decade after the incident.

1946
- Polyester resin and fiberglass cloth used by the U.S. military becomes available to the public, and a handful of surfers try the technique on their wood planks in hopes of sealing their waterlogged boards. Doc Ball publishes his famous collection of photos, "California Surfriders."

1947
- Dale Velzy and friends unknowingly invent the first "surf trunks" by cutting the legs off their white Salvation Army-bought sailor pants.

Early 1950s
- Polyester resin and fiberglass construction catches on. Now that the lightweight balsa wood boards can withstand some abuse, the need for heavier woods is reduced to just small strips for stringers. Shapers start embracing power planers, while glassers and finishers try out belt sanders and industrial metal grinders used by welders to create a smooth finish. A bona fide surfboard industry begins to emerge.

1950
- Dale Velzy opens the first commercial surfboard-building shop in Manhattan Beach, Calif.
- A crew of Malibu surfers heads down to Windansea for the Fourth of July weekend contest. Many of them have new balsa and fiberglass boards made by Joe Quigg and Matt Kivlin. Local surfers say they look like potato chips. The moniker "Malibu Chip" sticks.

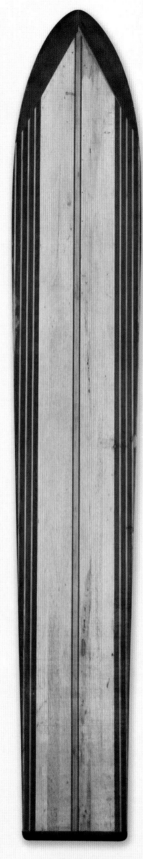

1939

PACIFIC SYSTEM HOMES

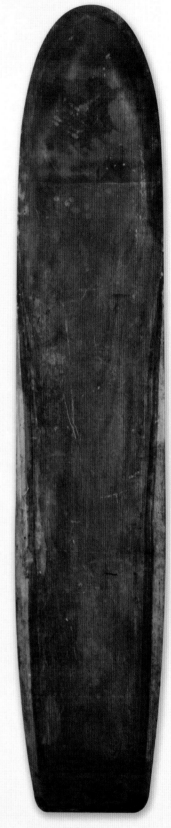

1940s

BOB SIMMONS

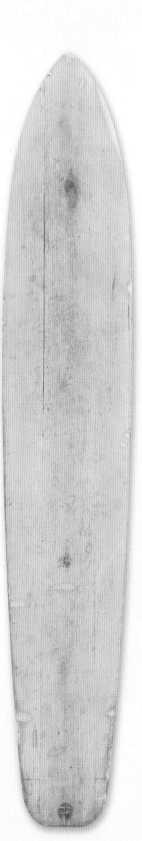

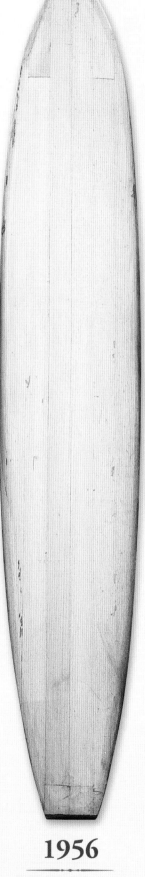

1950s
VELZY
MALIBU CHIP

1956
PAT
CURREN

1952
- Jack O'Neill coins the term "surf shop," as it is the name of his newly opened retail store (little more than a beachfront garage) in San Francisco.

1953
- Bud Browne premieres his first commercial surf film shot in 16 mm, *Hawaiian Surfing Movies,* in Santa Monica at a local high school; the film's success prompts him to quit his teaching job to become a full-time filmmaker.

1954
- The body of 35-year-old Bob Simmons is found just north of Windansea in La Jolla on Sept. 26 after his drowning three days prior.
- The inaugural Makaha International Surfing Championships are held at Makaha on Oahu. The event draws the world's best surfers throughout the decade and into the early '60s.
- After simply copying the tests run by the U.S. military on how to build a neoprene wetsuit, Bev Morgan acquires the materials and builds his own version. The modern wetsuit is born.

1956
- Dave Sweet experiments with polyurethane foam and successfully blows a hi-density blank that is compatible with polyester resin. The use of this material goes on to change the way surfboards are made and perform.
- Buzzy Trent coins the term "gun" in reference to surfboards built specifically to ride big waves.

1957
- It's generally believed that Waimea Bay is ridden for the first time, by a group of visiting Californians. Since the loss of Dickie Cross over a decade prior, the place was considered taboo.

Late 1950s
- Lifeguards and surfers in Australia and the U.S. begin using zinc oxide as protection from the sun's rays.

1958
- Balsa wood becomes more expensive and harder to obtain. With the aid of Hobie Alter, Gordon "Grubby" Clark begins blowing his own polyurethane foam blanks and soon makes them available commercially.

1959

- Companies like Walker and Foss begin blowing polyurethane foam for commercial sale, joining Clark Foam as the largest producers of surfboard blanks. The feature film *Gidget* is released. Based on the novel of the same name written by Frederick Kohner about his daughter Katherine's coming of age at 1950s Malibu, the film is cited as igniting the first "surf boom" in the U.S.
- After the successful five-year partnership between Dale Velzy and Hap Jacobs ends, Velzy goes on to open more shops, becoming "The World's Largest Manufacturer."

1960

- A decision to promote his film, *Surf Fever*, with a pamphlet turns John Severson into one of the sport's most famous entrepreneurs. His creation, *The Surfer*, grows to become the voice of surfing and opens the door for similar publications to test the demographic.
- After successfully selling surfboards out of his mother's garage for a time, Long Island's John Hannon opens the area's first surf shop—Hannon Surfboards—near Gilgo, N.Y.

1961

- Phil Edwards becomes the first surfer caught on film to ride the Banzai Pipeline on Oahu. The single "Let's Go Trippin'" is released by Riverside's Dick Dale & His Del-Tones. Dale unknowingly creates a new genre—surf music.

1962

- John Hannon, Charlie Bunger and a host of other local surfers co-organize the inaugural East Coast Surfing Championships in Gilgo. By 1965, the ECSC makes Virginia Beach, Va., its official home, where it continues to be held to this day.
- The inaugural Bell's Beach Easter contest is held near Torquay, Victoria, in Australia. The event later becomes the Rip Curl Pro and is recognized as one of the longest running pro events in existence.

1963

- The Windansea Surf Club is formed at the instigation of Chuck Hasley, and quickly becomes a formidable repository of world-class talent across the globe.

1964

- Filmed in 16 mm, *The Endless Summer* is released on the beach city surf circuit, two years prior to general release; the film documents the surf travels of Robert August and Mike Hynson around the globe "in search of the perfect wave."

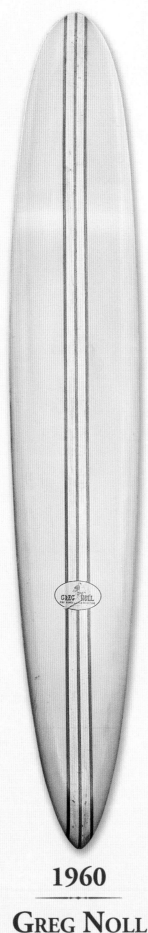

1960

GREG NOLL

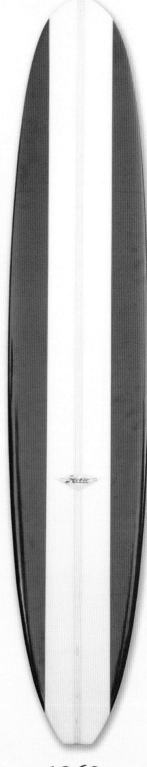

1960s

HOBIE ALTER

during the summer. While experimenting with the lighter shapes, Quigg created a 9' 6", 24-pound, all-balsa board with 50/50 rails and the glass fin, one of the earliest Malibu "Chip" surfboards. Its light weight and newfangled looseness helped create the hot-dog style of Malibu surfing, and sealed the demise of really heavy boards. Toward the end of the year, Quigg began work on a design he'd sketched of the first modern pintail gun. The finished, narrow pintail looked too drastic and was initially laughed at by some who saw it on the beach—that is, until they caught a glimpse of Quigg in action.

Meanwhile, using new technology and materials, Simmons designed the "Sandwich" board. His new board had a polystyrene foam core, a plywood deck, balsa wood rails and was wrapped with fiberglass. But despite the use of foam, the boards were still heavier than the balsas being built by Quigg and fellow board maker, Matt Kivlin. Simmons continued to experiment until his tragic passing in 1954, and often toyed with rounded rails, tail and nose contours, twin-fin boards, slot-tail designs and concaves.

In 1951 Quigg returned, this time shrinking board sizes beneath the eight-foot mark. His seven-foot, rounded pintails were dubbed "egg boards" due to their oval outline. These balsa boards were lightly glassed and featured low rails, a fiberglass fin and rail, tail and bottom rocker.

Six years later, Santa Monica's Dave Sweet constructed a surfboard using polyurethane foam and fiberglass. Almost more important, though, was Sweet's instrumental role in delivering a superior catalyst for resin via an uncle at Douglas Aircraft's plastics division.

Around this time, a new foam was being offered by the American Latex Company, and Quigg, Sweet and Hobie Alter all tested the early polyurethane foam with a few passes in their shaping bays.

Soon after, a salesman from Reichold Plastics entered Hobie's Dana Point, Calif., surf shop and showed him a sample of polyurethane foam. Already excited about the opportunity this superior material could offer, added with the inconsistent availability of balsa wood, Hobie decided to find a way to blow a uniform polyurethane blank that could easily be shaped. With the help of Gordon "Grubby" Clark, his glasser, the two delivered their version of the new medium and opened a Laguna Beach shop to make the blanks full-time.

As *The Endless Summer* helped launch an era of surf exploration in 1965, Hobie invented the glassed-in fin box and a removable fin in order to make traveling with a surfboard easier. Taking it one step further, Morey-Pope released the "Trisect," a three-piece, snap-together surfboard that fit into a suitcase.

Following a less-traveled path, Santa Barbara's George Greenough took his "Spoon" design kneeboard—a small, scooped-out board with a flexible tail and a wide-based, raked, foiled fin—to Australia. Local surfers took notice, and Greenough helped plant the seeds for the smaller surfboards to come, unwittingly becoming the "Father of the Shortboard."

One surfer/shaper who noticed the kneeboarder's presence Down Under, Bob McTavish, tried to incorporate the dynamic forces that drove Greenough's kneeboards into surfboard designs. The wide-open coastlines of Australia

- The first official World Surfing Championships is held at Manly Beach, Australia. Close to 65,000 spectators flock to witness the event. The title is won by local Aussie, Midget Farrelly.
- George Greenough—an eccentric kneeboarder from California— takes his specially designed "spoon" boards to Australia. While there he meets Bob McTavish, and the two combine their ideas and change surfboard design forever.

1965
- The inaugural Duke Kahanamoku Invitational is held on Oahu's North Shore. It is regarded by many as *the* premier surfing event until the mid-1970s.

1966
- *The Endless Summer* is re-edited and blown up to 35 mm and put into general release by Columbia Pictures; the $50,000 film receives positive reviews in *Time, Newsweek* and *The New Yorker.*
- The ISF/USSA World Surfing Championships are held in San Diego. Robert "Nat" Young surfs circles around the tip-riding contingent of Californians, winning the event atop his 9' 4" Gordon Woods surfboard named "Magic Sam." The new Aussie style— the precursor to the shortboard revolution— quickly makes waves around the globe.

1967
- Miki Dora drops his pants in a protest against the decayed state of surfing while in a heat at the Malibu Invitational Surf Classic. It becomes "Da Cat's" final contest.
- Bob McTavish and Nat Young travel to Hawaii for the Duke Kahanamoku Invitational contest with their newly devised Keyo "Plastic Machine" boards. The shortboard revolution has officially begun. Kneeboarding enthusiast and champion Steve Lis unveils the first split-tailed, twin-fin fish design.

1968
- Duke Kahanamoku dies of a heart attack at the age of 77. The "Father of Modern Surfing" would eventually be honored in numerous ways and inducted into nearly every hall of fame he was qualified to enter, among them the U.S. Olympic, International Swimming and, of course, surfing. In 1990 a 17-plus-foot bronze statue of Kahanamoku standing in front of a surfboard was dedicated at Kuhio Beach in Waikiki.
- Hawaii's Fred Hemmings wins the World Surfing Championships in Puerto Rico in the midst of the shortboard revolution on what was considered an archaic longboard at the time; it's seen by many as the last gasp of the traditional longboard for the next decade and a half.

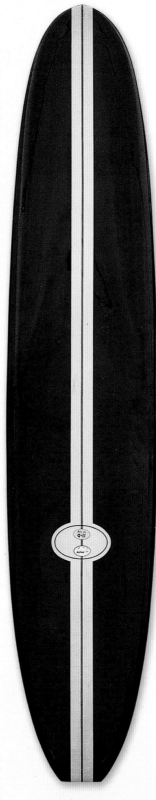

1960

GREG NOLL "DA CAT" MODEL

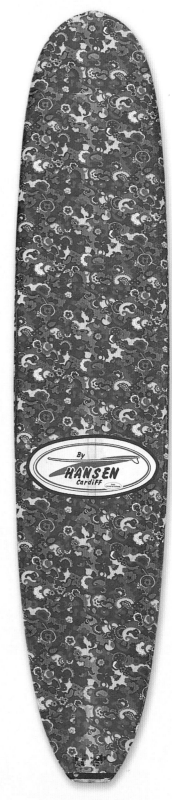

1967

HANSEN "COMPETITOR"

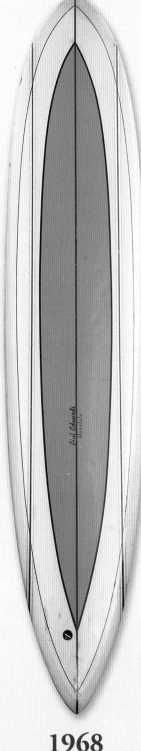

1967

BING
PIPELINER

1968

PHIL EDWARDS
"HONOLULU"

1969
- Paul Witzig's movie, *Evolution,* is released; the film is heralded as a documentation of the opening year (1968) of the shortboard revolution.

Late 1960s
- Lighter foam densities are offered. Removable fins are readily available, making board sanding easier, although a majority of them still have glass-on fins. Some begin using airbrushed paint on the hotcoat to make designs and pinlines.

1970
- California teenager Rolf Aurness wins the World Surfing Championships in Australia on his 6' 10" pintail. The contest is best remembered for Aurness' surprise win over the heavily favored Aussies, who were riding boards that proved too short.
- Lightning Bolt Surfboards officially opens its doors in Honolulu. Lightning Bolt would go on to become the most popular surfboard brand of the decade.

1971
- Ventura surfer Tom Morey invents the Boogie Board— a rectangular sled designed to have its rider lay prone while surfing waves— using polyethylene foam, a newspaper, an electric carving knife and an iron.
- The surf leash— a new device that attaches the rider to their surfboard— begins making regular appearances, helping push the performance boundaries, increasing the amount of surfers in the water and forever changing the act of surfing.
- The inaugural Pipeline Masters is held at Oahu's Banzai Pipeline. The event goes on to produce some of the most dramatic and memorable moments in competitive surfing history.

1972
- *Five Summer Stories* by Greg MacGillivray and Jim Freeman is released; it is their final sufing film. Brothers Malcolm and Duncan Campbell introduce their Bonzer design. The fin setup is a precursor to multi-fin surfboards, which would become standard. Frederick Herzog introduces Mr. Zog's Sex Wax.

1973
- Kevin Naughton and Craig Peterson publish their first travelogue in *Surfer* magazine, thus setting in motion the second great wave of international travel (Bruce Brown's film *The Endless Summer* is responsible for the first).

1974

- Hawaiian shaper/surfer Ben Aipa introduces his Stinger design. His crew of test pilots, which include Larry Bertlemann and Montgomery "Buttons" Kaluhiokalani, push high-performance surfing to a new level.

1975

- Maverick's, the big-wave spot in Half Moon Bay, Calif., (just south of San Francisco) is surfed for the first time, by local Jeff Clark. Despite repeatedly inviting others to join him, Clark would have it to himself for the next 15-plus years.

1976

- The first worldwide pro surfing tour—the IPS (International Professional Surfers)—is inaugurated by Fred Hemmings and Randy Rarick. Australia's Peter Townend wins the title based on points. Bob McKnight and Jeff Hakman secure the U.S. license for Quiksilver, an Australian surf company founded in 1973.

1977

- Bill Delaney's *Free Ride* is released; it is considered by some as the last great surf movie. The film showcases pro surfers Shaun Tomson, Mark Richards and Wayne "Rabbit" Bartholomew, among others. These surfers and their contemporaries become known as the "free ride" generation.

1978

- The National Scholastic Surfing Association (NSSA) is founded and headquartered in Huntington Beach. Surf company Billabong is founded in Australia by Gordon Merchant.

Late '70s

- As surfboards evolve, so do surfing maneuvers. Surfers in Florida and California begin attempting aerials in earnest.

Early '80s

- New, lighter urethane foam densities are being offered. Influenced by sailboard technology, surfboard makers—Greg Loehr, Clyde Beatty and John Bradbury among them—begin experimenting with polystyrene foam and epoxy resin.

1981

- Simon Anderson unveils his "thruster" fin setup— three small, glassed-on skegs. It becomes the most widely ridden surfboard design of all time.

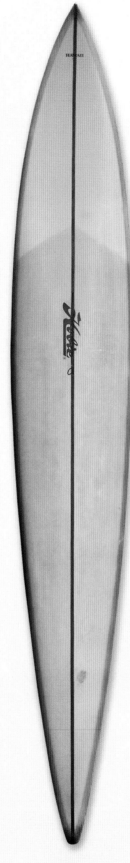

1971

HOBIE
MICKEY
MUÑOZ

1970s

GERRY LOPEZ
LIGHTNING
BOLT REPLICA

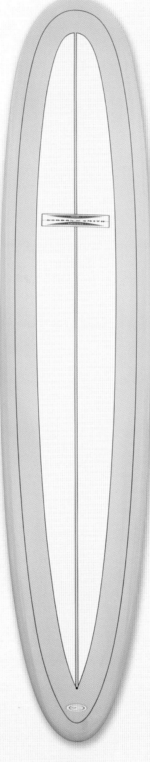

1980s
SIMON ANDERSON THRUSTER

1990s
GORDON & SMITH SURFTECH

1982
- The inaugural Op Pro is held at Huntington Beach; the Labor Day crowd is estimated to be in excess of 60,000 people. The contest sets a new standard for world-class competition on the West Coast.

1983
- Ian Cairns starts the Association of Surfing Professionals (ASP) and takes control from the International Professional Surfing (IPS) as the governing body of surfing.
- The inaugural Triple Crown of Surfing is held along Oahu's North Shore. The three-event series—usually held at Pipeline, Sunset Beach and Haleiwa—is meant to test the mettle of professional surfers in Hawaii's large winter surf.
- Australia's Tom Carroll wins the first world championship while riding a tri-fin setup.

1984
- Glen Henning, Lance Carson and Thomas Pratte start Surfrider Foundation—a nonprofit environmental organization dedicated to the preservation of our beaches and oceans.

1985
- Sean Collins launches Surfline, a surf reporting and forecasting tool. It goes online via the Internet in 1995.

1986
- The inaugural Quiksilver in Memory of Eddie Aikau big-wave contest is held at Waimea Bay. Brother Clyde Aikau wins the event.
- A full-scale riot ensues at the Op Pro in Huntington Beach as things get out of hand during the bikini contest; a police car is set on fire and stores on Main Street are looted.
- Nat Young helps champion longboarding's return by establishing a professional longboard tour. He wins four of the first titles.

1992
- Surftech Surfboards is founded by Randy French in Santa Cruz, Calif. The epoxy-composite board maker becomes the largest surfboard manufacturer in the world in a little over a decade.
- Laird Hamilton, Darrick Doerner and Buzzy Kerbox are witnessed being towed into Outside Backyards on Oahu. The riders are strapped onto a gun-like board and towed by an inflatable Zodiac.
- Taylor Steele releases *Momentum* on video. The film features a group of young surfers dubbed the "New School," which includes Kelly Slater, Rob Machado and Shane Dorian. Slater goes on to win six world titles in the '90s alone, surpassing Mark Richards' old mark of four, set from 1979 to 1982.

1994

- Thirty years after the release of his initial hit surf film, Bruce Brown unveils the much-hyped sequel, *The Endless Summer II*, produced by New Line pictures; following the same format, the film follows two surfers—shortboarder Pat O'Connell and longboarder Robert "Wingnut" Weaver—on a surf voyage around the world; film costs top $3.5 million.
- Hawaiian big-wave charger and Waimea Bay regular Mark Foo drowns while surfing at Maverick's.
- Florida's Lisa Anderson wins the first of four consecutive women's world titles, officially launching the women's surfing revolution.

1998

- A mere six years after tow-in surfing is introduced, a massive swell hits Hawaii; Ken Bradshaw gets towed into the wave of the day—measuring somewhere around 45 feet—the largest ever ridden at the time.
- Taylor Knox wins the K2 Big-Wave Challenge—pocketing $50,000—by paddling into a wave with a 50-foot-plus face at Todos Santos in Baja California.

2001

- The day of the terrorist attacks on New York City the waves at local beaches are good, prompting a small number of surfers employed in the World Trade Center to shrug off work and go surfing. At least five other local surfers weren't so lucky and perished.
- A small group of surfers boat out to Cortes Bank, a big-wave break located 100 miles off of the California coast. Mike Parsons gets towed into a wave with a 65-foot face, the largest ridden at the time.

2002

- On Aug. 24, the U.S. Postal Service commissions the production of the commemorative Duke Kahanamoku postage stamp.

2005

- On Dec. 5, Gordon "Grubby" Clark shuts the doors of Clark Foam in response to pending legal issues stemming from the harmful chemicals used in the company's foam-blowing process. The event would send the surfboard industry into a tailspin as shapers and manufacturers scrambled to find other means of acquiring surfboard blanks. Some estimates were that, at the time of his closure, Clark was responsible for 90 percent of the industry's blanks production.

2006

- Kelly Slater wins his eighth world title, further cementing his legendary status within surfing.

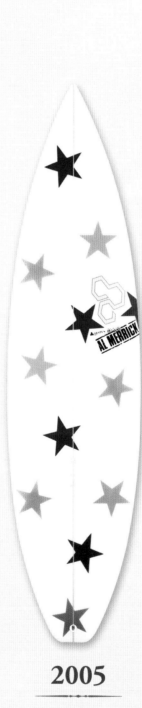

2005

AL MERRICK

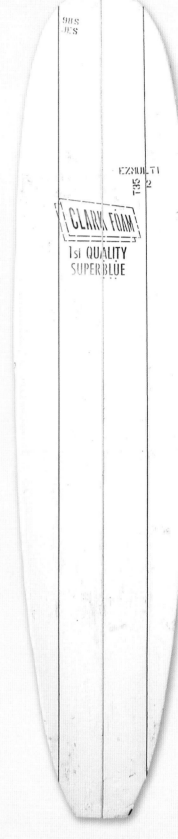

2005

CLARK FOAM BLANK

served as the perfect testing grounds for years of trial and error. And when Nat Young returned home after his convincing victory at the '66 World Championships in San Diego, McTavish was already working on such boards and the two would go on to collaborate on the radical vee-bottom designs that revolutionized the sport in 1968.

Almost simultaneously, a Hawaiian transplant from Southern California, Dick Brewer, was working on a short, light, teardrop-shaped board with a forward wide point, bulky front and a narrow pintail to help him tame the powerful Island waves. His "mini-guns" further shortened the length of the average surfboard, opening the door for a new chapter.

By 1970, longboards were already being seen as relics from a primitive past. The shortboard, with its futuristic outlines, theories and designs, pushed surfing into places unseen by riders atop the bulkier boards of the '50s and '60s. Australians, Hawaiians and Californians alike drove lengths down, refined the rails and sharpened the edges; the race to outrun the competition in design evolution was on.

A revolution was booming, but it wasn't until 1981 that the movement's most important feature appeared. Simon Anderson—an Australian shaper and professional surfer searching for a competitive edge—unveiled his "Thruster" (or three-fin) setup, which allowed him more drive, to ride higher and drop deeper on the wave face. Anderson's thruster became the mainstream staple. Boards were redesigned specifically for the fin setup. Mass soon decreased, dimensions shrunk and glassing thinned until shortboards were whittled to their breaking point.

Similarly (or contrarily, depending on your perspective), Anderson's invention was being fastened to the rear of a new type of surfriding vehicle—the progressive longboard. Driven by ultra-light foam and 6/4 glassing techniques, a longboard revival emerged in the late '80s and blossomed in the '90s. But, like shortboards, some of the progressive longboards were cut down until they became too fragile and no longer even resembled the logs of yore.

As the line between longboards and shortboards nearly disappeared, a group of young Southern Californians decided to look backward. The new traditional movement aimed to return the sport of longboarding to its pre-1967 roots with a revival of classic posturing, noserider shapes and raw soul, with a dash of current surfboard-building techniques.

Another trend that developed in the latter 1990s was the (re-)emergence of the midlength shapes (or funboards)—generally between 7' 0" and 8' 6". Although these basic shapes were not new, the popularity of midlengths, eggs and "big guy tris" stemmed from their adaptability in most wave conditions and their ease of paddling.

Fish, bonzer and single-fin designs also experienced newfound popularity in the late '90s as both longboard and shortboard professional surfers illustrated performance possibilities on these long-overlooked models, which were all the rage in the '70s but were shelved with the dawn of the shortboard revolution and the introduction of the thruster.

During the '90s not only were surfers and shapers experimenting with old and new designs, but also with technology used to create a surfboard. Various types of foam were seeping into shaping shacks along the coast, while others ventured into new technology altogether. In 1989, Randy French founded Surftech, a surfboard manufacturer that would specialize in replicable molded/composite-laminate boards.

On Dec. 5, 2005 the surfboard industry was turned on its head when Gordon "Grubby" Clark without warning shut down Clark Foam, the primary producer of surfboard blanks (some estimated as high as 90 percent of U.S. blanks). In a statement he released soon after the industry-altering closure, Clark explained the decision was based on pending legal issues that stemmed from the chemicals the company used in the production process, which were allegedly harmful to the environment and employees. Shapers were left to scramble for the last available Clark Foam blanks, and following the panic of Clark closing his doors were forced to pursue new sources for blanks.

—*Chasen Marshall and Ryan Smith*

Olo

In pre-contact Hawaii it was the king of boards and the board of kings—the biggest, baddest board of the ancient Hawaiian quiver and to be ridden only by royalty or chiefs, warriors and *kahunas* of the highest rank and status. At 22 feet long, six inches thick, 16 to 17 inches wide and weighing as much as a staggering 200-plus pounds, it must have taken a rider of exceptional strength and dexterity to master the *olo*, but among the chiefly and warrior class of old Hawaii—the *ali'i*—surfing skill and athleticism were very highly regarded. The olo board itself was a revered icon, a phallic symbol according to scholars, and the making of such a board was attended by elaborate ritual and ceremony at every step in a process that could take as long as two years to complete. The board was seen as a living entity and each had its own highly significant name that was also importantly linked to the individual for whom the board was intended.

Olo boards could be made from a number of native woods including *ulu* (breadfruit), *wiliwili* (much like balsa) and strong, hard *koa*. According to Tom Pohaku Stone, a professor of Hawaiian Studies and a Honolulu-based surfer who has made a specialty of researching and re-enacting the old ways, the process began with the selection of a tree from which the board was to be made. A kahuna, or priest—who was also likely to be the craftsman who would make the board—assembled the people and led the chants and pageantry acknowledging the gods that created the tree, ensuring that the life form would be preserved even as the tree was felled and hewn into a board. Sacrifices of food—a red fish, a pig and other such items—or even human sacrifices in exceptional circumstances were offered up and fires were lit around the roots of the tree. The same rituals were used no matter if the tree was still standing or had fallen down naturally in the forest, or indeed, if the wood came from a tree trunk washed up on the shore. Such a log, says Stone, might have been a redwood that had drifted to Hawaii from the Pacific Northwest U.S. Such an item would have been even more highly revered and given special significance as a "gift from the gods."

How the ancient Hawaiians were able to make a surfboard from a tree trunk in an age when they had no metal tools remains something of a mystery. Perhaps fire was used in a controlled way to burn away the excess timber after which the charred wood could have been scraped with stone tools. Perhaps, says Stone, even the notoriously gnarl-grained and knotted koa logs could have been split with wood or stone wedges and hammers, the kahuna-craftsmen having the knowledge, experience and intuition to understand how the wood could be "flaked" into the basic form. Regardless, arriving at a smoothly finished shape must have been extremely labor intensive.

—*Paul Holmes*

In 2001, Greg Noll attempted to re-create a Hawaiian olo; one problem—tracking down a 16-foot piece of koa wood.

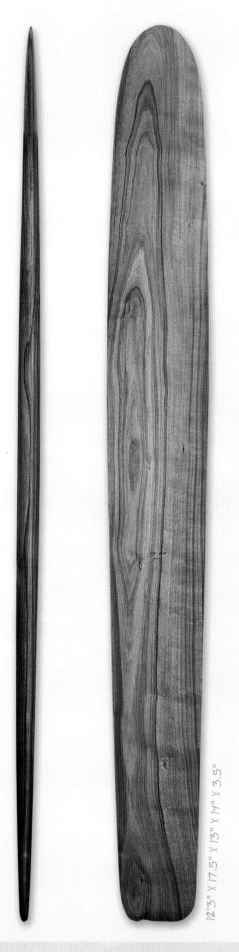

12'3" X 17.5" X 13" X 14" X 3.5"

2001 OLO

Greg Noll's 2001 (buffed and oiled) replica of the ancient boards ridden by Hawaiian royalty. "This board is proportionate to an olo board that hangs in the Bishop Museum," said board collector Spencer Croul. "Although it does not have the exact dimensions, because Greg couldn't find a 16-foot piece of solid koa wood." The board weighs 150 pounds.

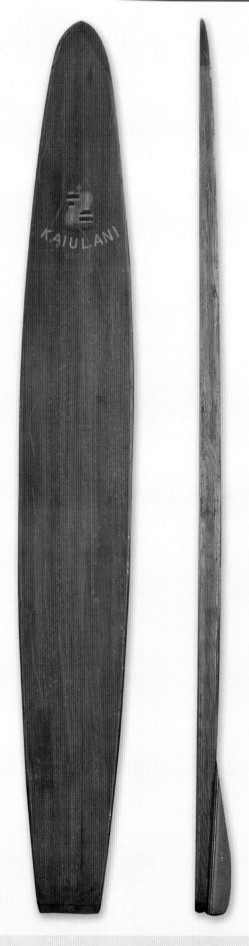

KAIULANI PACIFIC SYSTEM HOMES OLO

This late-'30s Pacific System Homes board is the sister board to the one at the Bishop Museum. The board's "fin" is an early aluminum keel fin.

Redwood Planks

CHIEF

11'6" X 23.75" X 17" X 16.75" X 4.75"

The first documented surf sighting on the coast of California dates back to 1885 when three Hawaiian princes took to the waves near Santa Cruz at the mouth of the San Lorenzo River. This introduction to the state that would eventually become surfing's epicenter was made on redwood plank boards—and likely left bystanders searching for some comprehension of what they were witnessing.

The incident introduced a new recreational activity to the princes' newly adopted mainland home. While the Hawaiians had been surfing in some way, shape or form since the 15th century, surfing was a new phenomenon to the contiguous coastal states.

A glance at some of the early photos of surfing from the end of the 19th century presents images of stone-figured, athletically sculpted Hawaiians coasting toward the beach upon bulky slabs of wood that represent some of the earliest forms of waveriding equipment. These boards were little more than a 10-foot-plus, thinned-down trunk of a tree (*koa, wiliwili*, breadfruit or redwood) with a rounded nose—which as any experienced surfer would know, says little for the performance or maneuverability of the archaic equipment.

While Hawaiians and Polynesians were in general adept canoe surfers, these boards were among the first forms of equipment that resemble our modern image of waveriding. The plank boards could be used in attempting to harness the power and speed of the swells that crashed upon the shore all around the Hawaiian Islands' coast. The plank surfboard—the word "plank" was not widely used until the 1930s—can be linked to the original surf craft, with boards of that time tracing their roots to the Hawaiian *olo* or *alaia*. An example of the typical measurements for the plank-style boards the Hawaiians were riding could be seen in one of Duke Kahanamoku's hand-crafted redwood planks from 1910, which was 10 feet long, 23 inches wide, three inches thick and weighed 70 pounds.

DUKE KAHANAMOKU
You may have seen this personalized board, purchased from Duke, featured in one of many Hawaiian advertisements. Its solid redwood deck is distinguished by its one-of-a-kind hand-painted symbol of a Hawaiian chief, signifying Duke's high standing as a waterman. It weighed 80 pounds and was believed to be shaped in the mid-1930s.

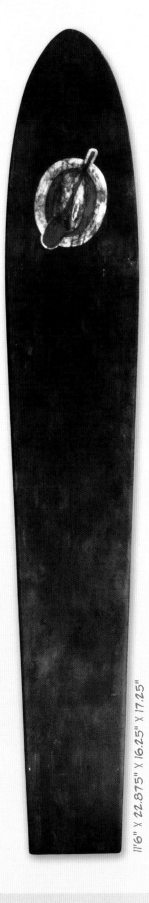

11'6" X 22.875" X 16.25" X 17.25"

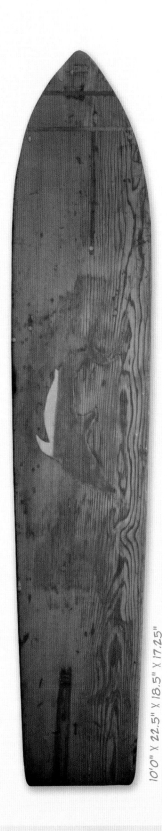

10'0" X 22.5" X 18.5" X 17.25"

10'1" X 21.5" X 16.75" X 16.25" X 2.875"

OUTRIGGER CANOE CLUB

Made of solid redwood, this board has the Club's logo on its nose. Its origins date back to the cradle of surfing. This one was used by Outrigger Canoe Club members into the '30s and '40s. Eventually it spent some years at the beach entrance, before being removed when the organization relocated.

SHARK INLAY PLANK

All hand-shaped boards are sculptures; in this case, the shark inlay adds an additional artistic angle to it. A strong testimony to the era. The original owner was Dr. Richard Arnest, M.D., who surfed Waikiki in the '30s. His son carved the inlay intending to make a bar countertop with the board.

EARLY 1900S REDWOOD PLANK

"This board is associated with the Duke Kahanamoku era of design. Solid planks of redwood that were being imported from the mainland, primarily for the construction of piers, buildings and harbors, became available for surfboard construction," explained board collector Spencer Croul. The hand-painted crest on the nose bears the initials of a woman who rode the board. The board weighed 68 pounds and was made around 1915.

Coasting into the shore at a slight angle—which was nearly the limit of the board's performance ability—riders would use maneuvers such as bicep-flexing poses, backward riding, headstands and other tricks to demonstrate their ability and comfort on the board.

In the pre-contact era, the predominant material used for Hawaiian boards was native woods found on the various islands, which were hewn and shaped without the use of metal tools. Some boards, however, were made of a less common material in Hawaii, redwood. Every so often logs would wash up on the beach and would be made into boards. During the early years of board construction, these boards were highly prized since they were considered a gift from *Kanaloa*, the Hawaiian god of the sea.

In the post-contact years, the accessibility to redwood—along with the introduction of metal tools—due to its import for construction purposes (ex. Honolulu Harbor) made it the predominant material. The eventual devotion to redwood over the other native woods found on the Islands and along the California coast was also due to the ease with which the long, straight-grained wood could be manipulated and shaped. One of

To customize their boards, many of the early surf pioneers in the Islands would adorn their boards with a name or logo.

the beneficial features of the wood was its lack of knots, which made shaping easier with the redwood; shapers needed only access to a saw, drawknife, hand planer and sandpaper to mold their ideal board shape and measurements. What was most attractive about the board material was when there was a desire to alter the original design, surfers could do so without requiring heavy-duty equipment.

During the early developments of the redwood plank boards, it wasn't uncommon for riders to customize the aesthetic element, much the way modern-day surfers will adorn their board of choice with stickers, spray paint designs and deck pads. Typically the redwood boards of the era would include a "spirit" name (it was a Hawaiian tradition to name each board) or the board owner's name (or the name and logo of his club), which was often painted, inlaid or burned into the board's deck somewhere near the nose. The planks were also often coated with several coats of varnish, which would provide a glossy appearance and waterproof the wood.

—*Chasen Marshall*

Boards were sometimes engraved with the name of their owner, but the Hawaiian tradition was for each board to be given a unique "spirit" name.

Early Foam Boards

*I*t was in the early '50s that Dave Sweet found his life's calling as a surfboard builder. But the surfboard business had yet to establish itself as a legitimate trade. His early presence in what eventually became an industry allowed him to play a pivotal role in how surfboards would be constructed for the next 50 years. Nobody knew it then but a transformation of significant scope was about to unfold. A shift in both the materials used to make surfboards and the mindsets of the participants was underway. This change, ushered in by Sweet, would reach all the way into the next century—the foam surfboard.

Sweet began to experiment with Styrofoam, although he certainly wasn't the first to do so. Several before him had done the same including Joe Quigg, Pete Peterson, Bob Simmons and others, Dale Velzy in particular. Velzy shaped an all-Styrofoam board as early as 1948. What separated Sweet's work from his contemporaries and those before him was his fortitude and commitment.

It was sometime around 1953 that Sweet first ordered an extruded piece of Styrofoam. Laying down a template, then cutting the outline with a saber saw caused the foam to gum up and melt. Undeterred, Sweet hand-shaped the brick-like slab into a period design shape, then sealed it with a red epoxy coating. In clandestine surf sessions he rode the board that winter at Rincon, and later Malibu, the whole time covertly testing the foam contrivance under its disguise of color.

In 1954, Sweet discovered the existence of new and superior foam called polyurethane. Unlike Styrofoam, urethane was compatible with polyester resin. This new foam successfully allowed a fiberglass lamination and seal. The problem was, formulating this stuff was no easy deal. Not even his supplier knew how to use or mix it. Consequently, embarking on this new frontier devoid of any tutelage only added to the mystery and confusion. Alone and intrepid, Sweet built his own mold and stepped into the great unknown.

A tedious trial and error process followed in an intense and expensive learning curve. Gaining the knowledge of how to mix and pour the foam, clamp the mold securely shut within seconds and strive to avoid air pockets was no easy feat. Liquid urethane foam components were mixed together for about eight to 10 seconds and then poured into the mold. Moments later the mix expanded to approximately 20, maybe 30, times its volume. Almost instantly the concoction yielded extreme heat and dangerous pressures.

Sweet quickly learned that foam blown at lower pressures lacked stability in real world conditions such as those encountered at the beach. Heat and ultraviolet exposure caused poorly formulated foam within a fiberglass lamination to continue its expansion, causing distortion, delamination and eventual structural failure. The odyssey to properly formulate the liquid urethane continued with no easily found solutions.

"I was determined to make things work and money was the most essential ingredient to continue moving forward. Money was hard fought, which forced me to confront a series of challenging decisions. I went to the extreme and sold my new car. In actuality this turned out to be a very positive move. I purchased an old Dodge station wagon that was clearly better suited for my new situation.

"With my skills and techniques somewhat honed, I was confident and ready to begin building surfboards. In the series of ongoing obstacles to overcome, I was now in need of a commercially fabricated mold to make surfboard blanks. With the

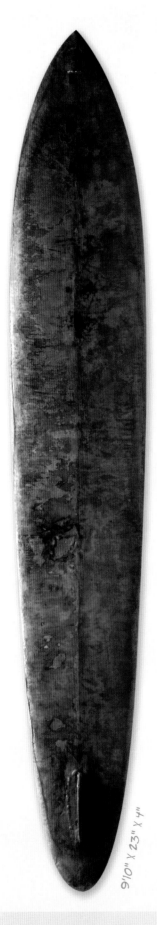

9'10" X 23" X 4"

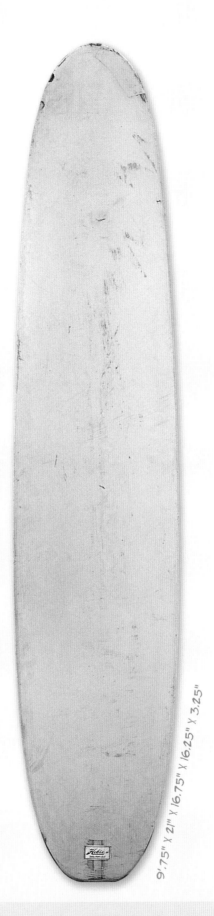

9'.75" X 21" X 16.75" X 16.25" X 3.25"

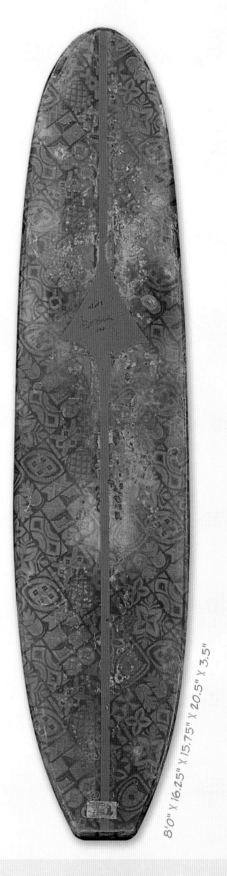

8'0" X 16.25" X 15.75" X 20.5" X 3.5"

DALE VELZY

This board is a polystyrene foam core surfboard that was made by Dale Velzy in the late 1940s. The shaped blank was coated with two layers of egg sealer—at the suggestion of his mother—to prevent the foam from being dissolved by the polyester resin used in fiberglassing it. At 34 pounds, the board was light compared with wood boards of the era, but Velzy did not care for the way it handled.

HOBIE SURFBOARDS

This is the earliest polyester foam and fiberglass board in board collector Spencer Croul's collection, although he admittedly covets a Dave Sweet foam board to refine his gallery. Originally referred to as the "Easter Egg" because of its pastel colors, this opaque pigmentation was a sly way to cover up blemishes in early foam production. It weighed 21 pounds.

HOLDEN

Possibly the first-ever fabric board. "A lot of people think it was a kid or girl board. Not true," says board collector Lee Nichol. "Velzy had released the "7-11" model and [Greg] Noll answered with the [eight-foot] "Blob." This was Holden's version, and he used it as a display board in his shop."

proceeds left over from the sale of my new car and the reserves I had in my savings, I began shopping for a mold.

"I found a company in Van Nuys, Calif., called Techniform that manufactured molds. I presented my idea to them of a steel and fiberglass surfboard mold. They were quite receptive and the project was soon underway. The high cost of the mold required that Techniform be partners in my endeavor. Building the mold took much longer than originally projected. In my persistence to finish the mold, I was eventually allowed access to the job and became quite involved in the outcome of the finished project.

"When the mold was completed in 1954 we conducted our first pour of urethane foam. For just shy of three months we diligently but unsuccessfully attempted to produce an acceptable foam blank. Our efforts were not without their exciting moments. More than a couple of times we ran for our lives, away from a creaking mold on the threshold of its capacity. Steel latch bolts once flew through the air like bullets. It's funny to talk about the episode now, but at the time it was a rather serious deal.

"My partners in the endeavor had basically given up and said the project was impossible and would never work. There was simply too much air trapped, preventing a satisfactory foam blow. I offered to buy out their half of the mold and they agreed. I amassed the necessary $6,000 from what was left of my savings and a variety of other sources. The mold was now mine," Sweet recalled.

Undeterred and no longer hampered by partners with only a lackluster attitude to successfully employ the mold, Sweet took matters into his own hands. With what his partners viewed as a defunct steel and fiberglass mold, Sweet kicked into high gear and implemented a series of ideas to make his dream a reality. The main problem had been clearly defined: all the finished surfboard blanks coming out of the mold were plagued with trapped air. This left the rise side of the blank fraught with air bubbles and holes. Upon close examination of the mold he noticed that if he

reversed the clamps that held the unit shut he could produce a blank a half inch thicker. In doing so, he was able to shave that same half-inch off the finished blank with a planer and eliminate the vast majority of the holes and blemishes. Countless discarded blanks later, and with experience gained by time and experimentation, Sweet successfully produced a workable foam blank. In doing so, circa 1956, Sweet went on to produce the first commercially offered polyurethane foam surfboard.

Meanwhile, Hobie Alter and Gordon "Grubby" Clark were working on their own version of the foam surfboard in Laguna Canyon, Calif. Unlike Sweet, they were working on molding their boards in two pieces, then joining the halves with a wide stringer to impart width. Says Hobie, "Yeah, Sweet was working on foam surfboards for a considerable time before us, although I must add that he had no idea what Grubby and I were doing, nor did we have any idea what he was up to."

Hobie continues, "We first became aware of urethane foam from our Reichold salesman, Kent Doolitle. He brought a small chunk of foam by one day. Grubby was my glasser at the time. He tried a mix with a bellyboard mold but the foam did not expand as we expected. This marked the beginning of a long trial and error period for us. We built a half surfboard mold and did on-edge pours, as we were worried about the pressure of the expanding foam. I had saved $8,000 and put it all into the project.

"After six months we spent all the money, I got an ulcer and pretty much got nowhere. The idea of foam was great. I was still shaping most every balsa board myself. Initially we were attempting to produce a blank that needed little or no shaping, something we never achieved. The way we were formulating the Reichold foam did not lend itself to shaping. Eventually we got some new material from American Latex that saved us. It expanded better and, best of all, it was dusty to the touch, which allowed shaping. Sometime during 1958, Hobie Surfboards made the transition to foam. Balsa surfboards remained available as a custom order but at a slightly higher price."

After a failed partnership with his brother Roger, Dave Sweet was once again the sole proprietor of the Dave Sweet Surfboard Company. Manufacturing and pouring the blanks accurately required Sweet's uninterrupted attention and focus. A single break in concentration during the several-second exercises of pouring the activated liquid foam then clamping the mold shut would likely yield a reject blank. Often the work became nerve-racking if only because of the discipline the process required. During periods of back orders and heavy demand, Sweet tells of how he would come home at the end of the day mentally exhausted. There was an upside of these seemingly endless stints of repetition and observations working the mold though: knowledge.

It was during such a time that he discovered how to eliminate the trapped air that had distressed him from the very inception of his project. Through the introduction of a special paper laid out in the mold, the forced air from the rise of the foam was retained in the porosity of the paper, allowing a nearly perfect blown blank. The result was nothing short of exceptional. Immediately he reversed the mold latches to their original position and began producing blanks as he had originally engineered and planned.

Using the paper in the foaming process made Sweet a master of the polyurethane foam formulation. Further experimentation yielded yet another discovery. Sweet devised a rather unique 60/40 formula mix of Freon-blown and water-blown foaming components. The potion produced an excellent composition within the finished blank allowing the option of a "hard shell" finish or one that was easily cut and hand-shaped. Blanks were now coming out of the mold looking like roughly finished surfboards.

Each new success in the foaming room fed the next. With basic foaming procedures now established, Sweet went on to ice the cake. Shortly after the paper revelation, he devised a series of multiple inserts that became infinitely adjustable. When properly positioned, these inserts made it possible for a finished blank to come out of the mold to the specifications and dimensions of a custom ordered board, eliminating the need for hand shaping—a feature unique to the industry.

To compensate for the extra weight inherent in the higher density foam formulations, Sweet devised a stringer system that was again unique to the industry. In a free-thinking departure from conventional norms, Sweet elected to rout his stringers into both sides of the board. The deck and bottom stringers structurally tagged together where they converged in the last eight to 12 inches of each end of the board. Additional strength was found in large part in the eight-pound density outer hard shell foam—more than double that of other custom surfboards of the day. For those who opted for a conventional stringer, through-hull stringers remained available. Sweet believes that about 80 percent of his boards left the shop with the inlaid converging stringers and the other 20 percent employed conventional layouts. Supplementary benefits permitted setting the rocker and locking in the desired curvature with the chosen stringer system.

In spite of the many superior qualities of foam surfboards over their wooden counterparts, they were not universally nor immediately accepted. Tagged with names like "Flexi-Flyers" and "Speedo Sponges," the older, more established guard's resistance to change caused the transition time from wood to foam to bog. Slowly but steadily the changeover to foam transpired, and they were in strong demand. By late 1958 the change was well underway; Sweet was awash with orders.

Dave Sweet Surfboards, with its distinctive arrowhead logo, held an acknowledged position among the most well respected brands in the surfboard business. From its early beginnings during the '50s all the way into the early '70s, the company prospered and played an active role in the sport. But without doubt the legacy left by Dave Sweet Surfboards was the polyurethane foam surfboard.

—Mark Fragale

Simon Anderson Thruster

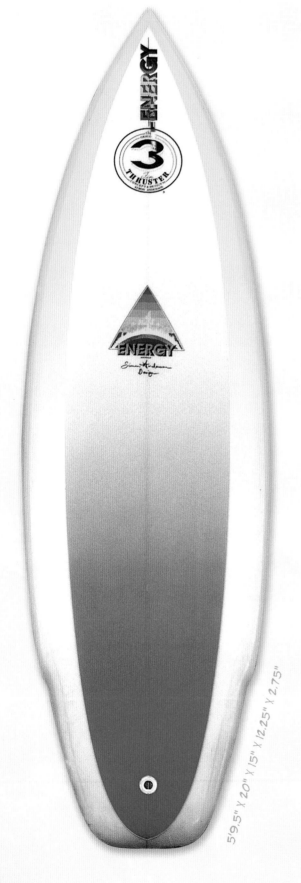

5'9.5" X 20" X 15" X 12.25" X 2.75"

The year was 1980 and professional surfer Simon Anderson was frustrated. The big guy (6' 2" and pushing 200 pounds) from Australia's North Narrabeen was still ranked among the top 20 surfers in the world, but he'd been on a bit of a backward slide since he was ranked No. 3 in the world just a couple of years earlier. Furthermore, at 26, he wasn't getting any younger. In a sport where champions tended to be in their early 20s—like fellow Australian Mark Richards, who'd already won back-to-back world crowns and seemed to be unbeatable on his Twin-Fin surfboard— Anderson felt his career as a pro might have already peaked. Still, as a surfboard designer and shaper, like many other pro surfers of the '70s, at least he had his trade to fall back on.

The thoughtful, easy-going Anderson took stock of his situation and analyzed what was going wrong. The pro tour consisted of some two dozen events, most of which were held in small waves. That alone put him at a disadvantage. Anderson's power-surfing style and his big-boned frame were better suited to larger surf and single-finned boards. His approach favored huge backhand re-entries and off-the-tops, square bottom turns, vertical lip drives and mind-boggling layback tubes. He didn't care for the skittish feel of the twin-fins that Richards and many other top pros were riding to rack up radical moves in weak waves. Unconsciously at first, Anderson began to employ his surfboard design knowledge to develop a novel solution to his dilemma. As he described it in an interview at the time, "I was looking for something that would go good in small waves. I found it hard to get that in a single-fin board. Eventually, in an act of desperation, I went to twin-fins. But then in bigger surf when I needed it, I found I couldn't adjust to my single-fin. It's a lesson everyone has to learn the hard way. If you're going to ride twin-fins, you have to ride them all the time. About that time Geoff McCoy came out with the "no-nose" with its pronounced rolled vee and that made a big improvement when I started using those in my boards, but I still couldn't keep up with small-wave riders. I still

SIMON ANDERSON THRUSTER

The Simon Anderson Thruster remains one of the most influential and longest standing surfboard designs of all time. The three-fin system gave riders more drive and hold off the bottom as well as snappier, controlled off-the-top maneuvers. Anderson's squashtail also remains the shape of choice today. It weighed nine pounds.

wanted a board that would go like a twin-fin in small waves without causing me problems when I got back on my single-fin. The obvious answer was to put a small single fin on the back of a twin-fin."

In August 1980 at the Energy Surfboards factory in Brookvale, Sydney, Anderson began to experiment. He'd noted that twin-fin boards were equipped with two fins that had roughly the same amount of surface area as the bigger fins he used on his single-fin boards. He also noted that he was getting better performance from the narrow-nosed, wider-tailed boards he was making after being inspired

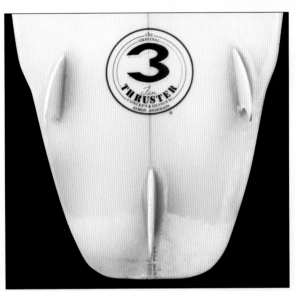

The Thruster fin configuration gave surfers the advantages of both single- and twin-fin designs in one.

by the McCoy designs. He opted to try three fins that were smaller than the twin-fin configuration—dividing the total area of one single fin by a factor of three. He placed the two leading fins slightly forward of where standard twin-fins would be located and positioned them so they were "toed-in" toward the nose of the board. The third fin was placed on the back of the board, as near as possible to the tail as it could be fitted. As soon as the board was finished, however, he spotted a problem. The rear fin's tip protruded beyond the back of the board and he was concerned that he might catch his feet or ankles on it while paddling or taking-off, risking gashes and cuts. He asked his sander, Energy Surfboards owner Steve Zoller, to take the size down a bit, resulting in a slightly smaller center fin in the tri-fin cluster.

After test-riding the board, he was impressed with its performance and dubbed his new design the "Thruster."

"The Thruster is a lot faster than a single-fin and faster than a twin in all but the smallest surf," he observed at the time. "The main advantage is you can get all those bursts of speed you get with twin-fins and the speed is maintained through the turn like a single. Also the board holds-in really well and it's very hard to spin out. It's more stable even than a single-fin. I mean, you can ride a board with a 16-inch tail and still hold-in on waves of eight feet. Also, they're loose off the top but more positive than a twin."

Anderson knew he was onto something, but he didn't reveal it right away. As the pro tour went to Hawaii for the North Shore season, Anderson took his trusty stock of single-fins to tackle contests in the big winter waves. By spring of 1981, however, he had fine-tuned his design from the early prototypes and was ready to unleash the Thruster on the world.

It did not take long for the world to take notice. In giant surf at Bells Beach, Anderson won the traditional Easter contest on a 6' 6" Thruster. At the Sydney-based 2SM/Coca-Cola Surfabout, the world's richest surf meet held a couple of weeks later, he won again, pocketing $30,000 in prizes in just two events. Later that year, at the hugely prestigious Pipeline Masters, he swept the field again on his Thruster, ending the 1981 pro tour ranked No. 6 in the world. Quite aside from the accolades, the trophies and the big checks though, Simon Anderson's power surfing itself was testament enough to prove the Thruster's mettle. The usually self-effacing Anderson predicted that within a short period of time "half of twin-fin riders and half of single-fin riders" would be riding the design on the World Pro Tour.

But he was only half right: within a year or two almost everyone was riding them. And they remain, in yet more refined versions modified by the world's most skilled surfboard builders, the stock-in-trade of both pro surfers and recreational riders to this day.

—*Paul Holmes*

Bob Simmons Designs

*I*n an industry virtually defined by the creative mavericks that were its founders, there are few other surfboard builders as enigmatic and controversial as Bob Simmons.

Although he made only as few as 100 boards during the eight years from 1946 to his untimely death in a surfing mishap in 1954, Simmons left an indelible legacy in surfboard design and construction—and one that is still the subject of lively debate among surf historians and pundits to this day.

Was Simmons a towering figure in surfboard building? Or was he just an eccentric genius, a nutty professor with wildly futuristic but largely impractical design ideas?

One thing that is beyond argument, however, is that he was a technological pioneer—probably the first to use fiberglass as a surfboard material and, with his polystyrene core "Sandwich" board, certainly the first to envision boards made with complex composite technologies.

Simmons began surfing in the late 1930s when surfboards were either solid wooden planks or paddleboard-style hollow "kook boxes." With a penchant for math and science, he studied at the California Institute of Technology. During World War II, unfit for active duty because of the limited use of his left arm due to a bicycle accident, he worked as an engineer for Douglas Aircraft, which is likely where he came across a new material, fiberglass, being used in aircraft construction. By 1946, Simmons was using the stuff to protect the nose of plank-style boards he made under the mentorship of Gard Chapin, owner of a Santa Monica-based joinery, who was also a surfboard maker and the stepfather of Malibu surf legend,

Miki Dora. By the late '40s, Simmons was also collaborating in surfboard building with others in the Santa Monica-Malibu hub including design pioneers Joe Quigg and Matt Kivlin.

As fiberglass and balsa wood became the materials of choice for surfboards in the post-war years, Simmons became one of Southern California's "go-to" surfboard shapers and he became known for his spoon-nosed, extra-wide designs, often with concave bottoms and sometimes featuring two fins, one under each rail, intended to keep the wide tails from spinning out. Some of his most extreme experiments included a "slot-rail" board. Simmons also realized that the strength and integrity of a board made with a fiberglass skin permitted a shaper to graft an extra piece of balsa onto the nose section that could be "scarfed" to add extra rocker. But as other shapers like Quigg, Kivlin and Dale Velzy were experimenting with surfboard design through trial and error, Simmons's designs were informed by theories he had gleaned from scientific research on planning hulls.

Recalled Velzy: "Simmons had a book on oceanography and another on hydrodynamics and drag, another on powerboats and all these Navy books that showed things like the drag when pulling a barge, how much stress was put on propellers, all kinds of way out stuff. That was the kind of thing he read. What he didn't know he'd look up in a book and then figure out with his math. He wanted to know how much turbulence and drag was caused by a surfboard going 10 mph, or 15 mph. He reckoned that a surfboard went about 18 mph at its fastest. He figured it all out according to how big the board was, and how heavy the guy on the board was. It was all way over my head."

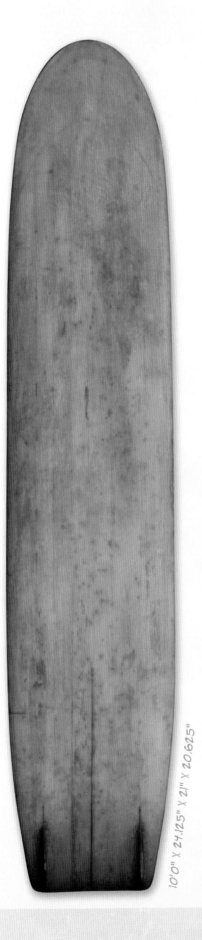

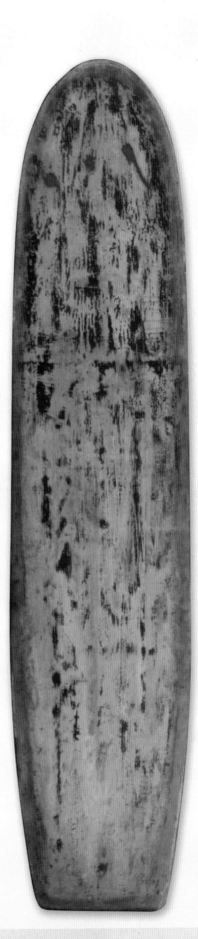

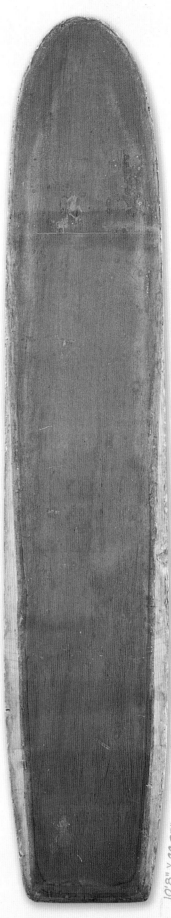

10'0" X 24.125" X 21" X 20.625"

10'8" X 22.75" X 20.75" X 19.5" X 4"

SIMMONS DESIGNS

Among his various designs were the concave, two-fin spoon (left and middle) and the "Sandwich" model (right). While his two-fin design was unique—and intended to keep the boards from spinning out—the general outline of the boards did not vary far from the plank-style boards, although wider. The Sandwich design adopted some technological ideas for surfboard building: the board is one of the earliest known applications of foam with mahogany veneer and balsa rails over a polystyrene core, glued together in a clamping jig and then glassed. Simmons's boards often measured over 10 feet with over 20 inches of width.

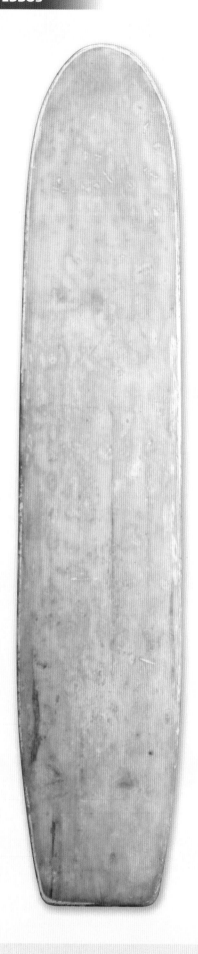
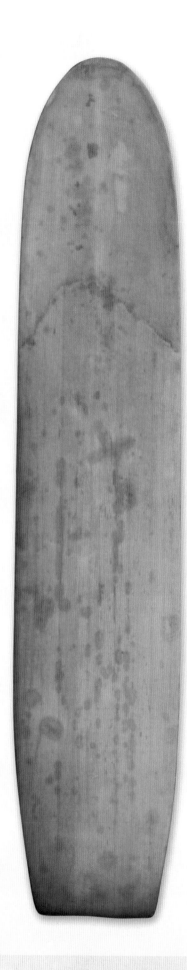
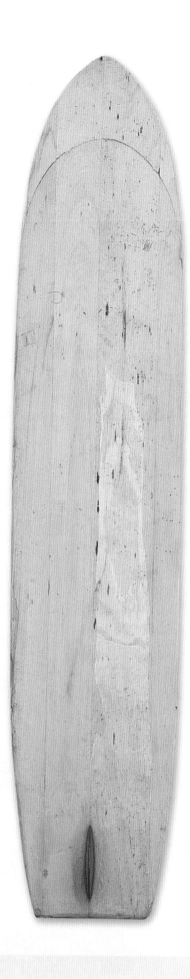

SIMMONS DESIGNS

While Simmons' reputation is one that remains a topic of discussion—genius or mad scientist?—what is not in question is the extent of his importance in the long-term development of the surfboard. While some of his designs were impractical, among his more celebrated accomplishments were his use of fiberglass on boards, the polystyrene core and the two-fin setup (which could be considered a precursor to the twin-fin). Most of his boards measured over 10 feet in length, with 21 to 24 inches of width and a wide, rounded nose.

Simmons and Velzy got along well and often played ping-pong together, he said, observing that Simmons was renowned for his cranky personality. But when it came to surfboard design, he added, they were totally at odds. "His boards were just too long and too wide for beachbreaks," says Velzy of the main source of their disagreements. "We wouldn't talk about boards while we were playing ping-pong, but afterwards, in the car, there'd always be an argument."

Commented Kivlin: "Simmons was interested in planing boards and when you see those old pictures of him he's always clear on the tail. That was his style, and his idea was to get a wave all the way down to the [Malibu] pier, even if it was only two feet high. But we became interested in getting in the curl and Simmons wasn't the least bit interested in that and couldn't really do that the way he surfed. But he was very innovative although I never really did surf any of his boards. Everything you see today has come down through trial and error. Simmons would wrap a theory around almost everything."

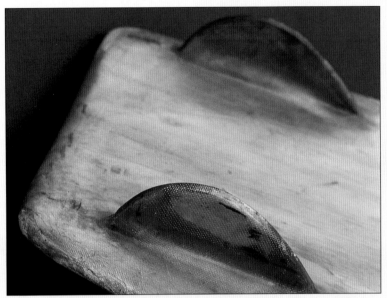

Simmons used a two-fin (or twin-fin) set up on some of his 10-foot-plus boards with the hope that they would add stability to the wide tails.

While Simmons will certainly be remembered in history as a radical experimenter in design theory, he is also recognized as an innovator in construction techniques, especially for his polystyrene and plywood sandwich boards that solved the problem of resin dissolving the foam.

The gluing of the components—with Weldwood glue—was done in a specially made clamping jig that Velzy believes was the result of a collaboration between the scientific imagination of Simmons, the craftsmanship of Quigg, the can-do enthusiasm and hard work of Kivlin and, quite likely, the joinery and door-skinning skills of Gard Chapin. The concept for marrying the diverse assemblage of materials and parts was certainly a Simmons original. Once the glues had set, bonding the top, bottom and rails around the foam core inside, the balsa wood rails could be fine-tuned by hand to create a smooth, foiled board that could then be fiberglassed to make it both strong and watertight. The finished product weighed at least 20 pounds less than the standard balsa and fiberglass board of the time, and was half the weight of many plank-style boards.

Reflected Velzy with obvious admiration: "They were strong and they were light, about 45 pounds to 55 pounds depending on what kind of plywood he was using. Some of it was mahogany veneer that was heavy, and he put three layers of glass on them. That was to prevent them from caving in or collapsing. The gluing in that jig was incredible. Everything fit together perfectly. You couldn't even find a seam. They did it scientifically and they did a bitchin' job, I think. It was damn clever."

For legendary shaper Reynolds Yater, however, it was Simmons's work on foiled rails and bottom contours that is his most enduring contribution to surfboard design. He says that with the benefit of hindsight, it's clear Simmons was already forging into a new age of slimmer-profiled boards, although he was likely inspired by what he saw Quigg and Kivlin doing in that arena too. "You've got to give Simmons credit," says Yater. "Kivlin and Quigg made better boards, but would they have done that if Simmons hadn't been doing what he was doing, stuck in his radicalness? They took it to a more sophisticated level, but I think Simmons was really the father of the modern surfboard."

—Paul Holmes

Gerry Lopez Pipeline Gun

"T he faster I go out there, the slower things seem to happen." —Gerry Lopez

These immortalized words tell the story of an icon whose soft-spoken cool at Pipeline has seldom been equaled throughout surf history: part zen, part empiricism, all wisdom.

With an elegance often likened to dance, or in more abstract terms, poetry, Lopez choreographed a lasting blueprint for the world's most photographed wave. It consisted of a late, near-vertical takeoff followed by a perfectly timed bottom turn, setting up the deepest possible line through the barrel. And yet simplicity may well have been Lopez's greatest feat. Because while tangible accomplishments are meant to be eclipsed—

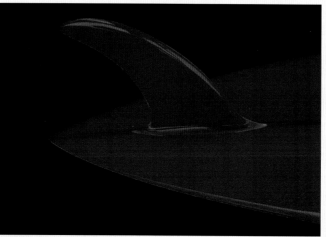

The single-fin setup was a mainstay on Lopez's boards due to its stability and predictability.

and indeed there are riders who have since gone deeper at Pipe—Lopez's spare, ultra-casual approach remains class. Nary a wasted movement, nor an instant of discernible fluster. Just that oft-imitated trademark stance (minor slouch, knees bent slightly), a meditative gaze and the purest, cleanest line imaginable. Point "a" to point "b" in no time flat, yet with the kind of understated poise that warps all perception of speed.

Of course every hero has a trusty steed, and in the case of Gerry Lopez it was, appropriately, a certifiable racehorse. Characterized by a sleek template and emblematic, lightning bolt insignia, the Lopez signature model was an eye-catching manifestation of the beauty, refinement and speed that characterized his tuberiding—an extension of the very aura he exuded. Design-wise, it fell somewhere between Dick Brewer's mini-guns and the single-fins ridden by Pipeline heir apparent, Shaun Tomson; the wide-point had been pushed back, but not yet to the point where trim and turn spots merged as one. But while Tomson's equipment enabled him to instigate changes in direction and trim speed from the back end of his board by essentially shifting his weight, Lopez's boards still mandated that the rider turn from the tail and then slide a few steps forward into full trim. All in all, there really wasn't anything of monumental significance to set the Lopez Lighting Bolt apart from other guns of the era. Far more noteworthy in the overall landscape of surf history was the man himself, and the legacy he etched into Pipe's now hallowed blue room.

Most surfers who were around in the early '70s and who bore witness to the Lopez mojo are understandably at a loss for appropriate words with which to express what exactly Gerry did out there. Certainly it can be said that at a time when a lot of riders were starting to flail, Gerry Lopez put the style and grace back in progressivism. And for that, plain and simple, loads of people from the North Shore to the North Coast of Oz wanted to surf like him. Meanwhile, the ever-cordial Lopez quietly went about his business of dominating Pipeline with a cool hand and an equally cool surfboard to match.

—Tristan Wand

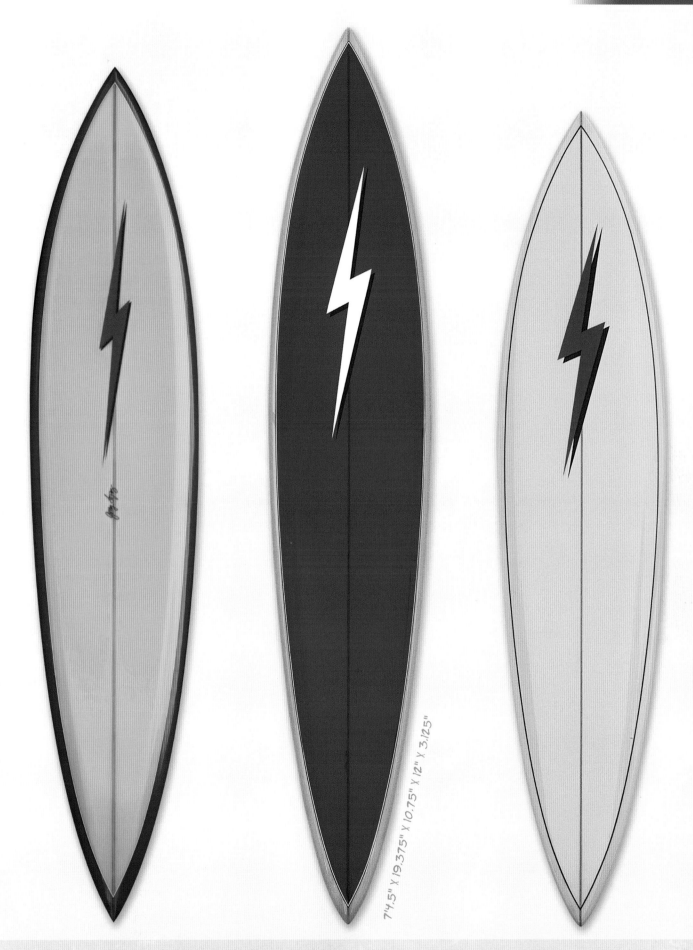

7'4.5" X 19.375" X 10.75" X 12" X 3.125"

LIGHTNING BOLT GERRY LOPEZ PIPELINE GUN

These replica Lightning Bolt semi-guns shaped by Gerry Lopez represent the mid-'70s era of Hawaiian design. From a technological design standpoint the board had little to set itself apart from other "gun-ish" designs of the era. More so, it was the rider—Gerry Lopez—and the style with which he rode them at Pipeline that set the oft-recognized Lightning Bolt board above others. The boards were typically in the mid-seven-foot range and weighed around 11 pounds.

1960s Noseriders

y the mid-'60s a casual observer might easily have deduced that surfing on the U.S. mainland had gone nuts—about noseriding. What had begun as the natural reaction to an idiosyncratic performance characteristic of the finless Hot Curl boards being ridden by the Hawaiians at Waikiki some 20 years earlier had become an obsession. The old Hot Curl riders could hardly have guessed what was to come. Their need to move forward on their boards was at first simply to trim and produce forward drive as they were drawn up towards the hooking lip whenever the board was angled across the face of a fast-breaking wave. Sure, they'd take the move to the limit, if the surf permitted, just for fun; they'd go beyond trimming to stand on the tip—and throw in a soul arch—simply for dramatic effect if they had the skill, daring and showmanship to get away with it. They couldn't have known that noseriding itself would become surfing's ultimate objective at the time. Nor would they even have dreamed that special surfboards would be designed specifically to maximize tip time. But by 1965 that is exactly what was happening.

During this period, surfboard companies had been enjoying great success by marketing team rider and famed surfer/shaper "models." But the boards being made and endorsed were still designed to be all-around performance surf crafts, although sometimes they were tailored to a specific type or size of wave—for Malibu, for example, or Hawaii's big winter surf. The obsession with noseriding reached a climax in the summer of 1965 when Tom Morey (no slouch on the tip himself, by all accounts) staged a timed noseriding invitational contest offering $750 in cash and two equipment classes—stock and special. The event attracted a turnout by most of the star tipriders of the day and several of them showed up with uniquely made or wildly modified equipment to maximize their performances in the special class. Some of the ideas were plain wacky—bricks taped to the deck near the tail, or plywood tail extensions. The "special class" was eventually won by Mickey Muñoz on a Hobie board featuring a wide nose and a concave bottom. Muñoz's 9.9-second winning score was probably not hindered by the fact he was one of the smallest surfers in the contest. Behind Muñoz came Mike Hynson (9.8 seconds) and Corky Carroll (9.6). Meanwhile, in the stock class, David Nuuhiwa tied for first with a 5.8-second score. Nuuhiwa was riding the Bing Surfboards "Donald Takayama" model on which he also won the U.S. Junior Men's title that year. It was clear from the disparity in the scores that equipment, not just expertise, played a significant role in the noseriding game—the shapers/designers got busy and the surfboard company heads put on their marketing caps.

Some surfboard companies that made boards for the "special class" and had seen them succeed used the models as prototypes. Indeed, Hobie went so far as to attempt to patent its winning design. Others took their observations and went back to the drawing board and the shaping room. Almost instantly, every surfboard label worth its salt had a noserider model, usually sold with a top noseriding surfer endorsing it. Generally, the boards reverted from the more elliptical outline that had been ushered in by the Velzy-Jacobs Pig to become a more parallel outline featuring a wide, round nose, often with a teardrop concave area on the bottom beneath it, and exaggerated rocker in the tail. Such boards also typically were fitted with a special fin to aid stability when riding on the tip. Dewey

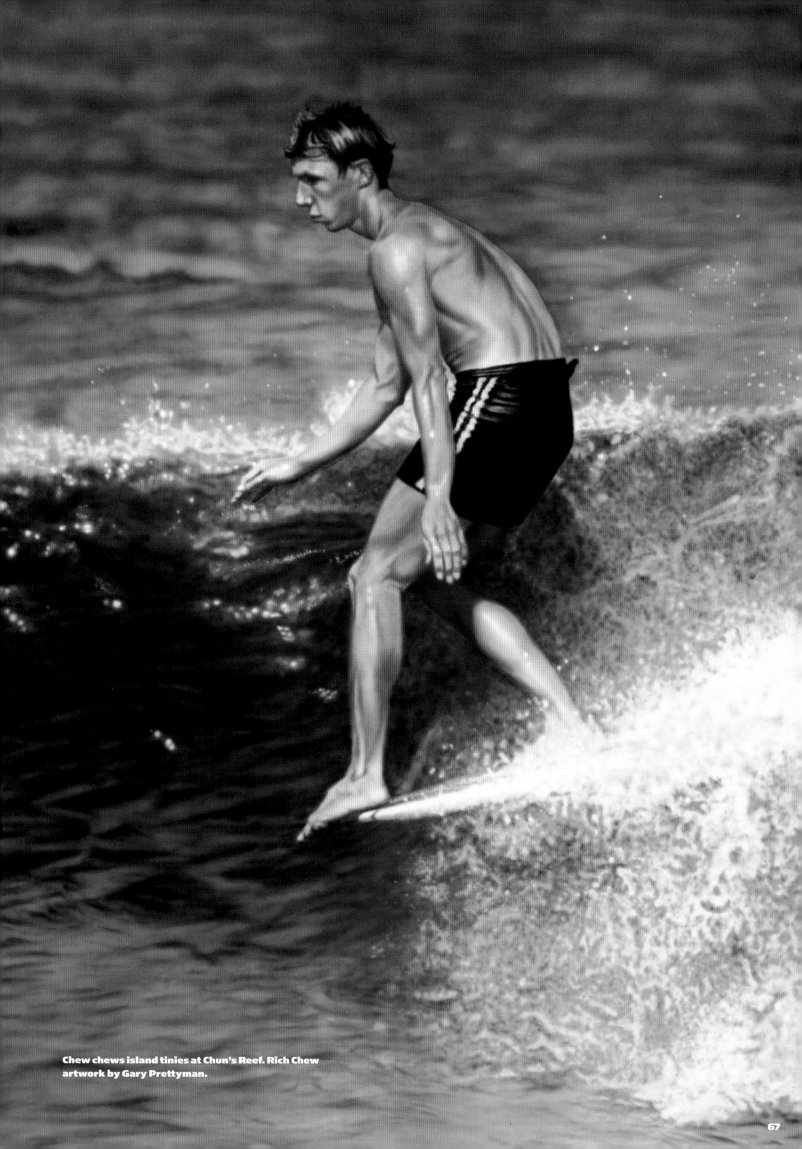

Chew chews island tinies at Chun's Reef. Rich Chew
artwork by Gary Prettyman.

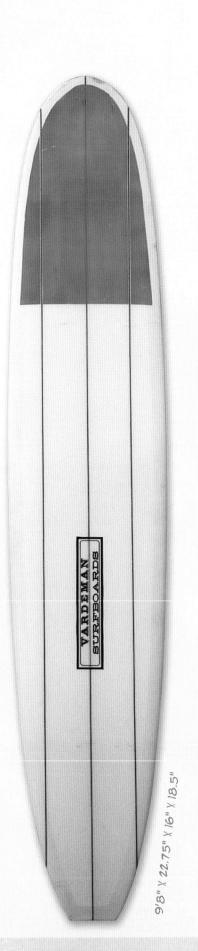

9'8" X 22.75" X 16" X 18.5"

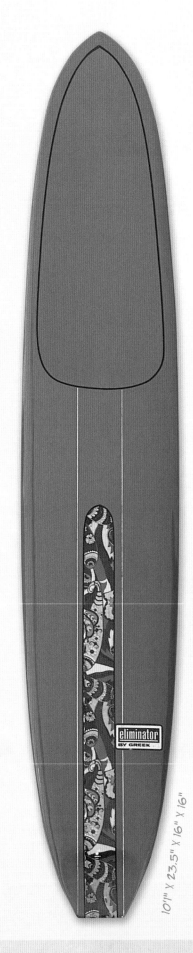

10'1" X 23.5" X 16" 16"

9'0" – 9'5" X 22.25" – 22.5" X 15" X 19" – 19.5"

VARDEMAN SURFBOARDS

Shaped in the house of Seal/Huntington Beach kingpin Sonny Vardeman, who benefited from the design feedback of team riders Tom Lonardo, Herbie Fletcher and Jackie Baxter and the planer prowess of Honeybear. Screamin' lime Slipcheck decking presaged late-'80s jet ski graphics. A rare custom stepdeck that never progressed into model status.

GREEK ELIMINATOR

Bob "The Greek" Bolen's gambit into the outrageous marketing frenzy that was the model world. The Greek would release one more longboard (the Liquidator) before diving headlong into the transition/revolution phase of production among other models like the Maui Teardrop, the Small Dimension, and the MacIntosh Apple, which, in looking back, might have been a nice moniker to trademark.

BING SURFBOARDS

Among the Bing stable of boards, the David Nuuhiwa Noseriding signature model was the top-selling board in 1966. The board's distinguishing features were the oval Bing logo and its concave bottom.

9'7" X 23" X 15.5" X 18"

9'8" X 23" X 16.5" X 16.5"

9'6" X 23" X 14.5" X 18.25"

SURFBOARDS HAWAII
MODEL A

Shaped at the Encinitas, Calif., foam studio of Surfboards Hawaii's John Price, the Model A's most significant features (other than the stepdeck) are the distinctive rising sun motif, three-stick glue-up and classy script logo.

GREG NOLL
BLACK CAT

This classic Miki Dora model originally belonged to a 16-year-old Houston girl who surfed it only a handful of times before storing it in perfect condition, for almost 30 years.

HOBIE GARY
PROPPER MODEL

The best-selling East Coast model in Christendom. Specifically crafted for Propper's high-energy, bullwhip style, and the lodestone for Florida board collectors.

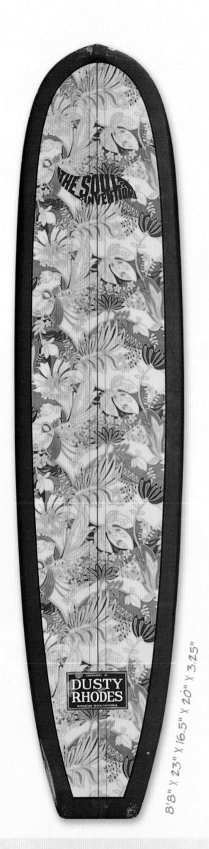

8'8" X 23" X 16.5" X 20" X 3.25"

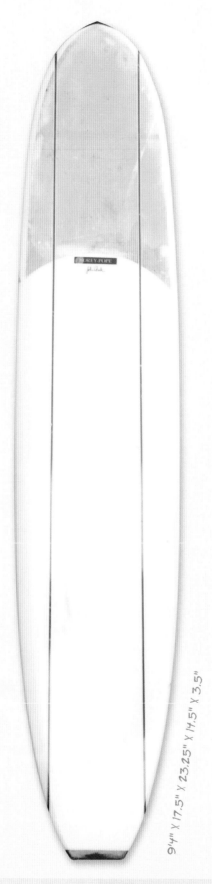

9'4" X 17.5" X 23.25" X 14.5" X 3.5"

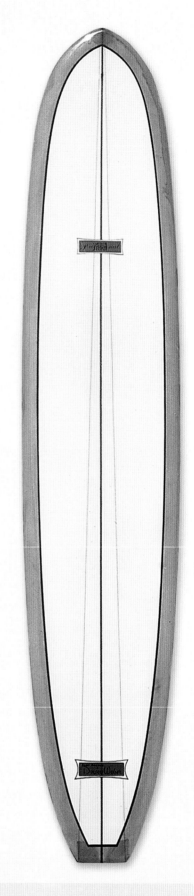

DUSTY RHODES
SOUL INVENTION

This obscure surfboard company was based out of Manhattan Beach and its boards were sold mostly in Southern California. The board featured a wide tail and nose, and could be viewed as a precursor to the modern noserider.

MOREY-POPE
PECK PENETRATOR

Developed by Tom Morey and John Peck, this board realized huge noseriding success and influenced the low-railed design work of Mike Hynson.

WEBER PROFESSIONAL

It was one of several models to follow the Performer and was one of the first boards that Weber crafted from lightweight foam blanks. It featured a stepdeck, kicked and dished-out rail and a thin, foiled profile with turned-down nose rails.

Weber's distinctive "hatchet" fin is a prime example and his "Performer" noseriding model became one of the best-selling boards of all time.

Donald Takayama went to his boss, Bing Copeland, and suggested they too begin producing a surfboard model designed specifically to make one not inherently functional maneuver—the noseride—easier to master by the masses. He also brought along a hot young surfer, and a great noserider, to endorse it. The fact that the noserider model bore the name of an exceptionally accomplished master of the art—David Nuuhiwa—made it an instant success, and it is estimated to have sold more than 10,000 units before the shortboard revolution led to longboarding's demise in the '70s.

Says Takayama: "At first Bing was worried that the David Nuuhiwa Noserider would hurt sales of my model, but I told him, 'Hey, there's plenty of room.' My model would noseride but it had a more pointy nose and it didn't noseride like a blunt-nosed board with a concave for extra lift and extra kick in the tail to produce some drag. David was already a phenomenal noserider; he blew everyone's mind. Noseriding is one of the hardest things to do in surfing. To be able to hang ten and keep your balance as you go through sections and all of that is a very difficult thing to do and it has a lot to do with total mind control. It takes 150 percent concentration just to say up there. David was just one of those really gifted people that had the ability, just as Joel Tudor has today. Every 20 or 30 years a unique surfer comes along that has really exceptional ability. David was one of them."

The board that Takayama designed featured a wide, blunt nose and a teardrop concave area on the bottom under the forward section—an element Takayama knew enhanced noseriding function that he had discovered quite by accident some 10 years earlier, in the mid-'50s: "I was shaping myself a balsa board and was almost finished, just taking a few last passes over the bottom with the plane," he says. "Suddenly the blade hit a knot in the wood up by the nose and the knot popped clean out, leaving a hole. I looked at it and thought 'I can't leave it like that.' So I carved out the area till the hole was

While fin designs varied throughout surfboard evolution, during the '60s noseriding was the predominant focus.

gone, leaving a teardrop concave area in the bottom of the board. When I surfed it, I found it rode the nose just great. The teardrop concave shoots water across the bottom of the board, forcing the rail to stay in the wave during noserides instead of dropping out."

A typical Bing "Nuuhiwa Noserider" in the low nine-foot range was 22.25 to 22.5 inches wide, with a 19- to 19.5-inch nose, a 15-inch tail and a 5.5-inch square tailblock. An extra 1.5 inches of kick in the tail gave the board about 4.5 inches of total tail rocker. The board was equipped with an 11- to 12-inch pivot fin, again designed specifically with noserides in mind. Many of the models were custom-ordered and tailored to the individual's size and weight. Since Takayama had moved on from the Bing shop shortly after the design took off (eventually forming his own company, Hawaiian Pro Designs), the vast majority of noseriders were shaped by Dan Bendiksen, and the remainder by others in the Bing stable of shapers including Dick and John Mobley, Wayne Land and George Lanning.

Contemporary longboarders are carrying on a great tradition in the art of surfing on the tip. It is even arguable that they are taking it to new and even higher levels of accomplishment and expertise. Old school purists may dispute that notion, of course, but the 21st-century explosion of noserides featuring hanging heels, sometimes with only one foot on the deck, is proof enough that the art of noseriding today is not just alive and well, but flourishing.

—*Paul Holmes*

1980s Tri-Fins

Although Australia's Simon Anderson introduced the Thruster surfboard, with its three-fin cluster setup in 1981, and showed the surfing world its true potential, it took fellow countryman Tom Carroll to fully dominate on one. In 1983, Carroll ended four-time world champ Mark Richards's seemingly endless reign of terror on the competitive scene, which lasted from 1979 to 1982, by becoming the first surfer to capture a world championship on a tri-fin surfboard. With catlike agility and saber-toothed ferocity, the 5' 6" Carroll tore through waves from 2 to 20 feet on his quiver of trusty thrusters. It turned out that Anderson's patented tri-fin was perfect for Carroll's high-precision, slicing style—an approach to riding waves that would dictate shortboard design over the next 20 years, thus drawing a decisive end to Richards's beloved twin-fin setup throughout the remainder of the decade and into the '90s.

Simon Anderson's development of the Thruster fin configuration set a precedent for shortboards, and big-name pros demonstrated its potential.

Whereas Carroll drew the template for waveriding early in the decade of decadence and Day-Glo, it was a quiet young man from Santa Barbara, Calif., and a brash kid from Cronulla, Australia who would take surfing and surfboard design to the next level, and capture the entire surfing world's collective imagination in the process. Quite arguably, never before, and never since, has a rivalry divided surfers like the one that existed between Tom Curren and Mark Occhilupo in the early to mid-'80s. It was an easy dichotomy to draw, as the two surfers were polar opposites—the regularfooted Curren honed his deceptively powerful style, which could best be described as flawlessly fluid, at Santa Barbara's Rincon; while Occhilupo's upbringing in an array of local beachbreaks and rock reefs, including the ultra-heavy Cronulla Point, reflected his goofyfoot, über-forceful attack on waves—and surf publications from Sydney to SoCal played it up.

In an era before professional surfers could live exclusively off of getting photographed performing a whole slew of special talents—charging big waves, towing-in or busting airs—the pro surfer of the '80s had but one place to make a name for himself, and that was the then-gladiatorial ASP World Tour (two seasons during the decade held 24 rated events, while the 1989 schedule included 25). And it was upon this world stage that the Occhilupo-Curren clashes of the '80s resounded most loudly, the high points being the '85 Rip Curl Pro at Bells Beach (in which Curren clinched his first world title) and the '86 Op Pro at

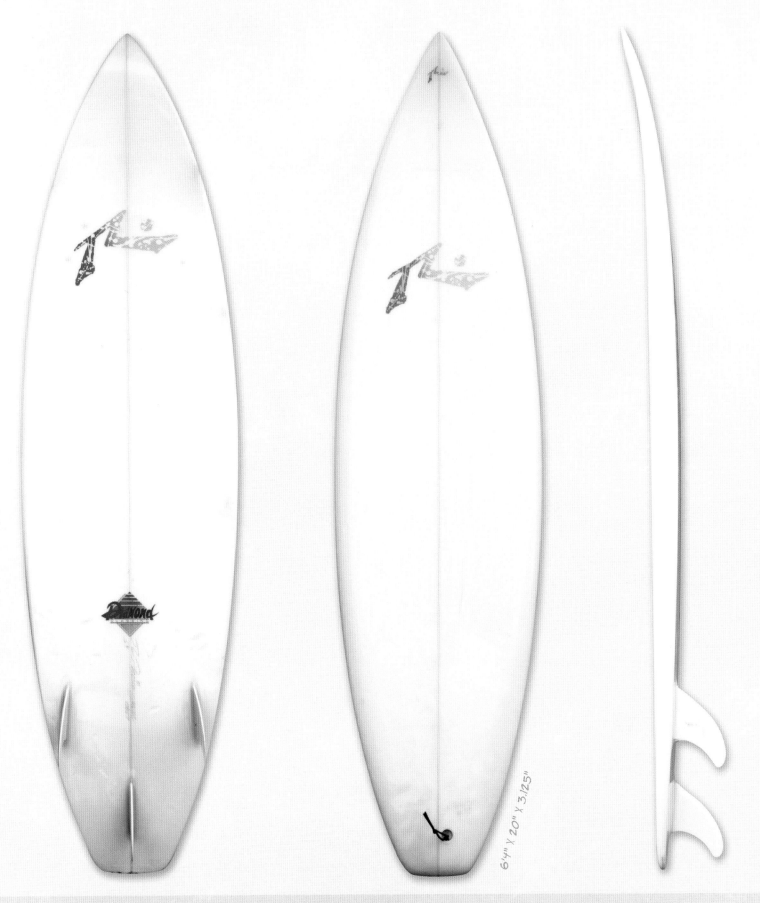

6'4" X 20" X 3.125"

RUSTY SURFBOARDS

This particular board was purchased off the rack in Southern California during the mid-'80s, probably either '85 or '86. These boards featured full, boxy rails and a beaked nose. Notice the neon-fleck "R." logo that was representative of the era. Though an abundance of shortboards very similar to this one were produced, few exist in pristine condition due to light glass jobs.

Huntington Beach (where Occy's last-second heroics were overshadowed by the ensuing riot).

But without doubt the effects of the rivalry were most strongly felt in surfboard design and manufacturing, for their respective shapers—Al Merrick and Rusty Preisendorfer—eventually built veritable empires on the backs of their two star team riders. While Merrick and Preisendorfer didn't invent the modern thruster, with feedback from arguably the two best surfers in the world at the time, the pair of veteran California-based shapers fine-tuned the design to its then-logical extent.

Under his Channel Islands Surfboards label, Merrick took the pre-existing tri-plane hull, which was a variation of the vee-bottom idea dating as far back as 1968, and reconfigured it as a pure double concave. In his design, two symmetrical longitudinal concave sections flanked the board's stringer starting at a distance about one-third up from the tail's end. The result was a mitigation of speed loss through turns, especially in textbook-Curren rail-to-rail surfing. Nowhere was this more evident than during the aforementioned '85 Bells contest in which Curren rode his now famous "Black Beauty" in what's widely regarded as one of the best-surfed heats in competitive surfing history.

Not to be outdone, the Rusty Surfboards brand name took on a life of its own thanks in large part to some of the most user-friendly shapes ever. Legions of devotees owned a stock Rusty, which typically measured 6' 2" x 19.5" x 2.5". These high-volume shapes featured full templates, flat decks with little rocker, a wide squashtail with a bump or pronounced hip and boxy, angular rails—and quickly became the preferred tools of heavy-footed powerhouses like Occy and his army of followers. Because of the boards' lack of rocker and exceedingly ample wide points, they not only flowed through flat sections with ease, but also facilitated rail-to-rail surfing and held fast during gouging turns in snappier waves.

As the decade came to a close, two of its brightest stars eventually burned out due in large part to the then-grueling world professional surfing tour. Both would resurface in the '90s, winning world titles to bookend the decade well past what some would consider their prime. As for the boards, the '90s ushered in a shift away from slicing, dicing and gouging to sliding, skidding and boosting. Thus, the surfboards became markedly narrower, thinner and lighter, with extensive tail and nose rocker.

—*Sean Preci*

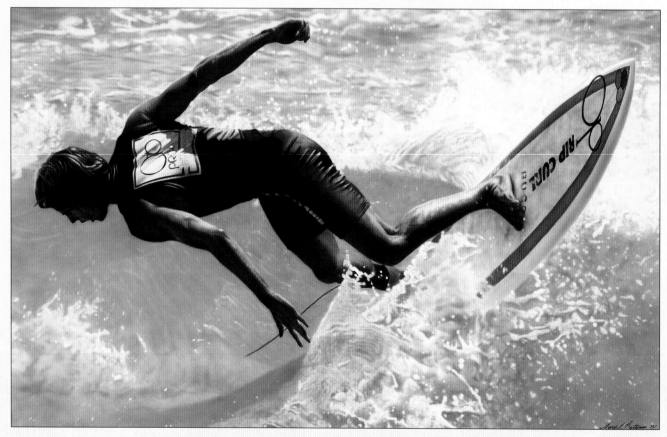

Tom Curren popularized "Red Beauty" with his victory at the Op Pro at Huntington Beach in 1984. Artwork by Gary Prettyman.

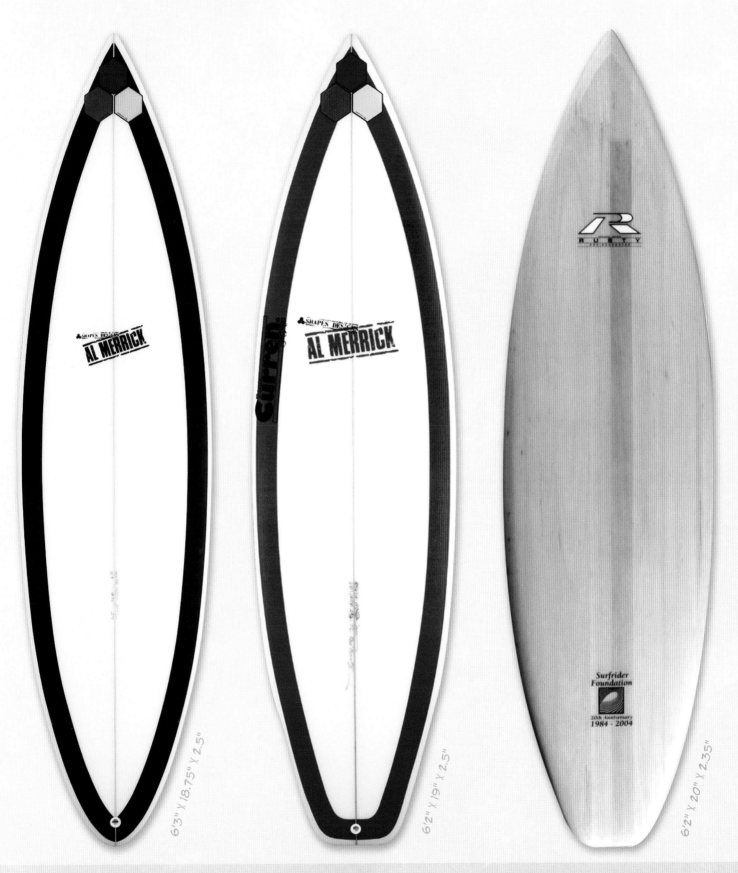

6'3" X 18.75" X 2.5"

6'2" X 19" X 2.5"

6'2" X 20" X 2.35"

AL MERRICK 'BLACK BEAUTY'

In what's been called one of the greatest surfed heats in competitive surfing history, Tom Curren defeated Mark Occhilupo on a board just like this in the 1985 Rip Curl Pro at Australia's Bells Beach. Replicas (like this one) have been turning up at beaches across the world more and more since its re-issue by Channel Islands Surfboards some 20 years later.

AL MERRICK 'RED BEAUTY'

Like its predecessor, Black Beauty, this board got its name thanks to the rail coloration. Tom Curren made this board famous by winning the Op Pro on it in 1984. Channel Islands began offering this replica of the early to mid-'80s Tom Curren model in 2006.

RUSTY SURFBOARDS

This board was shaped by Rusty Preisendorfer for a Surfrider Foundation fundraiser in 2004. It is Rusty's "'84" model, except made from balsa instead of polyurethane foam. These boards are near to exact what then team rider Mark Occhilupo was riding and winning numerous professional events on. The boards come with Rusty's original pre-"R." logo.

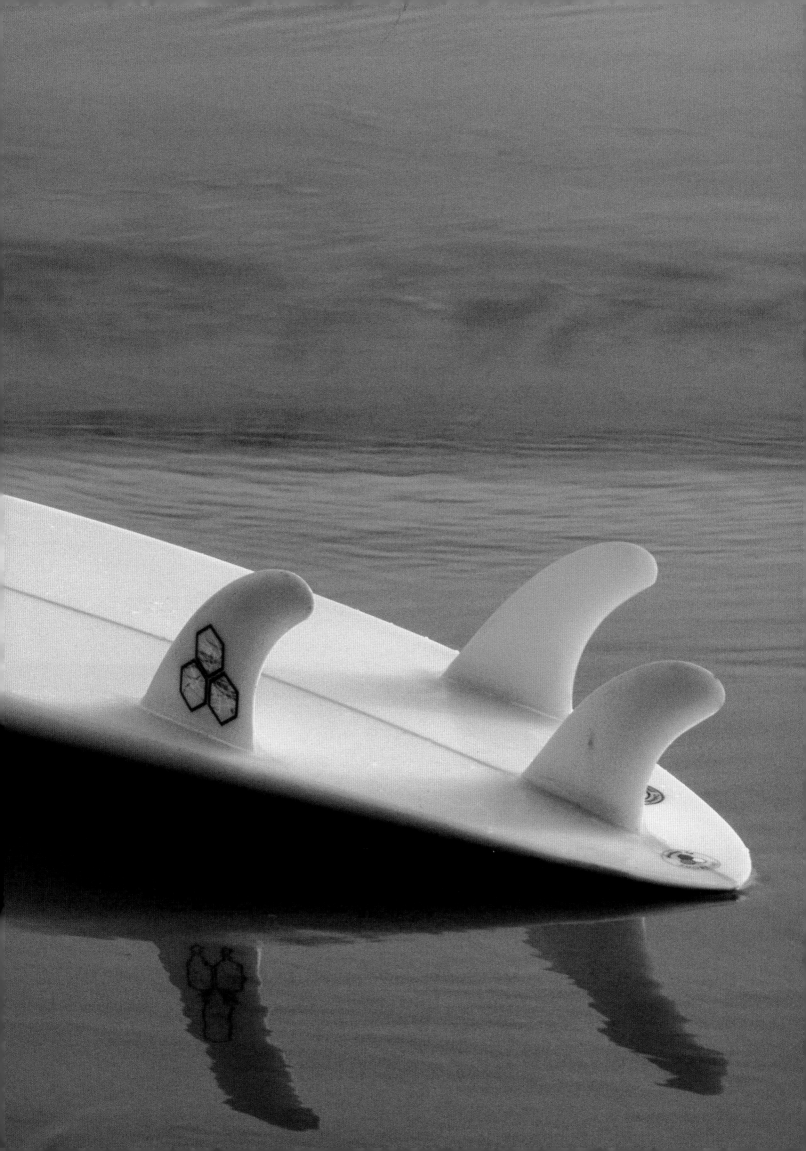

Hot Curl

*N*owadays we have longboards, shortboards and midlengths, among others, but prior to the mid-1930s the quiver was limited to hollow "cigar box" (or "kook box") boards or heavy redwood planks. Each had its fair share of recurring flaws that were felt by surfers from Hawaii, California and Australia alike. Splinters, speed wobbles, spinning-out and weight were among the common trials and tribulations.

To Wally Froiseth, Fran Heath and John Kelly it was a simple and logical alteration to an archaic product, one that would eventually revolutionize the face of the surfing spectrum. As teenagers growing up in Honolulu, the trio were avid surfing enthusiasts and innovators. With an adept knowledge of the various breaks that peppered the coast of Oahu—the South Shore in particular—they were constantly pondering how to improve the overall rideability of their equipment.

Before their innovative creativity set in, anyone with a passion for riding waves prior to the mid-'30s were subject to enduring the frustrations of the redwood planks that measured over 10 feet long, and were as effective as a sponge as they were for riding waves. Along with its tendency to soak up water, riders also had to deal with the board's inability to withstand increased speeds on larger waves. When racing across the face of a steep wave the boards would unpredictably slip out of control beneath the surfer, known as "sliding tail" or "sliding ass." Frustrations grew as a yearning to up the ante on their surfing experiences increased.

As devotees to their craft, and with plenty of time on their hands to experiment with their equipment, Froiseth, Heath and Kelly came to be the originators of the "Hot Curl" board, which would establish a major turning point in the process of surfboard design.

The change came in 1937 after acquiring boards from a company in California called Pacific System Homes. The original dimensions of their boards were 11' 0" x 17" x 3.75" with a 10-inch deep, round bottom and were characterized by a

HOT CURL

This board was originally owned by a Hawaiian family; it was ridden in Waikiki until the mid-'50s, most likely surfed by the Duke at the time. It's a classic example of the redwood Hot Curl era, with clean template lines and well-transitioned foils. Holes were drilled to attach a rope, for ease in holding onto the roughly 60-pound board.

10'8" X 19.75" X 11.75" X 14.875"

The alterations to the original Pacific System Homes boards—the vee-bottom and narrowed tail—provided added stability in larger surf and cut down on the amount of "sliding ass" boardriders had been experiencing. Hot Curls became not only precursors of big-wave guns, but also ushered in noseriding as part of the surfing performance repertoire.

semi-hollow board constructed of redwood strips that had been hollowed out in sections. The sections were glued and doweled together with two narrow spruce strips running down the middle. While the boards were satisfactory in their ability to perform at most Hawaiian breaks, they still had difficulty when the waves grew to larger sizes.

After a particularly frustrating session at Brown's near Diamond Head, following several consecutive sliding ass experiences on considerable-sized surf, Heath and Kelly made their way into shore with a thought in mind. They went directly to Kelly's house with their 75-pound boards in tow.

They called up Froiseth and let him know that his board was going to be subject to a few structural changes that they hoped would eliminate some of the flaws in the original designs. With hopes of providing added stability in the bigger surf they were finding at spots on the west side of the island and on the North Shore, they cut down the after-section of the board using an ax and a drawknife, narrowing the tail by nearly eight inches, tapering to a three-inch stern. The bottom of the stern was a rounded-vee (a sort of 1930s fin-like alteration) that would allow the board to better dig into a wave and prevent the slipping, while the nose was altered to more of a point, to give the board a somewhat big-wave gun look, conducive to heightened speeds.

The results were better than they could have anticipated. With the narrower tail, the boards better settled into the curl of the wave, locking in and providing a sort of vacuum effect that

These Hot Curl replicas were shaped by Jim Phillips and ridden by top surfers of the modern era including 1996 world longboard champion Bonga Perkins.

stabilized the rider and prevented the slide effect they had initially experienced. The new design enabled Hot Curl riders to take a high line on the wave and allowed for stylish performers such as famed Waikiki beachboy Albert "Rabbit" Kekai to walk up and down the board, noseriding with ease on a finless log.

The trio returned to Brown's the day after the changes were made and were encouraged by the boards' new ability to remain steady on bigger and faster wave faces, further whetting their desire to continue the climb to bigger and more challenging breaks.

The new board alterations and design caught on with surfers on the Islands, and with visitors as well. One such visitor came with the Merchant Marines in the early 1940s and witnessed some of the beachboys riding the unusual designs with style and ease. Dale Velzy returned home to California with a better idea of how best to improve the boards people were riding up and down the coast. Velzy has long been considered one of the founders of the modern surfboard design, but it was Froiseth, Heath and Kelly who helped to provide his original vision, and their Hot Curl designs had a lasting impression on him. Upon Dale's return to Hermosa Beach he began incorporating Hot Curl elements into his board designs as well. Velzy's Hot Curl templates went on to influence the development of the big-wave gun, and even one of Velzy's original and most popular designs, the Velzy Pig.

—*Chasen Marshall*

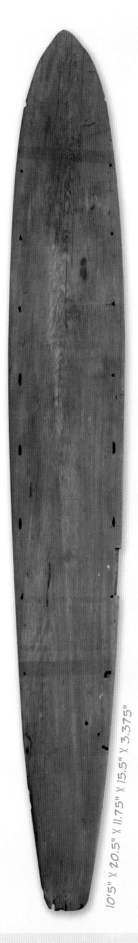

10'5" X 20.5" X 11.75" X 15.5" X 3.375"

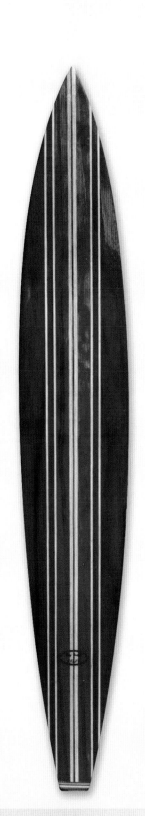

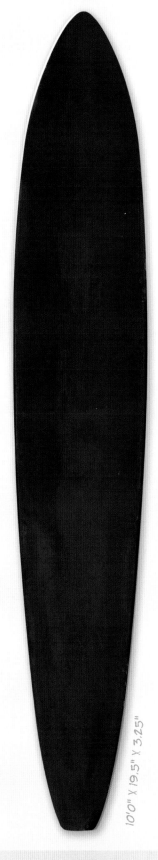

10'0" X 19.5" X 3.25"

HOT CURL

"The Hot Curl is the predecessor of the big-wave gun. Though the shaper of this board is unknown, it was most likely cut down from a hollowed redwood plank board," recalls board owner Spencer Croul. The Hot Curl's rounded, vee-bottom shape in the tail made it much easier to ride in bigger waves without "sliding ass." The board weighed 56 pounds.

DALE VELZY REPLICA

A balsa/redwood Hot Curl replica shaped by Dale Velzy in the 1990s showcases the master craftsman's woodworking abilities.

DALE VELZY ORIGINAL

This early '50s Dale Velzy Hot Curl was shaped from balsa, fiberglassed and fitted with a fin. Its wide point is eight inches forward of center and it weighs in at 28 pounds. Velzy was a big proponent of the Hot Curl design, which he first saw being ridden while in Hawaii during World War II.

Bing Pipeliner

By the winter of 1966/'67, reports had filtered into California of Dick Brewer's new and innovative surfboard designs. Brewer had a strong following of top name surfers seeking out his designs, and Duke Boyd, Bing Copeland's close friend and advisor, was quick to acknowledge these developments. So in fall 1967, they flew over to Maui on a mission to actively recruit Brewer to the Bing Surfboards family. Not only were Copeland and Boyd aware of Brewer's accomplishments, but they were cognizant of the business possibilities that could be realized by merging their two powerful camps. In a nutshell, Copeland made arrangements with Surfline Hawaii, then a Bing dealer, thus providing Brewer with a Hawaiian base to produce surfboards under the Bing label; a deal was struck, a contract signed and the Bing Pipeliner was on its way.

To welcome Brewer to the Bing-fold, Copeland and Boyd secured a new Skil 100 planer as a gift. With high-luster polishing, it was a gleaming tribute to both tool and shaper—and moreover, a powerful marketing tool. Through various print ad campaigns, the shining planer came to symbolize Brewer's status as the world's first "star" surfboard shaper. In step with this burgeoning stardom, Brewer's first focus at Bing was to bring his progressive designs to the mainstream. The Pipeliner was to be his first task. Available in three models (the "Standard," the "Island Semi" and the "Island Gun"), it was a rough carryover of his earlier prototypes with Hobie Surfboards: pulled-in nose and tail and the name "Pipeliner." But it wasn't until his arrival at Bing's that Brewer officially christened his design as such.

Like their Hobie predecessors, all three Pipeliners shared a redwood center-strip stringer that had been scaled down in width and material

to reflect a growing desire for lighter boards. "Greg Noll was blowing his own foam and experimenting with lightweight densities," Brewer remembers. "I recall seeing several examples produced by shaper Rick James of lightweight beachbreak boards that really stirred my imagination." The Pipeliner, in turn, went on to change the parameters by which all big-wave guns and speed designs would be judged from that point forward. The design axioms of prior big-wave guns mandated that the boards be long, thick and extremely heavy. Though by no means the first gun specialist, Brewer was the first to break away and challenge these longstanding criteria.

The Bing "Pipeliner Island Gun" model was, in essence, the first lightweight big-wave gun surfboard. Some may argue, but the theory is bolstered by sheer production numbers. Mike Hynson and others may have been onto it, yet not with the same consistency. Spurred hard by his riders, Brewer's creative designs were able to keep pace with one of the most rapidly changing periods in design history. His relationship with team riders was almost symbiotic. On one of his trips to California, Brewer remembers heading south to Mexico with Joey Cabell and Jeff Hakman to test out a few Pipeliners. What made this trip significant was Cabell and Hakman's push for an even lighter board. Dick Morales at Clark Foam ended up doing a run of light foam for the Pipeliner and the Bing "Nuuhiwa Lightweight" at the same time. To Brewer's best recollection, they may have driven the density of the foam into the 2.5-pound range— too light for an acceptable strength-to-weight ratio. They settled at a three-pound density for the remainder of the Pipeliner run. The lightweight blanks featured a rocker design sporting a flat midsection with pronounced kick in the nose and

tail. This became a defining element of Brewer's gun design.

With board weight diminishing, the next area to refine was the fin. Early Pipeliners utilized wide-based 10.5-inch skegs. Brewer and team rider Jimmy Lucas whittled away at this size until they had a "new moon" shape, also 10.5 inches, but with a significantly narrower base. This heightened the Pipeliner's performance. Back in California, David Nuuhiwa and Jock Sutherland found the board worked better still with a larger base and less depth.

Not long after, Nuuhiwa broke the nose off of his Pipeliner. Randy Rarick, who was as that time working with Brewer at Surfline Hawaii, suggested they round off the nose to create a 7' 8" board with a gun tail and a blunt nose. This new incarnation performed so brilliantly at Chun's Reef in Hawaii that Brewer incorporated the design into his offerings. Nuuhiwa's repaired board became the prototype for the Bing Lotus.

Other noteworthy developments followed in the winter of 1967/'68, when the Aussies came to Hawaii to participate in the Duke Classic. After the contest, the crew from Down Under went to Honolua Bay with their vee-bottom surfboards, the result of Bob McTavish's collaboration with kneeboarder George Greenough. Meanwhile Brewer and crew had been working towards the shortboard from a different angle, that of the mini-gun, using Honolua as ground zero. Leslie Potts was tearing the Bay wide open on a mini-gun that could trace its origins directly to the Pipeliner.

The rivalry between Brewer and McTavish was friendly, as the two shared a shaping room/think tank in Lahaina, and McTavish's influence on the mini-guns and Pipeliners was clearly visible in the light vee Brewer had incorporated into his designs. All the same, ramifications of this historic showdown in the middle of the Pacific would be felt a long time after. Brewer remembers flying to Oahu to shape Pipeliners at Surfline, only to return to Maui later in the same week to shape mini-guns. But the mainstream market had yet to embrace shortboards, and back on the mainland the established industry was attempting to make sense of these events. A perfect example was Bing's 1968 sales brochure, which heaped traditional mid-'60s-type longboard offerings like the Nuuhiwa Noserider alongside mini-guns, Australian vee-bottoms, Lotus teardrops and, of course, Pipeliners.

But by the summer of '68, the transition to shorter, lighter designs was well under way, and the ripple effect of the Bing Pipeliner firmly entrenched in surf history. In less than two years, Dick Brewer and his production run of 400 such boards had bookended an era.

—Mark Fragale

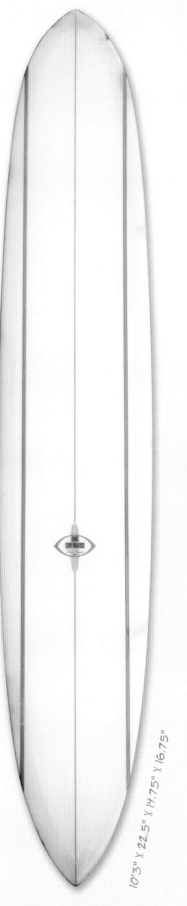

10'3" X 22.5" X 14.75" X 16.75"

BING PIPELINER

This board was made in the Islands at the Surfboards Hawaii shop, and was most likely shaped by Dick Brewer, although Gerry Lopez also shaped a few of them. In a 1998 letter to the previous owner, Bing Copeland certified these facts.

Greenough Spoon

Between fishing and riding waves at the then uncrowded breaks of Australia's Northern Territory, an 18-year-old Nat Young stumbled upon the template that would galvanize the shortboard revolution within two short years. The setting was Noosa Heads, 1965, and joining a small but seminal community of vanguard surfer/shapers spearheaded by Bob McTavish, Young spent the winter living and surfing alongside an eccentric American by the name of George Greenough. What Greenough's five-foot "Spoon" would ultimately do for surfboard design was nothing short of remarkable. And though unbeknownst to the vast majority of modern day shortboard pundits, few shapes throughout history have matched it in terms of overall, lasting significance.

It was a magical time, lineups heady with an almost palpable sense that something quite large—or *small*—was about to change everything. Indeed, the formal unveiling of Greenough's eponymous Spoon would later be regarded as the cusp of a new era. Young remembers clearly: "[Ti Tree] was a solid six feet and getting stronger by the hour, and George, Bob [McTavish] and I did a few crossovers that [filmmaker Bob Evans] recorded for posterity. Greenough was surfing his kneeboard "Velo," a five-foot-long fiberglass Spoon with very little floatation and a flexible tail. To say I was impressed is a mild understatement—I couldn't believe my eyes. The thrust and acceleration out of the turns that was sending him hurtling down the line was truly amazing and it looked to me as though Greenough was carving from further back inside the curl than anyone I'd ever seen

5' - 5'6" X 24" – 26"

GREENOUGH SPOON

The George Greenough kneeboard inspired a new era of surfboard design. The kneeboards he rode were flexible, exploring areas of the wave that were never negotiated by generations of surfers before him. The spooned-out foam and glass renditions allowed the board to torque and snap out of turns, expanding the thought of the value of bend and flex in board design.

before. I had to agree with McTavish, he was the best free surfer in the world as long as he had some substantial power in the wave. The G-force and foil that George had been gibbering on about all week suddenly made sense: he'd talked about how fish stored energy in their fins, in their whole bodies in fact, and when they wanted power to propel them forward they released that stored energy. It was so simple, why hadn't someone thought of this before?" That nobody had provides basis for Greenough's undisputed status as the originator of banked-turn, high-performance surfing.

The above fins were from the same era—the Hynson red fin and the raked skeg found on the Greenough "Spoon."

Several crucial innovations made possible this new approach to waveriding. Most obviously, the size and shape of the template itself. Characterized by a more generous curve and roughly half the length of the typical mid-'60s longboard, the Spoon was ideally suited to carving turns, cutbacks and directional changes previously inconceivable. Contemporary aesthetic emphasized glide and trim. And no wonder—the lumbering 10-footers of the day were all mass and no flex. Greenough's boards, on the other hand, featured minimal foam and resin. Instead the center and tail had been hollowed out and filled with fiberglass, which in place of stiffer, bulkier materials permitted a great amount of flex in the rocker. This enabled the board to adapt to a variance of conditions (save for mushy beachbreak). Additionally, and perhaps more importantly, it generated tension and release in the tail via "memory." Think tuna. Greenough

was a fine outdoor sportsman, who with a homemade rig fashioned of foam and venetian-blind cord kept the Noosa house perpetually supplied with fresh fish. No doubt he'd learned a thing or two from his preferred dinner fare, for his signature, raked skegs likewise drew inspiration from the fins of the once-abundant tuna that flourished in local waters.

Yet for all of its admirable characteristics, the Spoon could hardly be deemed an everyday-everyman's board. Not only did it falter in the absence of ample juice, but the performance benchmark set by Greenough hinged on his low center of gravity—stand-up surfers simply couldn't apply the same kind of power. Naturally, however, upon witnessing the Spoon's thrust and capacity for hard carves, Greenough's contemporaries sought to apply such technological advances to their own shaping endeavors. Upon returning to Sydney, Young immediately set about work on a stand-up board inspired by the Spoon. "It was difficult to explain," he recalls, "but I knew the whole direction of surfing had changed for me." So too had it changed for McTavish, whose advent of the "vee-bottom" longboard—which employing entirely different design tenets reflected a modern, new approach to surfing inspired by Greenough's kneeboarding virtuosity—sounded the opening bells of the shortboard revolution. The year was 1967, and surfing had indirectly but inextricably experienced a facelift at the hands of a rider who'd preferred air mattresses to standard foam boards.

—*Tristan Wand*

Weber Performer

Throughout the early '60s, Californian surfboard builders seeking profitability continued to fashion their best-selling design: surfboards designed for beachbreaks. For the most part these shapes were essentially modified Velzy Pigs, the industry standard of the period. Named after their originator Dale Velzy, these boards featured wider hips in the lower one-third of the board, flowing into a narrow nose by then standards. While the basic concept of the Pig was retained by other period shapers, the hips of the outline were placed progressively forward. The industry's allegiance to the tried and true left little if any room for differences between competing products. Diversions from the pack to gain a sales edge most often took the form of "trim," including decorative color schemes, elaborate stringer designs, tailblocks and the occasional noseblock.

In attempts to increase sales, surfboard builders initiated signature models endorsed by well-known surfers—a sales strategy similar to that of baseball gloves, where a star's name was prominently stamped upon the product. The biggest and best-known surfboard makers by now had at least one such model for sale.

The Turn Fin, popularly known as the "Hatchet Fin," helped define the Performer. First-generation models used a solid-color, fixed-position, fiberglass skeg, while second-generation boards had a removable version.

By mid-decade, the marketplace became more competitive with every passing day. Manufacturers continued to search for that elusive sales edge. It was Dewey Weber who first discovered the disconnect opportunity. His formula was simple: introduce a whole new type of surfboard with a unique and fresh approach, a breakaway design that incorporates a whole new outline—one with parallel rails, a thin overall profile and, most importantly, a look all its own. He named his new creation "The Performer."

The model was far and away the best-selling single surfboard in the history of the sport. During a two-year, modified production run, the model reportedly racked up sales in the range of 8,000 to 10,000 units. The concept and marketing of the Weber Performer could not have been better executed. During the mid-'60s proliferation of surfboard labels, Weber found a disproportionate share of customers. In addition to his already-established clientele of skilled surfers, the Performer brought him buyers of all different levels of ability, unquestionably due to the brilliant marketing of the surfboard.

The Performer's debut came in the form of full-color advertising campaigns published in bimonthly

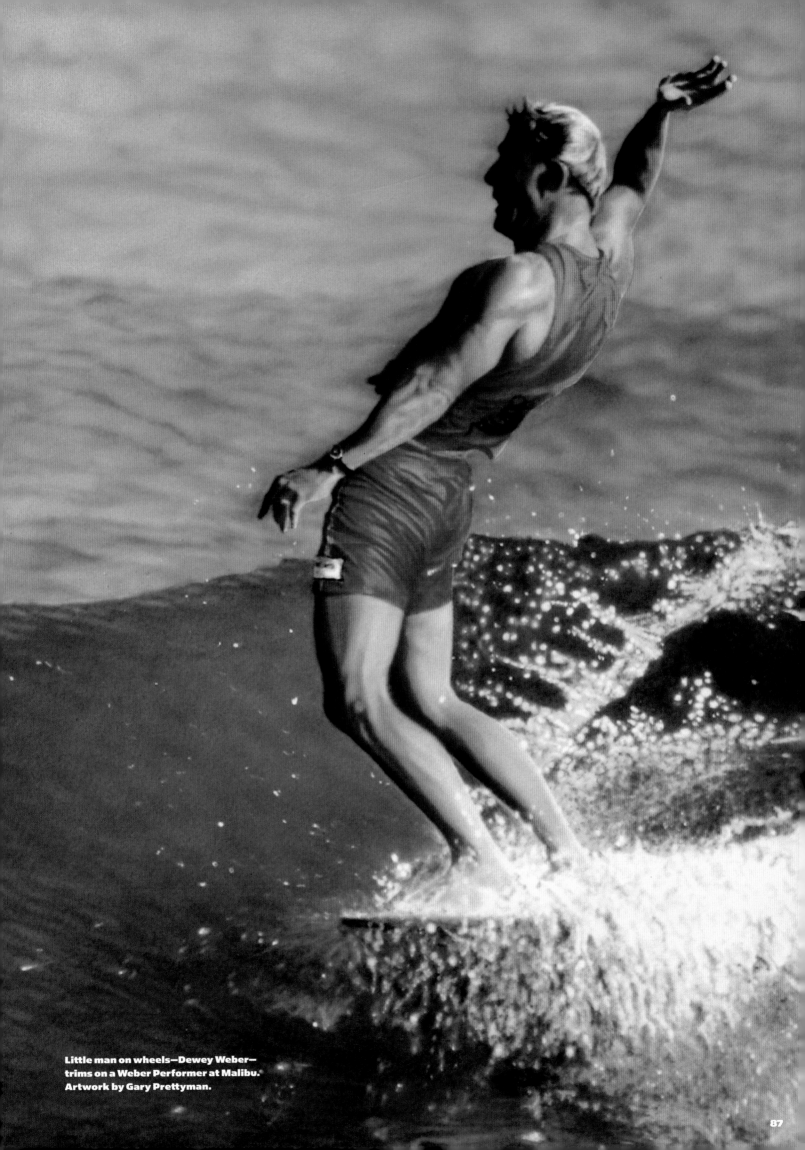

Little man on wheels—Dewey Weber—
trims on a Weber Performer at Malibu.
Artwork by Gary Prettyman.

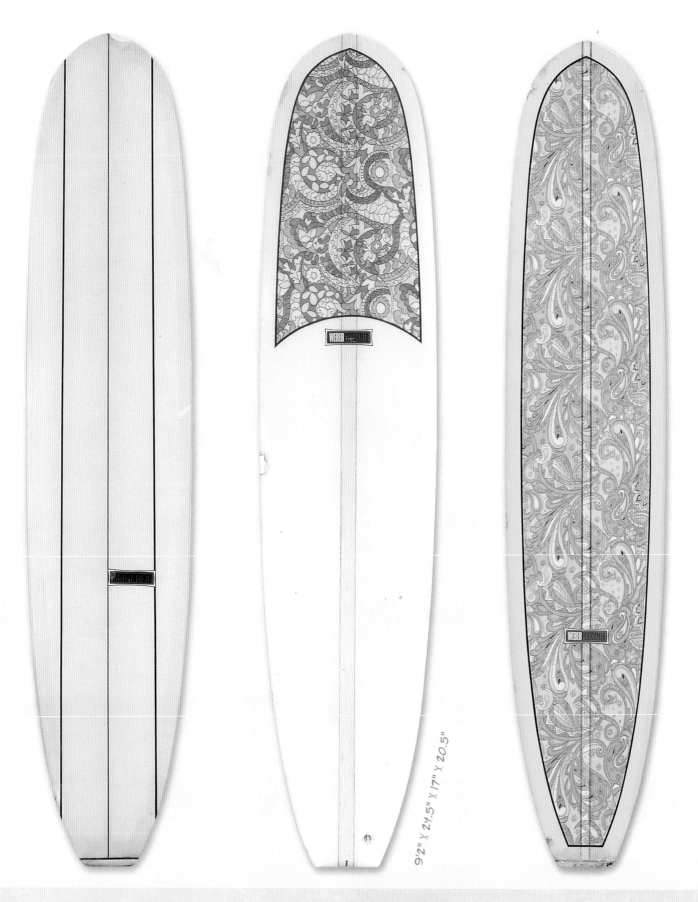

9'2" X 24.5" X 17" X 20.5"

WEBER PERFORMER

The Weber Performer, with its breakaway design from the status quo of the mid-1960s, was characterized by its parallel rails and individualized "Turn Fin." The board was available in a wide variety of stringer designs—including colored, high-density stringers to add contrast—and cosmetic layouts from clear-glassed classics to brightly colored, psychedelic prints. Unfortunately, fabrics from the era added unwanted weight when wetted out with resin, so were used only sparingly.

installments of the sport's then-premier periodicals: *Surfer, International Surfing* and a multitude of short-lived but well-circulated East Coast publications. The ads—dispensed like clockwork every 60 days for two years running—further entrenched the model in the mindsets of prospective buyers.

In conjunction with the ad campaign came a Weber Performer promotional road tour. The well-coordinated traveling road show focused on the Eastern Seaboard, where the biggest and best potential market lay in waiting. Back in California, Harold "Iggy" Ige, Weber's right-hand man, kept the well-oiled factory machine running faithfully, churning out product to meet the demand.

Conceived in 1965, then introduced and marketed after refinement and testing in early 1966, the Weber Performer was contrived as a surfboard designed to perform well in a wide variety of conditions. Says Iggy, "Dewey was a fierce competitor. I remember talking with him during long rides in the car about how he sought to create a surfboard that would meet the wide variety of wave conditions encountered at surfing contests. He became increasingly determined to build a board that was adaptable enough to function well during daily jaunts to the beaches on both U.S. coastlines."

Unlike big-wave guns and speed shapes typically found in signature models of the day, the parallel rail planshapes employed on the Performer were among the very first of modern day departures from the modified Velzy Pig. Though others had also begun employing parallel rails, it was the Weber Performer that initiated the trend. If measured only by sales, the Performer led the pack in the first genuine new direction of beachbreak planshapes of the '60s.

The second generation Weber Performer was unveiled in 1967 with a new template and new, distinct, all-caps laminate.

Physically, the Weber Performer was carved from a period Walker Foam blank in the 4.4-pound density range. Covered with double 10-ounce glass, top and bottom, with four laps on the rails, the surfboards fared well despite hazards and time. Typical dimensions of a 9' 6" board measured in with a 17-inch-wide nose, 21.5 inches at the widest point and a 14.5-inch-wide tail. Stringer configurations included a .75-inch T-band arrangement, which was found on the vast majority of stock boards, especially those distributed through wholesale dealer networks. Custom stringer arrangements remained available but only accounted for a small percentage of the run. Although available in East Coast and West Coast specified configurations, it took a trained eye to discern the nuance of differences between them.

The new outline shape of the Performer was enough to provide the model with a strong identity, but certainly the most defining feature once the board hit the beaches was its skeg. During the early '60s, most surfboard skegs were full draft, high-volume affairs. Among the earliest to break the pattern were companies implementing skegs that featured a swept-back rake and lower mass. Initially employed on big-wave boards, these skegs gave finished beachbreak surfboards a streamlined look that added to their sales edge in the showroom. The "speed skeg," as it came to be known, soon became standard issue.

Weber was surely aware of this trend, although finding a period Weber Surfboard with a speed skeg is unusual. Yet again, Dewey chose a different path. Always one up on the competition, a special skeg was devised for the Performer named the "Turn

Fin." The skeg was such a far-reaching departure from the norm that to copy it would have been blatant plagiarism; a few did and were forever branded as "followers." The unique skeg was referred to as the "Hatchet Fin," so named for its resemblance to a small ax. Call it a sales gimmick, but the fin played the most determining role in leading the model towards record-setting sales.

Throughout the initial production run, the finished, solid color, fiberglass-laminated skegs were routed into the stringers, then glassed in place. The rake angles of the fin were so steep, that in spite of a forward placement on the surfboard, the sweep of the design left the skeg extending past the tail block, often by several inches. In theory, the narrow base of the Turn Fin was to allow for easy turning but any real gains in performance are debatable.

As 1966 wound down, the Performer closed out the year with record sales for the company. The final ad of the series was the very same one that began the campaign a year earlier: a picture of a chessboard with the slogan, "It's Your Move." As the ad had hinted once before, something new was about to unfold for the Performer.

Fortified by a yearlong string of successes with the model, Dewey Weber Surfboards introduced a second-generation Performer for 1967. That year, the Weber Performer was totally revamped. Except for the parallel rails and Turn Fin, little else was retained from the first model. The Dewey Weber red, black and white company logo was no longer used. Instead the model received its own laminate, now spelled "WEBERPERFORMER," dressed out in capital letters. In Detroit automotive tradition and ad style, the newest ride's design features, which were highlighted in ads, included an exceedingly wide, super-scooped nose, a removable polypropylene Wonderbolt fin system and a one-inch, high-density foam stringer bordered by .25-inch redwood strips. The 1.5-inch composite stringer allowed the added width necessary for what was now the widest production surfboard on the market.

The well-coordinated Weber advertising strategy was once again revved up, but this time in overdrive. Weber contracted with *Surfer* magazine for another installment of advertisements, although this go around with twice the size and twice the punch. Says Iggy, "We found ourselves reaching well into serious and never before attained production levels. The demand for the surfboards often outstripped our ability to build them. By the time the second series Performer was in place, we reached our peak production with a work force comprising maybe 40 employees with seasonal highs of turning out as many as 45 surfboards a day. During summer months we operated the factory six days a week, running at full capacity."

Iggy was second man in charge of the operation, just under Dewey. Maintaining quality and meeting production schedules became an ongoing, challenging quest. High volume necessitated the use of a jig to pre-shape foam blanks. Under Iggy's watchful eye, raw blanks were placed in the jig, shaved and shaped to within .125 inches of tolerance and made ready by a team of rough shapers. He then turned the rails and finished off the shaping of most every Performer that left Weber Surfboards. By producing surfboards in this manner, the Performer was likely the most consistently precise surfboard of the period.

The second-generation Performer was the first of what would become the "platform" templates of the time. It measured in with full nose dimensions at 19.5" x 23.5" of extreme beam width and 16 inches of tail carrying into a full 7.25-inch tailblock when measured on a nine-foot example. The broad, super-kicked design initiated a barrage of wide surfboards that offered their own interpretations, among them the Con "Ugly," Hansen "50-50," the Rick "UFO," Bunger "360," Jacobs "422," the Greek "Eliminator" and others.

Staggering annual sales continued by then-industry standards. By 1967 the wholesale network had grown to eight exclusive and 20 multi-line outlets for a total of 28 agencies within the network. Dealers were as diverse as Ron's Skin-diving Shop in Mobile, Ala., and Felix's Marine in Michigan.

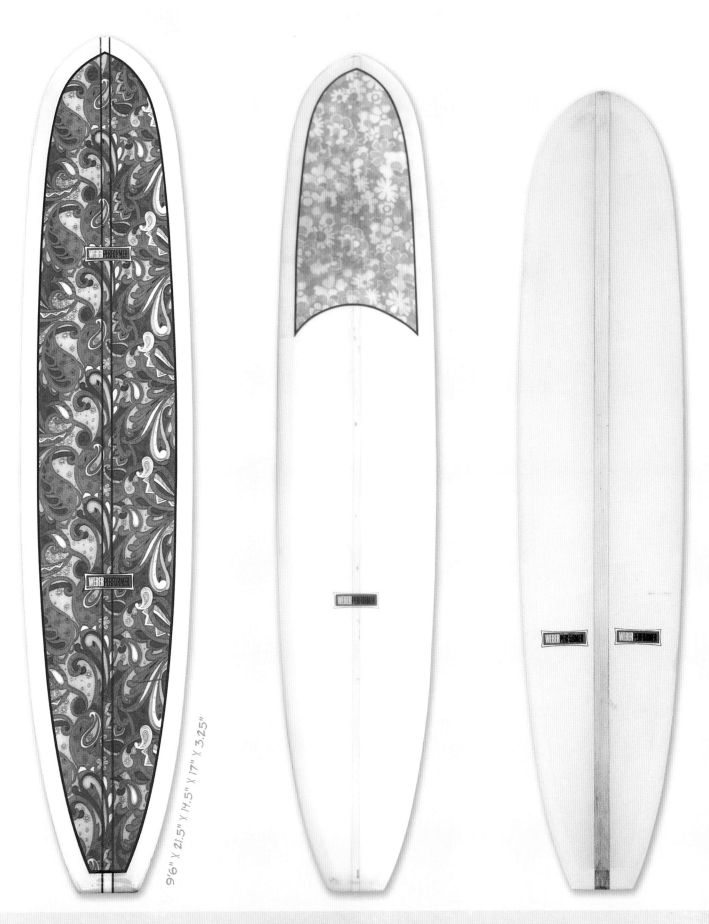

9'6" X 21.5" X 14.5" X 17" X 3.25"

WEBER PERFORMER

This Weber Performer is a representative of the first mass-produced surfboard models, and it was also one of the the most popular designs from 1965 to 1967—the noserider. Weber was smart enough to catch onto the noseriding fad, and consequently achieved monumental success with the Performer. The boards weighed around 25 pounds.

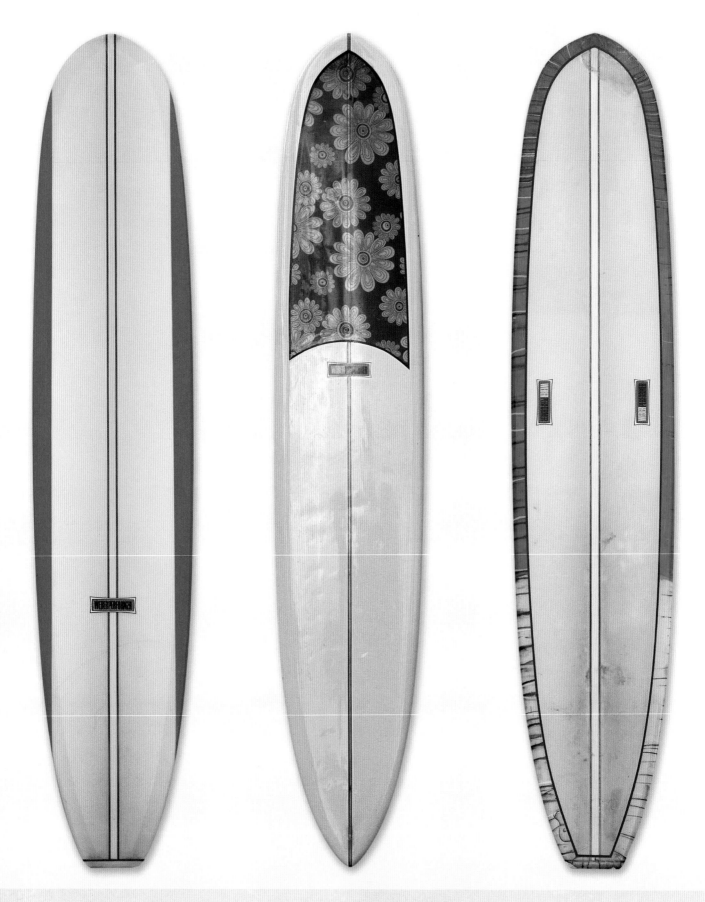

WEBER PERFORMER

The Performer underwent a series of revamps and design adjustments during its two-year run and was so well marketed it is reported to have sold as many as 10,000 units. The second-generation Performer offered variations in widths and nose rocker.

Deeper into the 1967 run of the second-generation Performer came the availability of three different widths and three differing levels of nose rocker for the model. Accordingly, the option to employ a wide balsa stringer or thin wood strip in place of the standard foam T-band stringer allowed the model some moderation from its previously stringent dictates. By offering alternative rocker flows and narrower beam widths, the board became increasingly adaptable. These combinations allowed for fine-tuning to each individual's needs while preserving the soundness and purity of the Performer concept. This softening of design provided several months of additional longevity for the model within a rapidly changing marketplace.

Nonetheless, the Performer reached its conclusion after an enormously successful second-year run. The transition to short surfboards was closer than anyone knew, and by the winter of '67/'68, the first longboard epoch was approaching its end. Ultimately this variation in equipment brought an end to the Performer's heyday and the popular platform shapes built by others that the model gave rise to.

Dewey and Iggy had, by now, wisely enlisted the talents of Nat Young from Australia, then Mike Tabeling of Florida to promote Weber Surfboards. Young's Weber "Australia" enjoyed a strong following during this period, while Tabeling brought the Weber "Pig" (a head-high shortboard rendition of the Velzy Pig) to East Coast prominence. Numerous other Weber models followed, although none would achieve the notoriety and sales success that the Performer had realized.

Beginning in the 1970s, the surfboard industry slowly became a shadow of its former self. The advent of the backyard "underground" shaper was at hand, and he came with low-cost surfboards. Also, with little to no real overhead costs to negotiate, these small board-builders made it all but impossible for the bigger operations to remain viable. A precious few established manufacturers made it across the line and maintained profitability, but, for the most part, the big name labels that had dominated the industry perished. Weber Surfboards was among those that experienced a difficult fallout, but would make a comeback in the 21st century.

—*Mark Fragale*

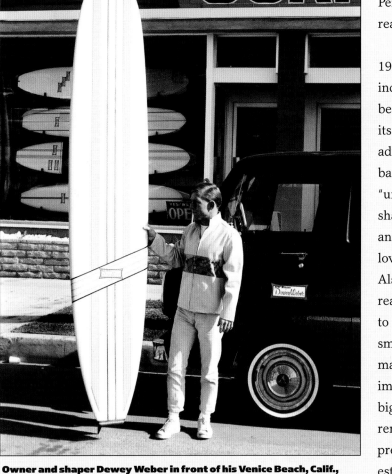

Owner and shaper Dewey Weber in front of his Venice Beach, Calif., shop with the first-generation Performer. Photo: Weber Surfboards.

Mark Richards Twin-Fin

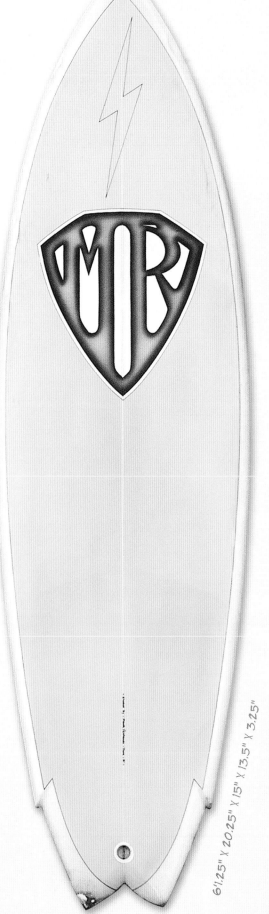

6'1.25" X 20.25" X 15" X 13.5" X 3.25"

Overlook any conceivably negative connotations to the name "Wounded Seagull" and one can see how Mark Richards's handle was something of a self-fulfilling prophecy. With a style wholly his own—one knee tucked into the other and arms cast in his trademark flapping posture—Richards set himself apart early on. But if ever this designation bothered him (and it certainly didn't seem to), he never let go of his uniqueness. More accurate would be to say that Richards grew into it, chalking up four consecutive world titles between 1979 and 1982, and leaving behind a stylistic blueprint attributable in large part to the eponymous boards he popularized. The MR Twin-Fin, a design both arising from and further promulgating Richards's virtuosity, was in a manner of speaking the air beneath the wounded seagull's wings.

The twin-fin design, of course, was hardly a novel concept. And if Richards is to be credited with its popularization, Bob Simmons deserves acknowledgement as the original mastermind behind its conception. As far back as the late '40s, the eccentric trailblazer was building wide-tailed, "dual-fin" spoons from solid balsa. In fact Simmons drowned near Windansea riding one such early protoype. But the twin-fin vision lived on, and in the decades to follow a host of pundits—from Steve Lis and his split-tailed "Fish" to the ultra-smooth David Nuuhiwa—made refinements that ushered it right on into the early 1970s. Fast-forward to 1978. A young Mark Richards rushes the World Cup at Sunset Beach on a 6' 6" twin-fin. Strategic, serendipitous or just plain stupid? Whatever combination of the above, the move was a crapshoot at best. And it fell flat. Yet the story behind Richards's ascension to the upper echelon of professional competition—and his determination to tackle big

MR TWIN-FIN
Though short-lived, the twin-fin design had a tremendous effect on surfing. The shorter, wider design allowed for looser, tighter turns, and no one embraced the concept more than four-time world champion Mark Richards. Lack of drive, however, would inspire a new design that would soon dominate most of the surfing world—the thruster. The board weighed seven pounds.

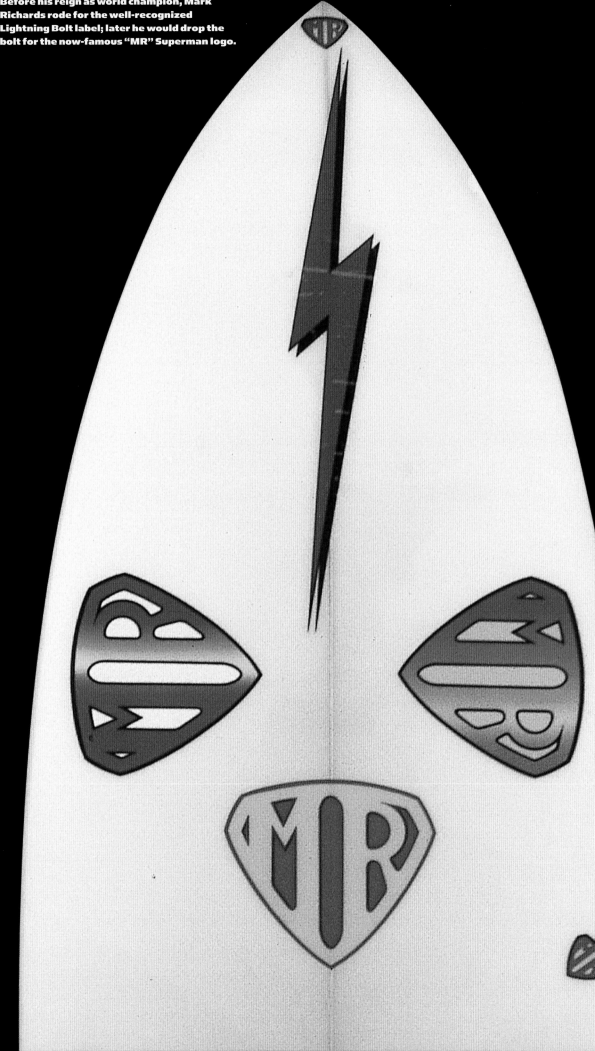

Before his reign as world champion, Mark Richards rode for the well-recognized Lightning Bolt label; later he would drop the bolt for the now-famous "MR" Superman logo.

Hawaiian surf on a shape originally intended for small waves—is nonetheless noteworthy in the context of not only surfboard evolution, but the stylistic paradigm shift that accompanied it.

In a nutshell, the saga goes something like this: fish-style twin-fins found favor with a crew of hot, young Islanders mentored by '70s power surfer, Ben Aipa. Witnessing the board's potential, big-wave hero Reno Abellira brought one to Australia, where it temporarily stunted the up-and-coming Richards's characterized by tighter arcs and the aggressive, slashing attack that Richards owned. Horizontal was out, vertical was in; and in no time flat, this radical new aesthetic had become the keystone of the pro surfing judging system. If you weren't attacking the waves like Richards, you sure as heck weren't going to beat him.

It was with this in mind that tens of thousands rushed out to purchase their own piece of the MR lore. Super-quick directional changes, snapbacks, a

The MR Twin-Fin featured a wing-flyer swallowtail and "toed-in" fins, all of which helped it turn on a tighter arc.

powers on a single-fin. But while Richards's best efforts proved futile on the 1978 world tour, he was to emerge victorious the following year when he rode his twin-fin in all but the biggest waves of the Hawaiian-based events. The key, it turned out, was adequate preparation in the form of a healthy rotation of equipment—twin-fins and single-fin guns—just prior to the North Shore season.

Streamlined, fast and maneuverable, the MR Twin-Fin fueled a new approach to surfing way of surfing farther out on the face than ever before—these were all part of the Mark Richards legacy. But the MR Twin-Fin, as one might imagine, was not for everyone, and naturally prompted a whole slew of bad Wounded Seagull imposters. Attempting to control these boards, with their wide planing surface, required an individual of above average skill level. For Mark Richards, the four-time world champion, they worked pretty darn well.

—*Tristan Wand*

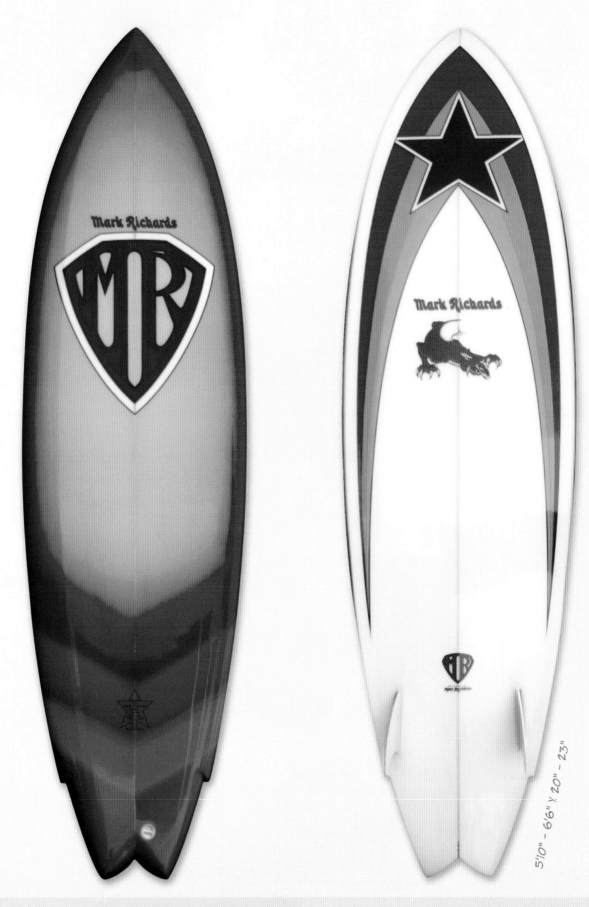

5'10" - 6'6" X 20" - 23"

MR TWIN-FIN

You may recognize this board from Bill Delaney's film, *Free Ride*, where Mark Richards proved that it could be ridden in surf of practically any size up to roughly 10 to 12 feet. The board allowed a riding transition from one of horizontal to vertical in the span of only a few years.

1960s Big-Wave Guns

During the late '50s and early '60s, California's Pat Curren quietly put forth big-wave boards based upon his experiences as an early pioneer of surfing Oahu's North Shore. Among Curren's crowning achievements was a comparatively small run of foam guns with Reynolds Yater. Recalls Yater, "Pat produced about a dozen of the Yater/Curren models out of our Santa Barbara shop sometime around 1964." The boards were alphanumerically coded beginning with board C-1 and examples are known to exist up to C-11, which is probably the last board of the series. Its dimensions are 11' 0" x 21" x 4", with a 15-inch nose and a 9.5-inch tail. Rocker flows and rail configurations blended nicely and led into a relatively flat tail section.

The designs afforded excellent paddling and much greater control in the high-speed, big-wave drops experienced in larger waves. The boards weighed in commensurate with others of the day, either side of 40 pounds, and were typically equipped with a red skeg and clear-glassed. With the advantage of 40 years of hindsight, the significance of Curren's accomplishment is now evident. These surfboards remain among the most coveted period pieces of the era.

Also noteworthy among '60s big-wave gun builders was fellow California native, Greg Noll. Noll first visited the North Shore in 1954 at the age of 17, and by late '57 led the now-famous eight-man exploratory party out to ride Waimea Bay. Noll quickly realized that surfers couldn't ride big waves unless they could first catch them. Thus, a typical Noll-shaped gun of the period averaged between 10' 10" and 11' 2" in length, about 22-inches wide at the midpoint with a 13.5-inch-wide tail, a 14.5-inch-wide nose and thickness right around four inches. These behemoths were not designed with turning or performance in mind; they were meant to allow the rider to experience big-wave surfing and live to tell about it. Although Greg Noll Surfboards—the largest surfboard manufacturing operation in the world at the time—opened in Hermosa Beach, Calif., in 1965, Noll continued visiting Oahu's North Shore every winter until 1969. In the process, Noll, along with Buzzy Trent, cemented reputations as surfing's first legitimate big-wave hellmen, especially on film and in print with help from the surf media.

But perhaps the most enduring player in the production of big-wave guns in the '60s was Dick Brewer. An understudy of Bob Shepherd and an accomplished big-wave surfer in his own right, Brewer has been churning out heavy artillery for the Hawaiian winters for better than four decades. His impact on gun design is immeasurable. Big-wave boards were and are his life calling. As rider/shaper and proprietor of famed Surfboards Hawaii, established in 1961, Brewer produced period big-wave boards on Oahu's North Shore. As a result, he gained invaluable knowledge and keen insights during these early and formative years. Guns fashioned at this Hawaiian outlet benefited from the best feedback the cottage industry of big-wave surfboard fabrication had to offer.

Both during and after Surfboards Hawaii, Brewer would shape boards for Harbour, Hobie and Bing, implementing refinements to gun design the whole while. In what would become among Brewer's last boards constructed along traditional lines, he produced an 88-board signature model run for Hobie. Licensed out and produced in Hawaii, the boards were primarily sold to the established

Miki Dora dropping in on a wall at Waimea Bay on Oahu. Big-wave surfing was as much about one's mindset as it was the necessary athleticism and equipment. Photo: LeRoy Grannis.

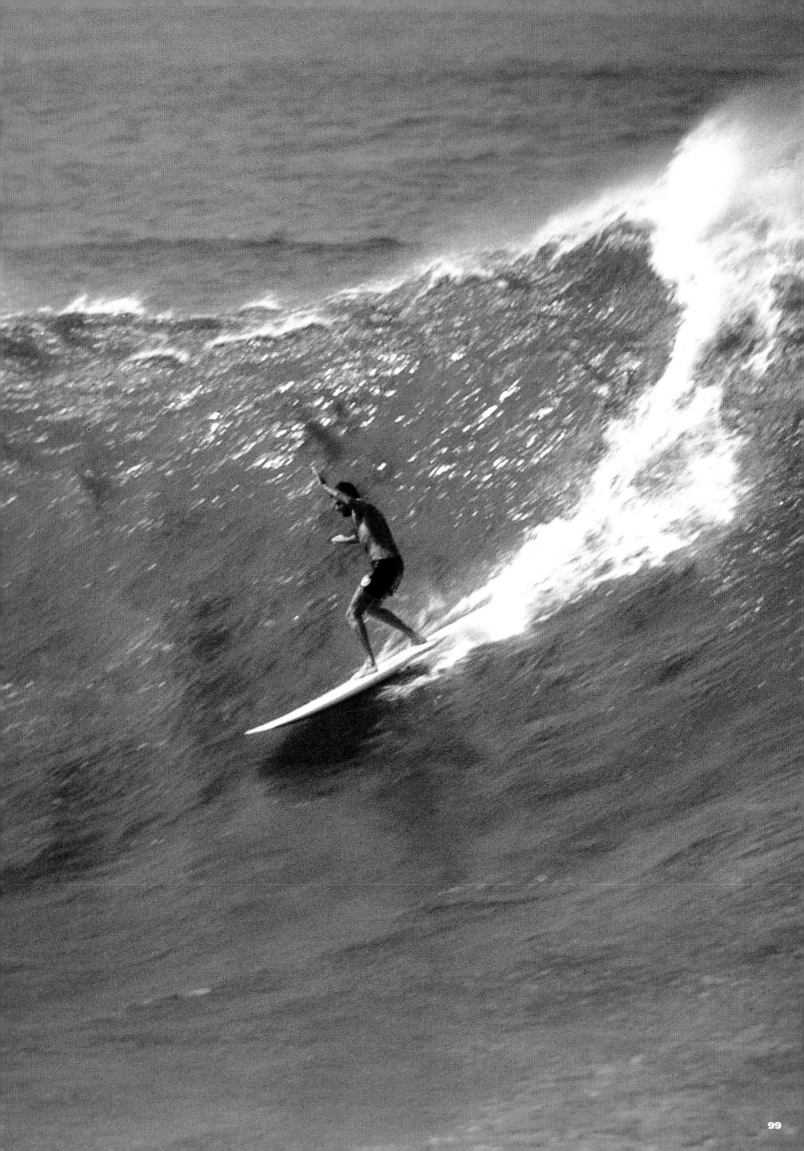

10'6.5" X 21.5" X 12.5" X 14.5"

11'9" X 21.5" X 10" X 13.75"

10'0" X 22" X 9.5" X 15"

WARDY HAWAII

Wardy opened a shop in Waikiki on Kalakua Avenue for a short time in the mid-'60s and turned out a limited amount of guns that are almost impossible to find today. This particular board weighed 36 pounds.

HOBIE DICK BREWER

One of the longest of the Dick Brewer Hobie run, this No. 73 elephant gun was made with high-density (green) foam stringers. The board weighed 45 pounds.

GREG NOLL AIPA

Ben Aipa shaped and designed this transition-era board for Greg Noll's Surf Center Hawaii Shop. It has a long, narrow-based fin and was Max Lin's personal North Shore gun. The board weighed 22 pounds.

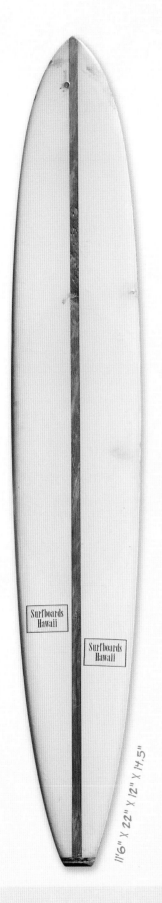

11'6" X 22" X 12" X 14.5"

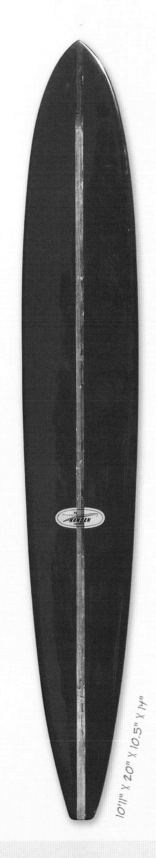

10'11" X 20" X 10.5" X 14"

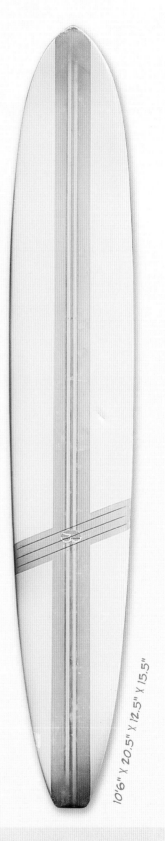

10'6" X 20.5" X 12.5" X 15.5"

SURFBOARDS HAWAII

This No. 101 Dick Brewer shape has a solid 1.5-inch stringer and was made for team rider Melvin Vincent. The board weighed 45 pounds.

HANSEN SURFBOARDS

Mike Doyle's personal board used at Sunset Beach. The shaper of the board is unknown. The board weighed 36 pounds.

LARRY FELKER

Larry Felker was considered by many of the top surfers at Malibu in the early '60s to be one of the best shapers in Los Angeles. This board was originally shaped for movie maker Hal Jepsen's trip to Hawaii. The board weighed 37 pounds.

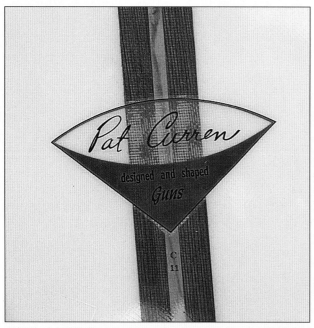

As a leading pioneer of big-wave riding, Pat Curren applied his prowess in monstrous surf to the development of the proper equipment.

guard of big-wave riders. Board dimensions spanned from just over 10 feet to just shy of 12 feet. Width was on either side of 21 inches, 15 inches in the nose and average tail width of 10.5 inches. Jeff Hakman would go on to win the first-ever Duke Kahanamoku Invitational contest on the model in 1965 at Sunset Beach. These boards embodied the collective design paradigms that defined an era—one that would soon come to an unforeseen and abrupt end.

It was Brewer who first broke ranks with the dictates of conventional wisdom. The fixed and strict parameters assigned to how a then-contemporary gun should be fabricated had previously gone unchallenged. Thing was, Brewer had an edge. Feedback from those who rode his boards found its way into each new board he shaped. He set out in a bold and new initiative with a modern gun format based on the futuristic premise that lightweight big-wave surfboards were viable. To Brewer's thinking, excessive length and weight were no longer necessary key design elements. In doing so he departed from a design continuum with foundations set a decade deep. Brewer's defection advanced big-wave surfboard design by quantum leaps.

The effects and consequent outcome of this

design change were immediate. Those who failed to embrace the blueprints for this new direction were left behind, even eliminated. So pronounced was this change that it altered the attitudes and mindsets of the players within the big-wave game. Arguably, up until this point in time, the main thrust in big-wave surfing was for the rider to successfully make the wave and survive the episode. The lightweight boards opened new avenues, adding an entirely new dimension to the experience of riding big waves. Free of previous constraints, riders were literally set loose to ride big waves with new lines and tracks. A changing of the guard was imminent, further redirecting where this sport within a sport was headed.

The board with which Brewer blazed the trail toward this new reality was the Bing "Pipeliner Island Gun." Lightweight, thin and foiled, the milestone surfboard immediately revealed the divergence from what was previously tried and true. Brewer introduced these concepts beginning in early 1967, but the Pipeliner models, especially

"You can't shoot elephants with a BB gun," said big-wave rider Buzzy Trent, inspiring nomenclature for big-wave equipment and Greg Noll's gun surfboard logo.

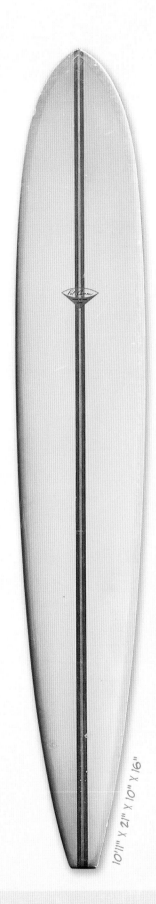

10'11" X 21" X 10" X 16"

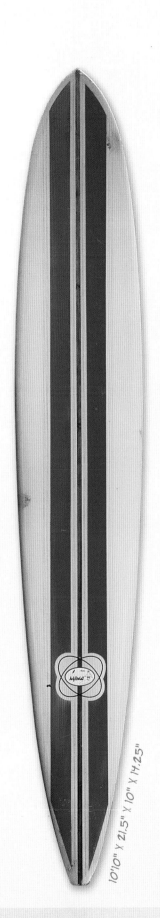

10'10" X 21.5" X 10" X 14.25"

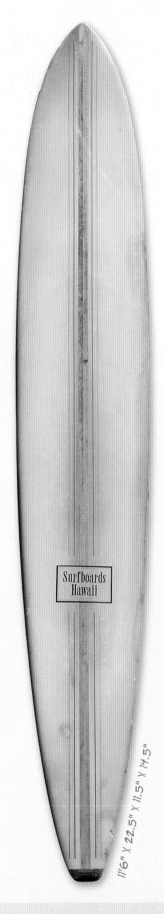

11'6" X 22.5" X 11.5" X 14.5"

PAT CURREN #C-2

Pat Curren was commissioned by Santa Barbara's shaping guru Reynolds Yater to make some guns for his Santa Barbara Surf Shop label. It is thought that a dozen were made, but only 11 are known to exist. The board weighed 40 pounds.

GREG NOLL

The design of this *alii*-colored (red and yellow) gun was reportedly influenced by Peter Cole. This board weighed 32 pounds.

SURFBOARDS HAWAII

This shape is typical of the Dick Brewer era at Surfboards Hawaii. This board weighed 44 pounds.

10'4" X 20.5" X 11.5" X 14" X 3.625"

12' X 23" X 12" X 16" X 4.25"

10'0" X 21.5" X 12.5" X 13.75" X 3.75"

HOBIE BREWER

In 1965, after being forced out of his own Surfboards Hawaii label, guru shaper Dick Brewer began a brief stint at Hobie Surfboards. He shaped this special model gun for team rider Buzzy Trent while working there as a big-wave specialist. The board weighed 30 pounds.

GREG NOLL X-15

Arguably the most beautiful and "ahead-of-its-time" board ever constructed by Greg Noll, this *extremely* heavy gun has a downrail in the tail with a razor-sharp edge.

HOBIE GUN

One of this board's recent owners showed this unsigned Hobie Gun to Dick Brewer and he pegged it as a Terry Martin shape. In its day, the distinctive high-density foam stringers were this board's calling card.

the guns, would be short lived. In a second phase of equally extreme change, just on the heels of these new advancements, yet another Brewer concept would rattle the now-feeble status quo. While the lightweight gun was still seeking and reaching for established *terra firma*, Brewer introduced the mini-gun. If the Pipeliner had cut the trail, then the mini-gun blew it wide open.

So immediate and profound was the transformation set forth in 1968 by the mini-gun that it left some of the greatest big-wave riders the sport has ever known disenfranchised. Some refused or were simply unable to successfully make the transition. More than a few players were forced to learn the game anew or retire. Several chose the latter. Winds of change swept through the shaping stalls and then the beaches. There was no looking back. A new and young contingent eagerly joined the big-wave surf roster during this unraveling. They built their experience and later their reputations with these new boards. A brave new world of big-wave riders was setting out in new directions.

During early development of the mini-guns, aka "pocket rockets," they were also referred to as "baby-guns." A typical period piece might be 8' 6" x 21" x 3" with a 15.75-inch nose and a 10-inch tail. The wide point was forward of center and tapered all the way back into a pintail. The shortened boards mandated later takeoffs and the surrender of knee paddling as a form of propulsion, but the loss of these qualities was more than compensated for by the gains in speed and maneuverability on the waves. Initially intended to improve performance in big surf, divergent camps began using mini-guns in both big- and small-wave venues. Hence, the board played a critical role in what is referred to as a "transition period," fostering the development of the shortboard revolution.

—*Mark Fragale and Sean Preci*

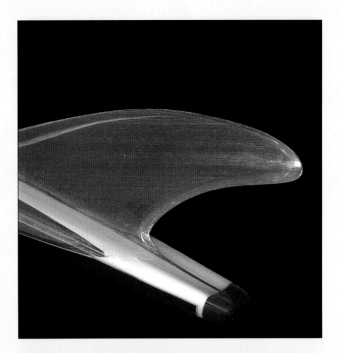

Fin templates on gun designs of the '50s and '60s changed continually. The wide-base, straight-backed skeg of 1958 (middle) became increasingly more foiled and swept back by the mid-'60s (top and bottom).

Aussie Evolution

*I*n the wake of the George Greenough "Spoon"-motivated Bob McTavish vee-bottom surfboard came yet another Aussie-founded development in the rapidly shifting shortboard revolution (the actual title did not come about until years later)—one that would forever alter the standards of the surfboard. Still hooked on the notion that waveriders could emulate the maneuverability and speed of Greenough's kneeboards, Australian surfers started their radical progression toward a "total involvement" style that had surfers riding in and around the curl near the end of the 1960s, with ax in hand.

In Paul Witzig's film *The Hot Generation* (1968) the vee-bottom was presented at its finest as ridden by McTavish and Nat Young at Maui's Honolua Bay. However, nearly a year later Witzig would release yet another film, *Evolution* (1969), which documented the elliptical designs the Aussies were beginning to ride. As demonstrated by Wayne Lynch, "S" turns and more vertical surfing was in full force and the Australian surf scene was declared to be on the verge of a new era in surfriding equipment and style—and quite notably, a divergence that for the first time was not American-borne. Inspired by the breakthrough that McTavish's design provided, Aussie surfers were convinced that they could cut down the overall dimensions of the boards they were riding, yet still maintain the performance that the vee-bottom allowed. In a matter of months average board lengths shrunk from 8' 10" to 5' 10" with the same elliptical outline shape. The various board designs carried many of the same characteristics with egg-shaped rails, a flat bottom, domed deck, hard tail and a Greenough-style fin.

In 1969 Ted Spencer was at the forefront of the *extreme*-shortboard revolution in place on Australian beaches. He swept the contest at Bells Beach and the Australian State Championships riding

NAT YOUNG SURF DESIGN
Keyo

5'9" X 19.5" X 14.875" X 15.875" X 3.125"

KEYO NAT YOUNG MODEL

So much of surfboard design progression is a result of trial and error. This Keyo Nat Young model is a good example of when "short" had gone too far. The Aussies in particular realized this after American Rolf Aurness beat them soundly at the 1970 World Contest in Australia by riding a longer board.

a roundish double-ended board. Upon his return from a six-month honeymoon in Europe, Young was shocked to see the changes made on the surfboard front. Average board lengths were in the sub-six-foot range, with Lynch reportedly riding a 5' 6" board. The boards worked beautifully when riding in the curl with plenty of power behind it, but when the wave flattened out, or a rider needed to connect sections, the board would be dead in the water. Nonetheless, the Aussie contingent of Lynch, Spencer and Young believed that the increased maneuverability of the shorter boards would provide an edge come the world championships.

When the 1970 Surfing World Championships in Australia came around, the locals were in for an awakening. From the earliest of heats the Aussies knew they were overmatched in equipment by an upstart teenage surfer from California, recognized for being the son of James Arness, the star of the TV series *Gunsmoke*. Rolf Aurness had been dominating the U.S. competitive scene and took the Aussies by storm, racing across wave faces at speeds no other competitors could match—on a 6' 10" rounded-pin—and he would sail into the shorebreak with plenty of momentum. The sad fact was that the boards Aurness was riding were not unlike the boards Lynch had been riding just 18 months earlier. With their obviously too-short shortboards, the Aussies could only watch and fight for second as their "innovative" designs hindered their potential. The shorter-board revolution they had attempted to institute had simply stretched too far

The common fin found on the Aussie boards were Greenough inspired. The raked skeg allowed sharper turns along the face of the wave.

and blown any world title aspirations for that year.

All the while, in the shadow of the Aussie development of the too-short shortboard, American shapers were attempting to mimic the new board designs. Bing, Weber and Gordon & Smith Surfboards were among the manufacturers attempting to pursue the Aussie concepts. Using the same sort of dimensions, they too realized that the board had limited potential—unless the boards were ridden in clean, powerful surf they were too temperamental for the average surfer.

Aurness' boards at the world championships had proved that shortboards could only get so short before they became problematic without more research into design concepts. Today, boards with similar lengths from the Aussie shorter-shortboard era can be found in the lineup, only with a more advanced outline—tail, rail, rocker and bottom contours—in place.

Without the modern designs, the Australian version of the shortboard revolution was at an end after alterations that proved too extreme, and by 1971 the average board size was back to a more reasonable six to seven feet. The revolution had finally found its limits.

The flaw in the Aussie design concepts was simply a lack of technological research. Most of the alterations they made to their boards at the time were based on a trial and error process that allowed a general feel to be discovered. While influenced by the Greenough Spoon the Aussies failed to

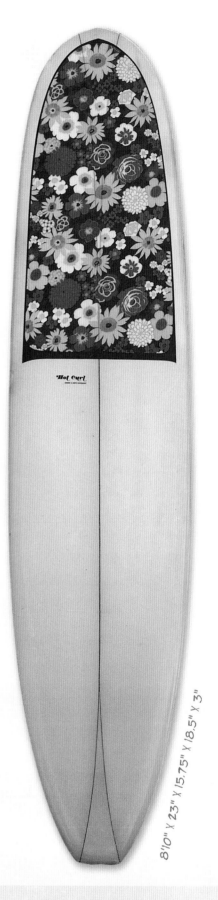

8'10" X 23" X 15.75" X 18.5" X 3"

GREG NOLL
FAIN'S FORMULA

Shaped with wide hips and a narrow pintail, the original Greg Noll Surfboards "Fain's Formula" model was a cross between the early mini-gun and later Aussie evolution-type design.

BING GOOD KARMA

Keeping in step with the hippy-dippy times, many board manufacturers looked to popular culture terminology when naming their surfboard models. Like the Bing "Good Karma," circa 1969.

G&S HOT CURL

This Gordon & Smith model was one of the most successful models to bridge the gap between longboards and shortboards. The shapers took the longboard noseriders into mind and shrunk them down to go along with the shorter-board mindset going on at the time.

7'9" X 14.5" X 12.75" X 19.75" X 3.25"

7'8" X 14" X 22.5"

6'6" X 19" X 14" X 13.5"

WEBER SKI

"To me this represents three traditions of [surfboard] design—Australian, Hawaiian and Californian—all in one board," said board collector Spencer Croul. Indeed, the Aussie influence is credited on the board logo itself: "Australian Inspired for Dewey Weber." While the Brewer mini-gun worked well in chunky, sizable surf, the Ski design became the state-of-the-art performance board. The board weighed 11 pounds.

BING LOTUS

When the shortboard caught on, two design schools quickly formed: the Australian vee-bottom and the Hawaiian mini-gun. Dick Brewer's enormous big-wave design experience made him the natural leader of the latter camp. Because he was working with Bing at the time, the Lotus became the first commercially available mini-gun.

WEBER AUSTRALIA

With its domed-deck and typical bluefin tuna-inspired fin, this Weber board was typical of the designs being implemented around the globe following the influence of the Aussie board concepts.

recognize the true value of the kneeboard design; it wasn't the size that enabled the maneuverability, more so it was the flex in the board that allowed the flat rocker (along with high-aspect ratio fins with plenty of flex as well) to work.

The hype that manifested from the Aussie concepts was adopted by the media. This attitude altogether disabled the longboarding scene and the U.S. surfboard manufacturers that had invested so heavily in carrying an extensive inventory of the larger boards. The major manufacturers were swept aside (some went bust, while others quit and moved on to other venues) by the influx of backyard shapers who were applying any and every concept to their board designs and alterations, and, in the end, were simply re-creating a number of board characteristics that had already been applied, only with a new twist—it was as though they were reinventing the wheel. It would be 20 years before the longboard renaissance would return dignity to loggers—led, ironically, by a young Joel Tudor and a mature Nat Young.

—*Chasen Marshall*

The classic fin design from the Aussie evolution era; this particular removable/adjustable fin came from a Weber Ski (left).

6'8" X 20" X 13.25" X 15.375"

WEBER SKI

"A board originating from a very short period of time in surfboard design history: the transition between then and now, the longboard and the shortboard ... the time when I started surfing. It utilized the Guidance Fin System," recalled board collector Fernando Aguerre.

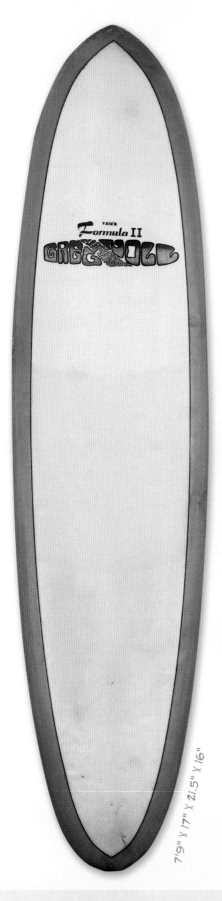

7'9" X 17" X 21.5" X 16"

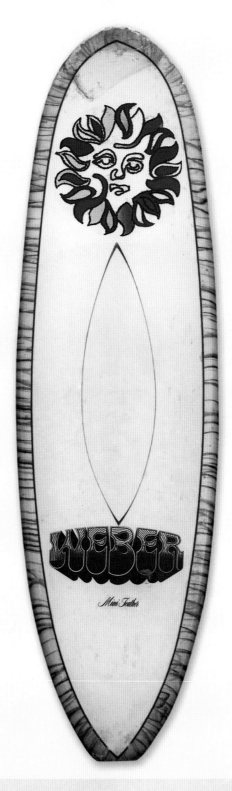

GREG NOLL
FAIN'S FORMULA II

"Old-time" Malibu surfer Johnny Fain again teamed up with Noll to develop a refined, roundtail California point-wave board. The roundtail represented a compromise between a stiff-turning pintail and a sharp-turning squaretail, and became the standard issue at the end of the transition era.

WEBER
MINI-FEATHER

A scaled-down version of the original Feather (which had typical longboard measurements), the Mini-Feather was created to coincide with the trend of the shrinking longboards, or simply the shorter boards being ridden from Australia to the coast of California.

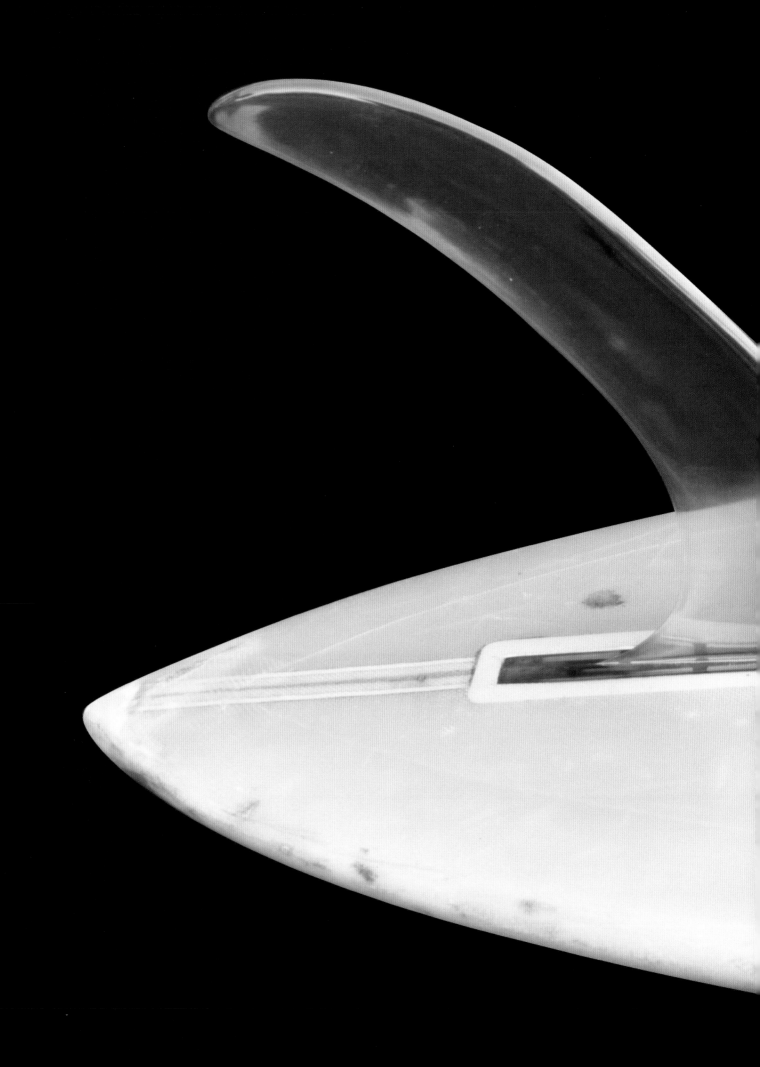

Velzy-Jacobs Pig

By 1954 Dale Velzy had been shaping surfboards for more than 10 years and was arguably the most experienced of the few such craftsmen in Southern California and, by extension, the world. Beginning with cutting down beaten-up redwood planks in his early teens, Velzy had gone on to start making boards from scratch during the years of World War II, and in the post-war period he'd experimented with surfboard designs in both redwood and balsa "plank" and "Hot Curl" styles. In 1950, at Manhattan Beach, he opened the first commercial custom surfboard-building shop on the coast.

With the advent of the Malibu Chip on the cusp of the 1950s, Velzy created his own versions of it too, by which time he was already envisioning surfboard outlines that were less parallel in appearance based on templates he made utilizing more elliptical curves—the result of trial-and-error experimentation he'd made in shaping hundreds of boards. Shortly after he teamed up with Hap Jacobs to launch Surfboards by Velzy and Jacobs in Venice, Calif., Velzy was primed for an even more radical innovation. "I was fed up with doing the same thing day after day," Velzy said of the inspiration that led to the breakthrough design he called the "Pig."

"One day I told Hap, 'I'm going to make

Hap Jacobs with the first Pig shaped by Dale Velzy in 1954. Photo from the book, Dale Velzy is Hawk.

something different. I've made thousands of them and I can't stand these planshapes any more.'"

Velzy set to work on a balsa blank and started playing with outline curves from his Chip and Hot Curl templates, but in a most unorthodox way: using the nose of one for the tail and the tail of another for the nose, smoothing and blending the lines until he saw what he had been looking for—a narrow-nosed board with a wide tail and lots of curve through the "hips." Velzy thought it looked just like the profile of a pig "if you were looking down on it from a fence rail."

As soon as the board was glassed and fitted with a pivot-turning fin, Velzy and Jacobs's team rider Mickey Muñoz was pressed into service to test the new design, and the two partners immediately knew they had hit on a dramatic improvement in surfboard performance. With its widest point aft of center, the Pig caught waves easily because it paddled well and its narrow nose did not push as much water. Even more significantly, the board turned on a dime—with less effort—because of its wide, curvy tail.

Word of the new design's exciting potential spread like wildfire along Southern California beaches, fueled not least by the fact that Velzy and Jacobs' stellar surf team—Muñoz, Kemp Aaberg, Lance Carson, Mike Doyle, Dewey Weber and more—all began riding the new design. A new style of riding emerged—hot-dogging—characterized by powerful bottom turns, snappy cutbacks and noserides. The Pig had set the stage for a new phase in surfing's high-performance evolution.

—Paul Holmes

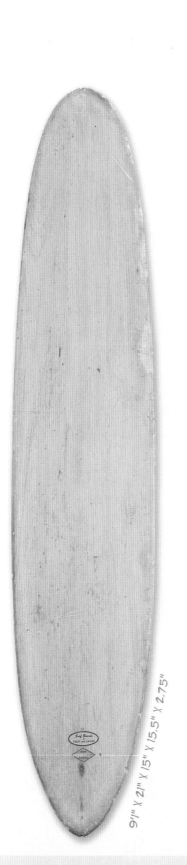

9'1" X 21" X 15" 15.5" X 2.75"

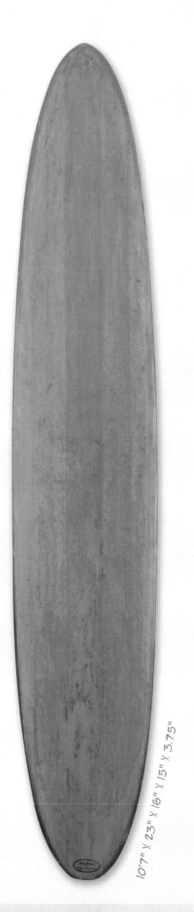

10'7" X 23" X 16" X 15" X 3.75"

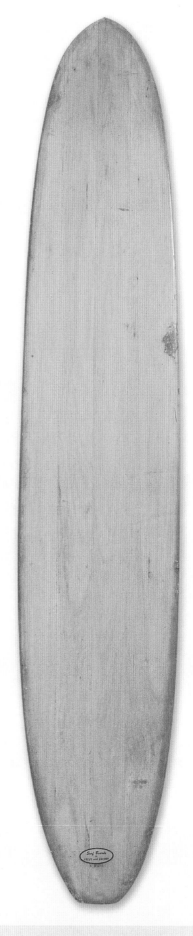

VELZY-JACOBS SEMI PIG

"Velzy's famous quote was 'Simmons made them light, but I made them turn.' He related a story to me about taking the outline of a Malibu Chip and reversing it, and that became the Pig board. This balsa board was probably shaped by Hap Jacobs, but it is my early representation of the pig board," recalled board owner Spencer Croul. This board weighed 20 pounds.

VELZY-JACOBS PIG

If Hobie Alter was the first shaper to make the total switch to foam, then Dale Velzy was probably the last. He stood by balsa—because it was proven and because it was aesthetically superior to early foam. Called the "Pig" because of its wide hip template, this was a popular and enduring design. The board weighed 50 pounds.

VELZY-JACOBS SQUARETAIL PIG

The Pig was made in a wide variety of sizes and template styles, but always with the essential element of a wide point three to five inches aft of center and plenty of curve through the tail. Such elliptical outlines would become standard until noseriders of the mid-'60s reverted once again to more parallel templates.

1970s Speed Shapes

For some Americans, the zenith of the counterculture revolution peaked somewhere in San Francisco's Haight-Ashbury district during the summer of 1967, aka the "Summer of Love." For others, many surfers included, the events surrounding that time period were merely the spark that ignited much broader and long-lasting change. By the end of the decade the shortboard revolution was in full swing—with surfers experimenting heavily with a multitude of different variations in the length, shape and rail configurations of their surfboards. But board design wasn't the only thing waveriders of the late '60s and early '70s were tinkering with.

While built for velocity, the speed shapes were instrumental in the progression of the ultimate maneuver of the '70s—the tube ride.

The Timothy Leary-induced "tune in, turn on and drop out" philosophy that characterized the era was certainly adhered to by many of the surfing populace. To surfers, it came to fruition as a "return-to-country" movement away from many of the commercial and "impure" aspects of surfing, such as organized competition, in exchange for an unfettered relationship with waveriding—or what came to be known as "soul surfing." Some of the tenets related to this ideology were communal living, meditation, vegetarianism and a constant drive to attain the ideal, or perfection, often fueled by very liberal drug usage: psychedelics like LSD,

psylocibin mushrooms and peyote in particular. One of the most famous quotes that sums up the era comes from Quiksilver co-founder and high-performance surfing godfather Jeff Hakman, who admitted that "the best memories of my surfing career" came while riding Honolua Bay high on LSD with his friend, Jock Sutherland.

But drug use and alternative lifestyles weren't the only things culled from the late '60s that fully flowered in the "Age of Aquarius." Aside from the new shorter lengths in surfboards, the hard, down rails introduced by Dick Brewer around 1967, which were later tucked under at an edge, also carried through to the new decade. Brewer, one of the forerunners of the shortboard revolution, unveiled these features in his mini-guns, or "pocket rockets," named so for their extraordinary ability to sustain speed and control in the curl of the wave. Thanks to this new rail configuration, surfers were now able to redirect their forward momentum into more critical parts of the wave, furthering the overall spirit of exploration of the time.

These boards also quite literally opened the door to what would become the ultimate maneuver of the '70s—the tube ride. It was no surprise that one of Brewer's early disciples would be the first surfer to truly master the art of tuberiding. Gerry Lopez's well-earned reputation as "Mr. Pipeline"

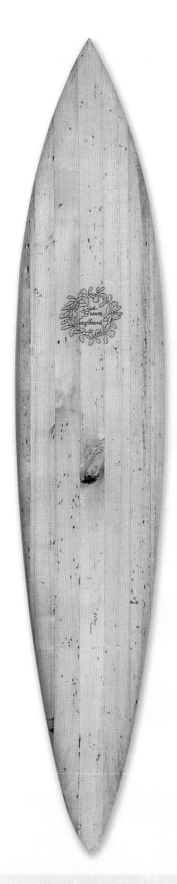

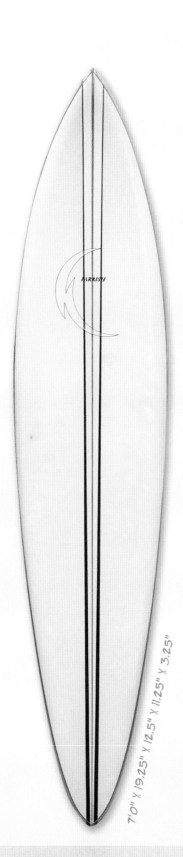

7'0" X 19.25" X 12.5" X 11.25" X 3.25"

8'0" X 19.375" X 9.25" X 12.5"

DICK BREWER SURFBOARDS

While guns from the '60s are considered far more valuable than their full-figured counterparts, this '70s version, a Dick Brewer chambered balsa, would have to be considered a score of epic proportions, and a trustworthy friend in any hollow situation.

TOM PARRISH

In the mid- to late '70s, Tom Parrish-shaped guns were among the most sought after surfboards anywhere, in particular along Oahu's North Shore. This board, made in 1977, has a seldom seen "Moon Bolt" logo as opposed to the traditional lightning bolt of the time.

MIKE HYNSON RAINBOW

This "Rainbow" model is a beautfiul example of the psychedelic influence of the early '70s by Mike Hynson. It has a single box fin, a weight plug on the nose, exquisite airbrushing and pinlines composed of hundreds of hand-drawn yin-yangs and oms.

8'0" X 19" X 11.25" X 12" X 3"

HOT BUTTERED
SURFBOARDS

These "spaced-out" graphics and the pulled-in pintail were typical of Australian Terry Fitzgerald's work in the mid-'70s. He became known as the "Sultan of Speed" for his approach to riding waves at breakneck velocity.

DEXTRA
SURFBOARDS

Dextra Surfboards was one of the longest-running popout companies. The Downey, Calif.-based company had its doors open from about 1963 on into the beginning of the shortboard era (as shown here).

SPIDER MURPHY
SURFBOARDS

Murphy shaped Shaun Tomson's boards throughout the '70s. Tomson rode boards just like this one at Pipeline and Off The Wall, and in Bill Delaney's film, *Free Ride*.

during the first part of the decade was based on his Zen-like approach to placing his lean frame square in the mouth of the beast and casually getting spit back out time and time again, showing no signs of duress all the while. In fact, this blasé aesthetic—making the extremely difficult look effortless—quickly became the norm at the time. And as surfers attempted to get deeper and deeper in the barrel, boards became narrower and more streamlined in order to fit the wave's contours better.

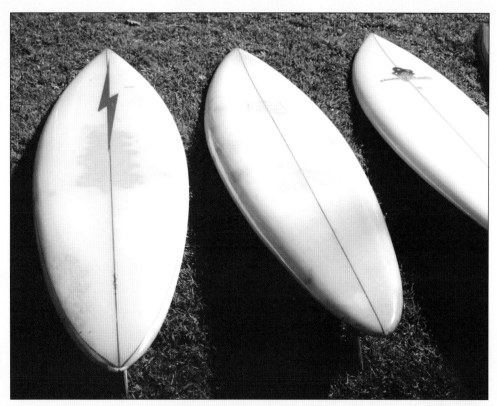

The lightning bolt insignia was often directly correlated with the tube-riding connoisseur of the '70s, Gerry Lopez—otherwise known as "Mr. Pipeline" for his finesse at the dangerous break.

Though tuberiding provided surfers with the ultimate high while riding waves, allowing them to temporarily return to the womb, high-performance surfing also gained new respect and hordes of practitioners. Speed was the name of the game in the early to mid-'70s and few surfed faster than Australia's Terry Fitzgerald. The "Sultan of Speed," as he was deemed during this period, pushed high-performance surfing on his trademark narrow, single-fin speed shapes. Another surfer that Brewer mentored directly, Fitzgerald shapes usually featured a wing, or bump gradually transitioning into a sharp pintail or swallowtail. Whether he was surfing Oahu's Sunset Beach or anywhere along Australia's East Coast, and especially at waves like Jeffreys Bay that required down-the-line surfing, Fitzgerald became famous for being one of the smoothest and usually the fastest surfer in the water. He was also remembered for out-of-this-universe airbrush art jobs (by Martin Worthington) on nearly all of his equipment.

Airbrushing surfboards was introduced in the late '60s and has been called "a cultural barometer for surfing" by surf historian Matt Warshaw. Thus, the spaced-out, psychedelic mindset of the time was clearly reflected in the artwork many surfers chose to feature on their boards. Fitzgerald was not alone with his signature galactic interplanetary space scenes. Other surfers who often cosmically colored their boards were Mike Hynson and David Nuuhiwa, whose long hair and groovy attire personified their generation. Other popular design concepts were underwater ocean scenes, perfect "dream" waves, rainbows and the yin and yang symbol. With employment falling far down on most surfers' list of priorities circa 1972, they had plenty of time to hand paint and custom design their equipment in an array of colors.

By 1975, the year before the first multi-event professional surfing tour was introduced, surfers realized that feasibly making a living off of surfing wasn't that far of a stretch. So, many waveriders trimmed their hair, partially cleaned up their act and the highly artistic paintbrush jobs became a thing of the past as surfers began to seek out sponsorships from legitimate companies in the still-burgeoning surf industry. In short, instead of living off the land, they opted to make a living from their surfing ability.

—Sean Preci

Tandem Boards

*I*n theory, tandem surfing should have much broader appeal. It is at once athletic and aesthetic, combining the strength, waveriding experience and skill of the male partner with the agility, poise and grace of the female, to produce an act of surfing that is, at its best, both amazing and strangely beautiful. In the '60s it was an aspect of the sport that captured the public imagination in a major way— the event that attracted both peak spectator crowds and media coverage at the first World Contest in Manly, Australia, and was regularly and extensively featured on national network TV coverage of the Makaha International Surfing Championships and other contests both in Hawaii and on the U.S. mainland.

It's unknown if tandem surfing dates back to the days of Hawaii's kings and queens, but it's certain that its modern form has origins with the Waikiki beachboys of the 1920s. Photos of the time show beachboys with tourist girls cradled in their arms or perched on their shoulders as they surfed the gentle, rolling waves. Lascivious stories abound concerning the old-time beachboys and their subterfuges with young women who wanted to experience the thrill of surfing. The beachboys were well aware that their prowess in the sea, athletic skills and mastery of the waves could lead to an irresistible tidal flood of admiration.

In the '30s, mainland surfers visiting Hawaii, many of them lifeguards or watermen-adventurers, brought the novel idea of tandem riding back to San Onofre, Doheny and Malibu, among other West Coast spots. It was, after all, a great way to meet and impress women at any beach. By the late '50s, tandem surfing competitions—a more serious, athletic and more organized form of the fun—had become a fixture at the annual Makaha International in Hawaii and the U.S. Surfing Championships at Huntington Beach, Calif. Perhaps it was when the waterman/lifeguard/surfer ethic met the bodybuilding and gymnastic "physical culture"—at Muscle Beach, Venice, Calif., in the late '50s and early '60s—that fun met discipline and things began to change. The set-piece moves of tandem surfing's early days

INFINITY TANDEM

Competitive tandem surfboards are typically based on the weight of the team to be riding it. This particular board is for a high-performance tandem team, characterized by a pulled-in nose and tail. Some tandem board manufacturers have begun to make the boards using EPS technology, with positive results.

11'8" X 26.5" X 14.5" X 18" X 5.125"

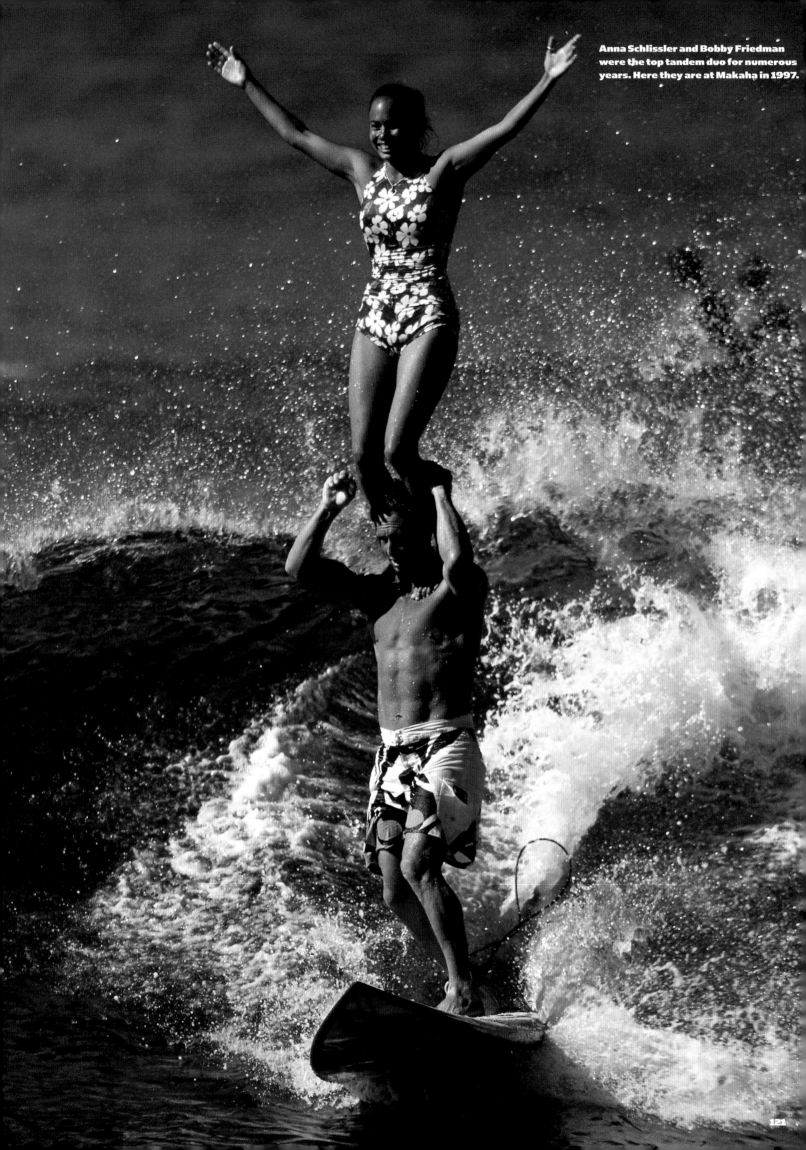

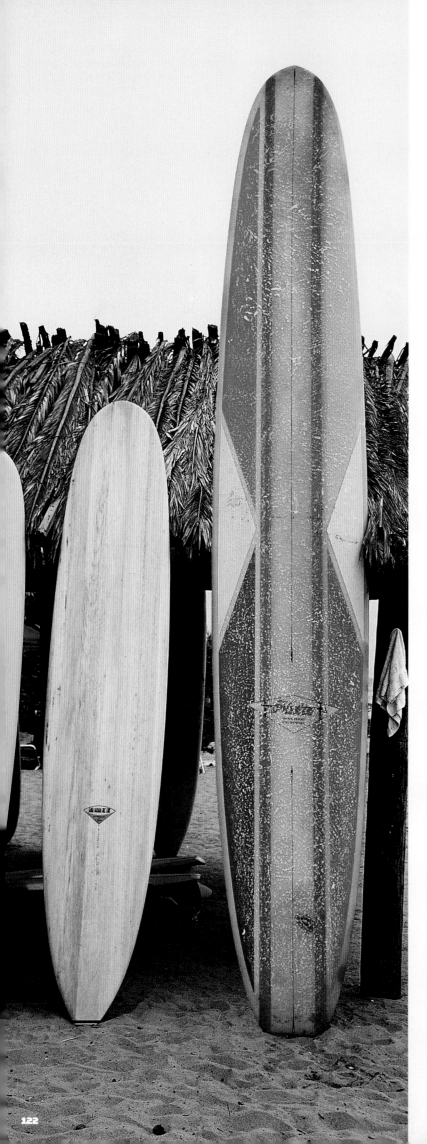

were limited to a handful of relatively simple lifts. Today there are almost 40, many of which are formidable gymnastic feats. Even some of the current crop of successful tandem teams concede it may have become just too complicated—highlighting a conundrum of controversy that swirls even among its own small, inner circle.

"The dark ages have come to tandem surfing, and that's why hardly anyone does it anymore and it's lost momentum," says Mike Doyle, who won the Makaha event three times and is still an avid recreational tandem surfer. "It used to be just about having fun—grab a girl off the beach, practice a few tricks before you paddle out—and then it was all about surfing ability and balance. Done correctly, tandem surfing is still all about riding the wave. What's happened is a bunch of gymnasts have taken it over and put surfing on the back burner."

Steve Boehne, who began competing at about the time Doyle was at his zenith and went on to become a driving force in the sport, disagrees with at least part of Doyle's argument, pointing out that technical progress is an inevitable byproduct of the competitive drive to excel: "It's just like in single surfing, nobody used to do roundhouse turns, off-the-lips or aerials. If you just want to surf the old way—take off, bottom turn, hang five—that's fine. But things progress. You either have to get with it and learn new techniques or things just go past you."

Outside of the competitive arena, however, there are tandem surfers who are pushing the limits of two-up waveriding. Most visible among them is Bobby Friedman, who also has the distinction of taking up surfing specifically to get involved in tandem. An ex-pro skateboarder and racquetball player, Friedman is a powerful natural athlete who first became captivated by the sport after seeing it on TV. In 1994, he walked into Boehne's surf shop, Infinity, in Dana Point, bought a board and, under Boehne's instruction, began practicing lifts with Anna Schlissler on the retail floor. Then he went out and learned to surf. In the space of just a

A vintage Hobie tandem board at San Onofre, a favorite SoCal spot for the "two-up" crew. Compared to the tandem board, the longboard doesn't seem to warrant its name.

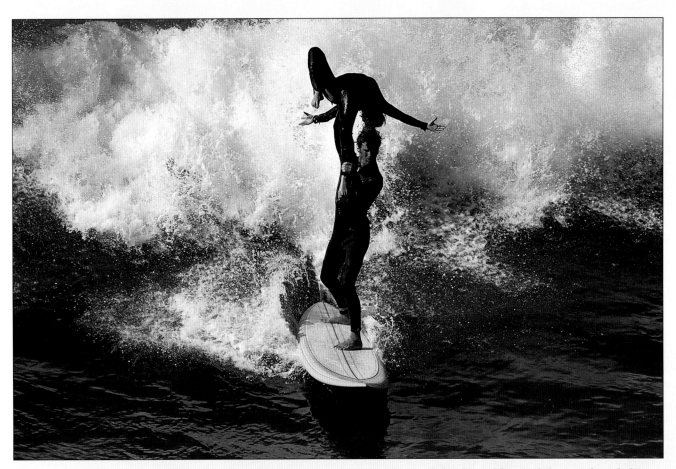

The tandem board has added thickness and length to compensate for the added weight of two riders and the speed needed to catch waves. Above, Steve and Barrie Boehne demonstrate the possibilities at the Huntington Beach Pier.

couple of years, Bobby and Anna became a force to be reckoned with in the tandem contest scene. But they truly made their mark by tackling waves that were big, hollow or otherwise challenging in ways that defied tandem surfing's status quo, garnering a level of interest from the surf magazines that other tandem teams of the '90s could never even dream of. "It had all been done," says Friedman of his extreme take on tandem surfing. "It was going to take something fresh to revive it."

Bobby and Anna tandem surfed spots that were deemed too dangerous—Puerto Escondido and Pipeline among them, got barreled at Duranbah in Australia, even tackled Waimea Bay on "small" days. Meanwhile, Friedman brainstormed with more experienced surfers and craftsmen like Bill Stewart, Phil Edwards and Mickey Muñoz to come up with boards—like the step-railed design he currently favors—that would allow him to push the surfing performance envelope in tandem. He has since continued to be a force in the sport with his

new partner (and wife), Tiare.

Although tandem surfing saw its heyday in the mid-'60s and was a regular feature at bigger surfing contests of the '70s and '80s (albeit more of a demonstration event) even after the shortboard revolution, it has continued to exist—waxing and waning in popularity and interest. But it never cultivated more than a small, core group of adherents, and never really has taken its rightful place among the diverse waterman disciplines that are finally being more widely accepted as a legitimate part of the waveriding heritage by surfing's community at large.

Though a widespread resurgence in tandem surfing has yet to materialize, the cooperative practice is undeniably grounded in surfing's long history. In 2006 tandem surfers held their own world championships in Hawaii with 20 teams coming from places as far afield as Australia and Europe to compete. Perhaps that will mark the beginning of tandem surfing's renaissance.

—*Paul Holmes*

Aipa Stinger

By the mid-1970s, an emergent world professional circuit was beginning to drive the quest for better-performing surfboards— surf tools that would add panache to a surfer's repertoire of turns and cutbacks, tightening the arcs they carved, permitting more extreme direction changes and pushing the limits by adding a vertical element to riding waves—all with the objective of higher scores on the judges' scorecards.

Some extraordinary surfing was going on in Hawaii at the time, with young rippers like Larry Bertlemann, Montgomery "Buttons" Kaluhiokalani, Mark Liddell, Dane Kealoha and Michael Ho at the vanguard of a new era of small-wave performances.

Says Hawaiian shaper and mentor to the group, Ben Aipa: "We had a bunch of guys from Hawaii whose surfing was just *beyond*, but their boards just couldn't keep up. I was lucky to be part of that movement of that new surfing."

Aipa describes watching Bertlemann applying his trademark skateboard-influenced turns in the early '70s, almost bringing them full circle into 360-degree loops, but just not being able to maintain speed through the final arc. He thought about how to tighten that arc. Move the fin up, he decided, and split the tail, like a swallow's. It worked. By 1973, Bertlemann was the U.S. champion and the swallowtail surfboard became part of the design canon.

A couple of years later, Aipa came up with another design innovation along similar lines, adding "wings" to the outline one-third up from the tail, along with a distinct "step" across the bottom in the rocker at the same spot. "I watched the guys surfing," says Aipa. "They were stinging the wave..."

The "Stinger's" design had the effect of creating a break in the rail line that allowed a single-fin board to release quicker and to draw tighter turns, also giving rise to a more vertical approach to the wave and the release necessary to bring the board back down the face after a lip-bash. The board could also be surfed more effectively from a more forward position, meaning that it was less necessary for the rider to move up for high-speed trim and back for making turns—simply taking a wider stance permitted both, under most circumstances. The Stinger, like the swallowtail, proved to be versatile

BEN AIPA STINGER

Ben Aipa's Stinger tail design put him on the map, and with team riders like Larry Bertlemann, Montgomery "Buttons" Kaluhiokalani, Mark Liddell and more. Aipa was a major force in surfing—and still is today.

7'0" X 20.5" X 12" X 14" X 3.25"

and effective in both small and mid-sized waves. Aipa, and those who followed his lead, made Stingers mostly in the mid-six to mid-seven-foot range, 19 to 20 inches wide and with the wide point typically three to five inches forward of center. Stingers came in swallowtail, rounded-pin and squaretail configurations.

The new wave of Hawaiian surfing spread globally and blew minds on the professional contest circuit on the U.S. mainland, in Japan and Down Under. An almost immediate Aussie convert was rising star Mark Richards, who had Aipa make him boards for several seasons leading up to his incredible run of four world championships beginning in 1979, by which time, after being tutored by Dick Brewer, he was shaping himself and mostly riding twin-fin swallowtails except in the biggest waves of the Hawaiian winter season.

Richards is almost reverential when he speaks of Aipa's design talent and shaping skills: "I've never seen anyone shape quite like Ben," he says. "It's almost as if the planer is part of him and he's simply transferring his own power and energy directly into the foam. It was amazing to see."

Ben Aipa came late to surfing—he didn't start riding boards until he was 23 after a stint as a semi-pro football player and then a football coach—but he immersed himself in it with an enormous passion and enthusiasm that continues unabated to this day. His own surfing reputation was established as a big-wave rider (he took eighth place in the 1965 Duke Kahanamoku Invitational, was a finalist the following year and finished fourth in the 1967 Makaha International) with deeply buried bottom turns, gouging roundhouse cutbacks and grace through power and speed. He began his shaping career at Makaha Surfboards in the mid-'60s and went on to work at the Greg Noll label (run by Charlie Galento) and then for George Downing at Wavecrest. In 1968, while working for Fred Schwartz at Surfboards Hawaii, he shaped the board that Fred Hemmings rode to victory at the world championship contest in Puerto Rico. In 1970, he opened his own shop, Aipa Surfboards.

Even from his earliest days as a shaper, Aipa felt that something was missing—something that made him want to experiment: "People were riding boards, not surfing them," he explains. "I wanted to top that. What if I put an edge here, what if I moved the fin up to here? I wanted to *surf* my board, not just ride it. When I played football I utilized the size I had and I was fast. When I looked at people surfing I thought, 'you guys look slow.' I wanted more."

Aipa delivered more—especially with the swallowtail and Stinger designs—and went on not just to shape innovative boards, but to coach future generations of champions including two Hawaiian multi-time world title winners, Sunny Garcia and Andy Irons.

Shaping and coaching in the arena of high-performance shortboard surfing was not the only venue for Aipa's energy and innovation during the '80s and '90s. Longboarding was making a comeback and, in Hawaii, Aipa was on the leading edge from the start.

Photos from the mid-'80s of Aipa's mini-tanker bottom turns, off-the-tops or radical cutbacks—at spots like Big Rights, Number Threes, China Bowls and Ala Moana among others—gave modern longboarding an early credibility it could never have attained just through the kind of old-school nostalgia sessions that were taking place on the mainland, however stylish the pose on the nose, and however fun the social gathering.

In recent years, though, Aipa has been concentrating on the Stinger version of longboards, explaining, "If they're being progressive, everybody's trying to find a way to make the board turn quicker. So bottom, rocker, fins, all have to be configured to make the board turn easier. I've been gearing the boards more towards the bigger guys, so the board is bigger, thicker, wider—but it's a Sting, so it's going to out-turn the other guys' big board."

In addition to the custom orders he makes in his Honolulu workshop, Aipa's modern Stinger shapes have been immortalized by the Boardworks EPS/epoxy surfboard line in sizes ranging from 6' 9" all the way up to 10' 2"—an exact replica of a board he still rides himself.

—Paul Holmes

Pacific System Homes

ounded in 1908 as Pacific Ready Cut Homes, a maker of "kit" houses, this obscure California enterprise can claim to be a pioneer in commercial surfboard building. During the early 1930s, the company diversified its operation on South Boyle Avenue in Los Angeles— a 24-acre wood-milling site—to begin making surfboards that were sold at beach clubs, sporting goods shops and even department stores.

Although they were little different in design from the redwood planks of the era, which in turn had been modeled from traditional Hawaiian *olo* and *kiko'o* boards, the Pacific System Homes boards were branded, literally, with a small swastika logo on the deck, near the tail. Thus they became known as "Swastika" models and were available in standard 10-, 11- and 12-foot models, some 20 inches wide and around four inches thick, with round, blunt noses, wide, square tails and a fairly parallel outline. Models were also available in bellyboard or what could be interpreted as child-sized versions. Later a 14-foot paddleboard model was also added to the catalog.

Constructed from glued and dowelled pine and redwood strips in various width combinations and often trimmed out with matching wooden laminate tailblocks and vee-shaped noseblocks, the boards were varnished to a high-gloss shine and were aesthetically pleasing to the eye. Bottoms were

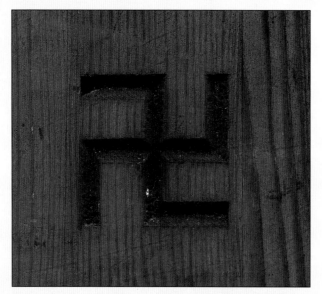

Due to the rise of Hitler's Nazi party in Germany, Pacific System Homes dropped the "swastika" logo.

slightly domed in the cross section and rails rounded up to a flat deck, but the boards had very little nose-to-tail rocker and they were, like all other boards of the time, finless. Accomplished surfboard builders Preston "Pete" Peterson and Lorrin "Whitey" Harrison reportedly designed and shaped the prototypes and were also available to fulfill any custom orders requested of the company.

Later in the decade, with the rise of Nazi Germany and war brewing in Europe, Pacific System Homes dropped the increasingly reviled swastika logo and renamed the boards as "Waikiki" models. By this time balsa wood was used instead of pine in the construction of the boards and the lightweight, tropical wood strips in combination with redwood could reduce the average heft of the finished product to as little as 45 pounds. In addition to its mainland distribution network the company found an outlet for Waikiki models at the Outrigger Canoe Club in Hawaii. The board was also featured on a poster for the steamship company Matson Lines, which also built and owned the Royal Hawaiian Hotel, although it was probably the attractive wahine paddling the board that was intended to sell the company's Hawaiian vacation packages.

By the end of the 1930s, Pacific System Homes got out of the kit housing business altogether, but if the idea was to concentrate solely on surfboard building it proved to be an ill-fated venture. The company closed its doors in 1940.

—Paul Holmes

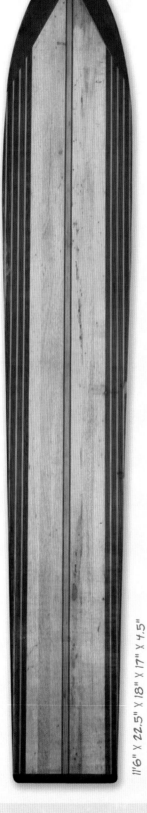

11'6" X 22.5" X 18" X 17" X 4.5"

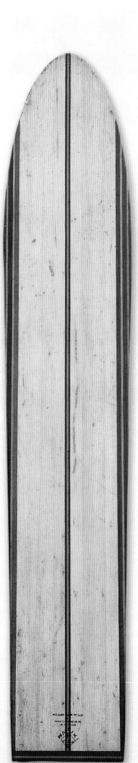
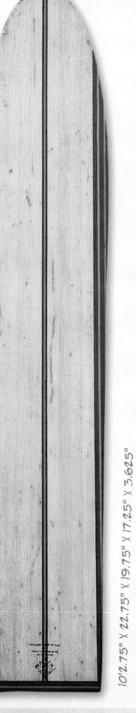

10'2.75" X 22.75" X 19.75" X 17.25" X 3.625"

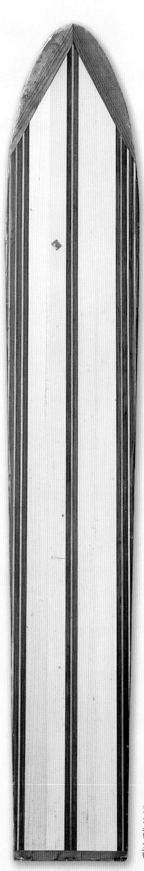

7'4.5" X 19.375" X 10.75" X 12" X 3.125"

BOB HANKEY

Bob Hankey and colleague Lee Adams shaped this board at Huntington Beach, Calif., while lifeguarding. It was made from a glued-up plank of balsa and redwood, purchased for $45 from Pacific System Homes in Los Angeles. The board weighed 109 pounds.

WAIKIKI MODEL

For obvious reasons, the Pacific System Homes "Swastika" model was changed to the "Waikiki." Although similar in outline, Tom Blake's influence is evident in this sugar pine and redwood plank that was made with hollow chambers to make it lighter. This board also has one of the earliest examples of a small fin utilized on a surfboard. It weighed 55 pounds.

BALSA WAIKIKI

By the late 1930s, Pacific System Homes was making boards from redwood and balsa. In those pre-fiberglass times, the boards had to be regularly varnished to prevent the porous tropical wood from soaking up water. Some of these boards weighed as little as 45 pounds, remarkably light for the era.

Stewart Hydro Hull

The idea came to him on a Saturday afternoon in the early '80s while watching hydroplane racing, one of his childhood passions. Bill Stewart was intrigued by the fact that the watercrafts could reach speeds of nearly 200 mph and make sharp turns without high-siding, much the way a surfboard catches an edge. A competitive surfer and innovative shaper, Stewart wondered if the technology on these high-speed boats could be applied to surfboards, both short and long.

Going to his San Clemente, Calif., shaping room and immersing himself in his new belief that a surfboard should be able to reach heightened speeds and still remain in control for high-performance riders, Stewart created a feature that he believed was comparable to the sponsons found on the bottom of the influential hydroplane boats. By eliminating completely rounded rails and instead creating a flat spot on the underside of the rail (beveled rails), Stewart was able to limit the amount of board surface planing across the water and allow for added speed.

Deciding to initially apply the new design to shortboards to further increase the speeds they could reach while racing across the face of a wave, Stewart also added a double-concave bottom—which had seen success on Al Merrick shortboards—to assist with controlling the speed as well as creating new levels of maneuverability.

Despite the success that his shortboards witnessed with the new combination of rail and bottom design, Stewart turned his attention to longboards, an arena that he felt would benefit more from the new elements, particularly the beveled rails.

In the late '70s and early '80s longboarding was tucked into the darkest corners of the shadows. Demand for longboards had all but disappeared as shortboards dominated board sales. So when Stewart decided to focus his time on longboards, not to mention a design foreign to the genre, he risked the credibility of his name and reputation. The success that was soon to follow never could have been anticipated, and it was his pioneering

STEWART
HYDRO HULL
Considered an everyman's board—from beginner to expert— the Hydro Hull was an easy board to learn on but could also meet the performance standards that professionals sought in their equipment.

attitude and desire to initiate change that would allow it.

As opposed to the rounded rails seen in previous-era longboards, Stewart's beveled rail design reinvented the possibilities for riding a longboard, which were known as more graceful, yet less maneuverable and fast than its shorter counterpart.

A long-time supporter of progressive surfing, Stewart had longed to create a longboard that was able to maneuver similar to a shortboard, with tighter turns, the ability to hit the lip of a wave and initiate aerials. The Stewart Hydro Hull was born.

By applying the features he had initially applied to a shortboard, Stewart was able to alter the way longboards were ridden and change the status quo for board designs. Beyond the rail design and the 2 + 1 fin setup (which Stewart claims to be the first to use), Stewart shaped the board with three concaves, which would allow the board to lock in better to a wave when on the nose, as well as have a loose feeling when working from the tail.

"I always called [the Hydro Hull] a Porsche in a pick-up truck," Stewart says. "The concept was when I'm on the tail it's a Porsche, and when I'm on the nose it's a pick-up truck."

The model would long be respected for its diverse ability. The board was successful by any standards, whether for a guy out for his first ride or a top pro looking for a new board to add to the quiver.

The Hydro Hull triggered the beginning of progressive longboarding, and arguably the rebirth of longboarding in the public eye. The board would go on to become Stewart's all-time best-selling board, and one of the top-selling models ever created, thrusting Stewart Surfboards into instant popularity. When he placed his first longboard-devoted full-page ad in *Surfer* magazine, no one at the time was pushing the sport. Over the next five years longboarding would experience a boom in popularity as surfers were pulling the cobwebs off their old logs tucked up in the garage rafters—and the Hydro Hulls couldn't be shaped fast enough.

—*Chasen Marshall*

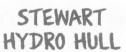

STEWART HYDRO HULL

With its beveled rails, the Hydro Hull enabled the rider to reach heightened speeds for a more high-performance ride, but could still lock in for noserides. Bill Stewart calls the board a "Porsche in a pick-up truck" for its diversity of ridability styles.

1960s Mini-Gun

It was a heady time. Guys walking around the jungles of Kauai, dusted, living in tree houses and emerging from the woodwork only when the swell kicked up. Mind-expanding drugs? Those were part of the story. But it didn't take a brain full of mushrooms to dig what was going on in the world of surfboard design. People were talking, and much of that talk centered around key innovator and respected big-wave enthusiast, Dick Brewer. Brewer had moved his shaping operation from Kauai over to Maui and for two momentous seasons, from '68 to '69, Honolua Bay's fabled bowl played host to a series of developments that would collectively encapsulate the transition between longboards and shortboards.

At the root of this so-named "shortboard revolution" was the Brewer mini-gun: a direct descendent of the journeyman shaper's Pipeliner design. Borrowing certain elements from the short vee-bottom surfboards Bob McTavish brought to "The Bay," the mini-gun set new precedents in speed and maneuverability. Imagine a scaled-down version of the Pipeliner big-wave guns, with some

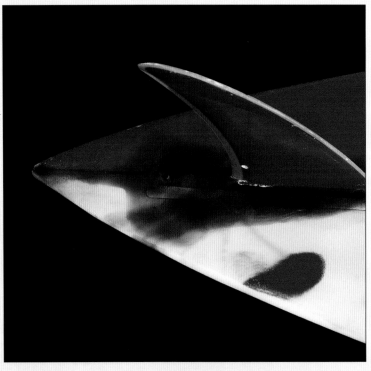

In stark comparison to the vee-bottom movement going on in Australia, the Brewer-inspired mini-gun featured a needle-like pintail .

subtle vee thrown in the tail to provide planing surface on hard, banking turns—a convergence of two essentially short-lived schools. The result was a widely popular template that quickly found favor within both the Australian and Hawaiian camps.

Averaging between eight and nine feet in length, the prototype being 8' 6" x 21" or so, mini-guns flat-out outperformed their predecessors in all but the most extreme conditions. But undeniably, it was in steep, demanding waves that they truly came into their own. Whereas McTavish's wide-tailed vee-bottoms had a tendency to track (and in fact bore minimal influence on the conception of the mini-gun to begin with), Brewer's new brainchild possessed the sleek, foiled profile to match freight train righthanders like Honolua Bay. Sporting the fundamental design attributes of Brewer's Islands-tested Pipeliner—hard down rails, teardrop outline, wide point forward—it had all the makings of a standard big-wave gun of the time ... minus a couple of feet in length. Less area up front meant less opportunity to dig a rail. And by extension, the rider was now able to make adjustments in trim from the sweet spot of his board, rather than having to step back and crank the thing around. In short, with knowledge of the lineup and an ability to

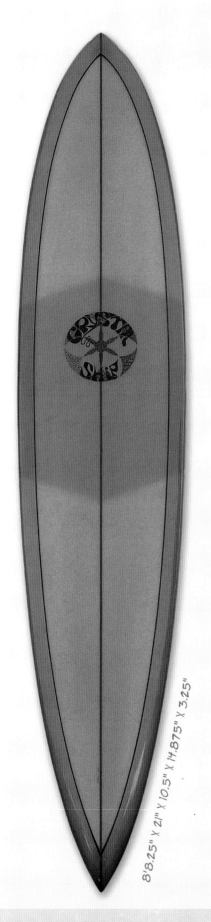

8'8.25" X 21" X 10.5" X 14.875" X 3.25"

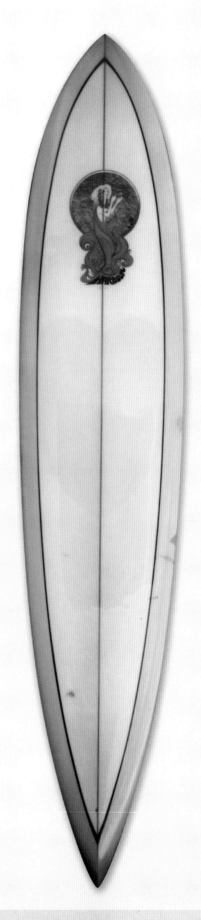

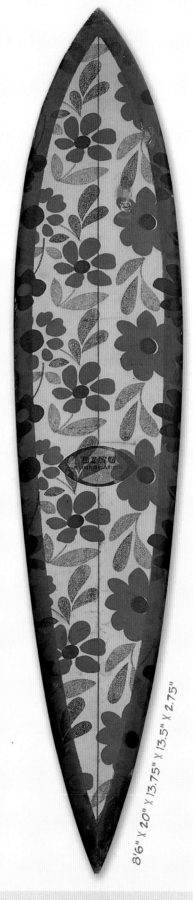

8'6" X 20" X 13.75" X 13.5" X 2.75"

BAHNE CRYSTAL SHIP

A close representation of the Brewer mini-gun, a refined design that came out of experimentation with wide-tailed shapes that had a tendency to skip out too easily in overhead surf. This is also the earliest example of Hawaiian design influences on board shapes as a whole. The board weighed 16 pounds.

HARBOUR SURFBOARDS

Just like every other shaper that attempted to jump on the mini-gun bandwagon, Rich Harbour presented a design that typified the characteristics being implemented—a pointed nose and tail with a sleek look.

BING SURFBOARDS

Bing Copeland was at the forefront of surfboard design throughout the transition period between longboards and shortboards. He may not have come up with the revolutionary designs we know of today, but was consistently not far behind in bringing these shapes to the mainstream.

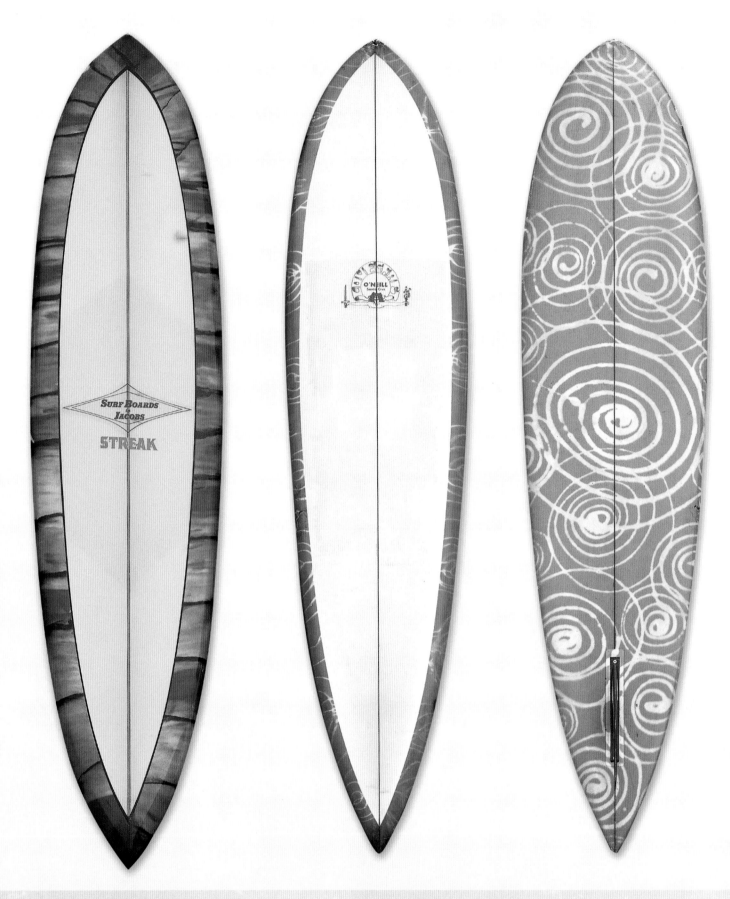

HAP JACOBS STREAK

Shapers like Hap Jacobs made the transition from the classic longboard period of the '50s and '60s to the shortboard revolution and beyond by adapting their styles.

O'NEILL LOVECRAFT

While the O'Neill Lovecraft model didn't stray from the typical board designs of the time period, what helped this board to stand out from the rest was its aesthetic element.

execute later takeoffs, one was able to put the mini-gun in places previously unfeasible—surfing further back in the bowl than ever before. Some truly groundbreaking jam sessions illustrating this were headlined by Joey Cabell, Jock Sutherland and Jeff Hakman, among others. Those in the know went to Brewer, who'd been shaping out of an old pineapple factory in Lahaina. But legends weren't the only ones behind the shift to smaller equipment.

There was a whole confederation of Honolua Bay mavens who lived for those magical

By the late 1960s, as board sizes were drastically decreasing, the size and shape of fins were also in a transition, as seen with this swept-back design.

days when the right combination of tide, west swell and northeasterly tradewinds spun hollow, dreamy, green perfection. When breaking in proper form, the wave's three distinct bowl sections could be connected—though not without sufficient technical know-how and a fast surfboard, geared toward the constant climbing-dropping pattern that enabled a rider to keep pace with Honolua's racy walls. That board was, of course, the mini-gun, and it caught on like a wildfire. Recalls noted soul surfer Herb Torrens in *Paraffin Chronicles*, a firsthand account of the changes that altered the face of the sport: "With each new swell there would be five or six more guys trying out the mini-gun thing. Veteran older guys and rookie young guys sharing a common experience of something new. Learning the ropes, and getting in on the new era. One by one, they would all get it, and all knew there would be no going back.

"I remember driving down Front Street in

Lahaina and seeing trash can after trash can filled with scrapped fiberglass. Longboards were stripped and reshaped. Then the day came when there were more guys with mini-guns out at Honolua than on longboards. The end of an era..."

Torrens, for his part, seriously debated stripping a brand-new gun he'd had shipped over from the mainland from board sponsor Chuck Moyer; excessive length, chunky outline and full, thick rails made it ill-suited to Island standards. "But stripping a brand-new board," Torren reflects, "just didn't seem right. I should have just shipped it back, or sold it and sent the money back. Instead, I did a very selfish thing. I sold it and used the money to buy a new Brewer. . . . I regret not paying Chuck back, but I don't regret getting my next board." Torrens was fortunate enough to watch while Brewer shaped his order, a flat-bottomed 8' 4" teardrop gun shape that would've looked much like a Pipeliner with its nose sawed off. "And what a board. A magic board."

Like most anyone who's seen Brewer at work, Torrens is quick to extol the master craftsman's acute eye for detail. And in a sense, such attention to the finer nuances of board design mirrored the very changes that Brewer's riders were driving for out in the Honolua lineup. As big-wave surfers formulated increasingly specialized approaches to their quarry, shapers struggled to stay on par with what would soon be regarded as a veritable revolution. For Brewer, it was no struggle—he was at the helm.

—*Tristan Wand*

Mike Hynson Red Fin

*S*urf magazine readers of the period were officially introduced to the Gordon & Smith "Mike Hynson" model in a May 1965 print campaign and, while signature models were abundant, the Hynson was decidedly unique. These clear-finished boards were understated and elegant, with a three-stringer arrangement punctuated by double-thick outboard redwood sticks. The relatively racy template and trademark red fin made these boards instantly identifiable, even from afar.

With width dimensions running 15.5" x 21.5" x 16", these were no beachbreak slugs. Conceived from the beginning as reef and point tools, their rocker profiles were natural and moderate, with kicked noses for those ledgier moments. The rails were knife-like, but drawn high at both the nose and tail. To counteract these relative extremes, the bottom incorporated belly roll, keeping the boards loose and, by speed shape standards, forgiving. The finishing touch was a red skeg with a white center lay-up of Hynson's design. This skeg remained a hallmark of the model until the production run neared its completion, when Hynson upgraded to the newly designed "Hy-Performance" fin.

In the fall of '65, Hynson and fellow G&S cohort Harry "Skip" Frye were among a field of 24 invitees to the inaugural Duke Kahanamoku Surfing Championship, an invitational event scheduled for Sunset Beach on the North Shore of Oahu. Hynson set to work designing a hybridized Red Fin big-wave gun. Frye recalls, "Mike and I took four of the Red Fin guns with us to the Duke: two 10' 6" boards, a 10' 8" and a 10' 11". It was the first time I'd ridden Sunset, and I was so impressed with the performance of the pintail design that I remain excited by them today."

The width of the Red Fin guns was substantially narrower in relation to the "stock" models: 14.5" x 21" and a needle-like 9.75 inches at the tail. Rocker was kicked even more in the forward third, then foiled evenly aft. Rails were drawn high in the nose, producing increased belly at the entry point, transitioning through a neutral midsection and into hard, down rails in the tail. Average board weight increased by at least

9'0" X 21.5" X 16" X 15.5"

G&S HYNSON RED FIN

Foiled, knife-railed and dressed out in a Volan cloth finish with its distinctive red fin—the design was a classic and unique from its onset. Heavy nose rocker for the period, with high, drawn rails in both the nose and tail. Introduced in May of '65, this board had a three-stringer design that was all its own, and only 1,500 were made.

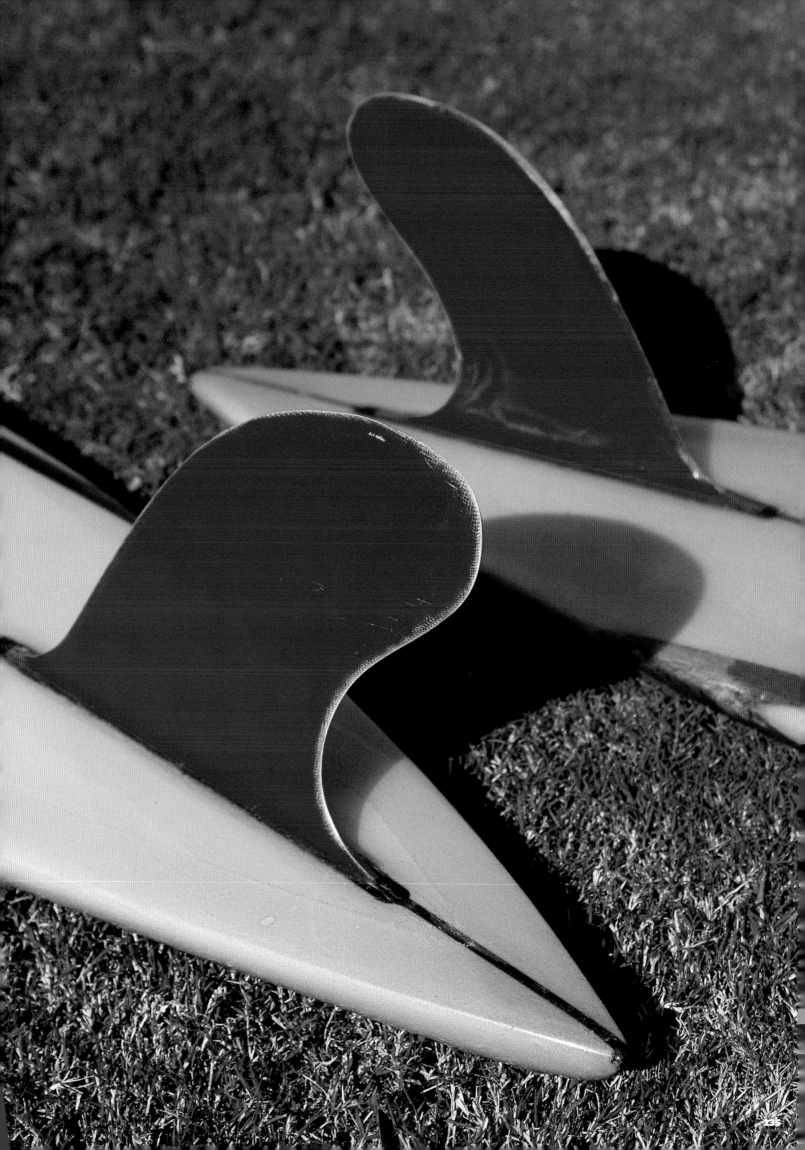

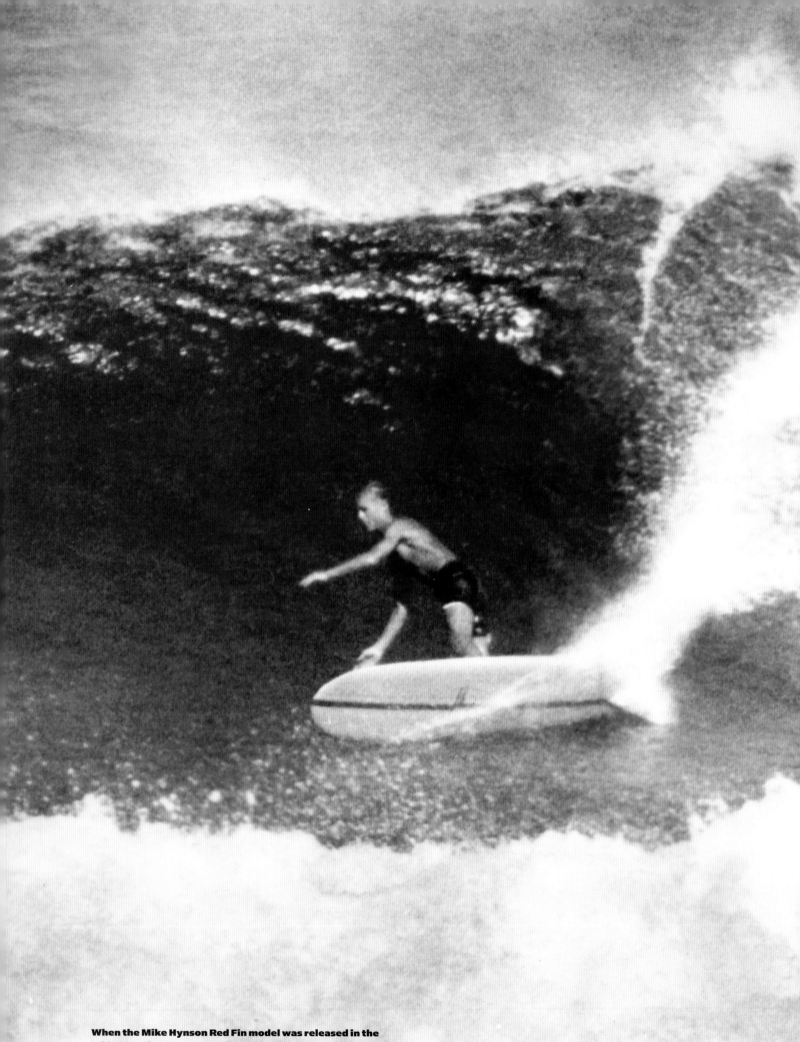

When the Mike Hynson Red Fin model was released in the
mid-'60s, signature models were all the rage. And just as
the board was easily identifiable in a surf shop, Hynson
was the same way in a lineup. Photo: Bruce Brown.

two pounds over the 34 pounds listed in the sales brochure, mainly due to almost two inches of redwood stringer. Hynson's discovery of 10-ounce Volan cloth at a boatyard further stiffened the guns.

This concern with weight became a key design element. The densest foam available was sought out, and the oversized outboard stringers afforded superior balance, providing for damping of the vibration and chatter elimination. "Quality and performance were paramount to me," recalls Hynson. "I wanted the Red Fins to be the strongest boards possible—the Rolls Royce of the industry."

The Red Fin guns reflected much of what Hynson had learned from his mentors. "Pat Curren and Mike Diffenderfer kind of took me under their wings during my early trips to Hawaii," Hynson remembers. Fine points like rocker, drawing the rail line and cutting templates were irrevocably etched into his mindset. This informal tutelage gained in the tight confines of a North Shore Quonset hut came to fruition in the Red Fins.

The boards also reaped the benefits of Hynson's charisma. "Hynson was popular and well-liked ... a leader," recalls G&S co-founder Floyd Smith. "He had everybody on those red-finned boards, and had everything going for him. If another shaper was on to something new, Hynson had to know about it. He'd head up the coast at a moment's notice to pick up on a developing trend. I was furious when he left us for Hobie [Surfboards] only weeks before the filming of *The Endless Summer*. It was Larry Gordon's cool head and compassion that brought him back after the movie was completed."

Gordon recalls that in '65 nearly half of G&S's 3,000-unit production were Red Fins, and including the carryover into '66, some 1,500 Hynson models were produced. But the guns were far, far rarer. "I built about a dozen Red Fin guns while at G&S," Hynson says. "I did make a few for Skip, Barry Kanaiaupuni, Dennis Ranny and maybe Buzzy Bent, but mostly they were for me. I took them with me to Hawaii, and usually traded them off for a plane ticket home. That's how they went into circulation." Gordon remembers an even smaller run.

Red Fin production started to wind down in '66. Lighter, wider boards were coming into fashion, and the Red Fins eventually evolved into the "HYI" and the "HYII." Hynson continued to make a precious few guns within the HY framework, and these new models reflected the new aesthetic, with color tints, a new logo and reduced stringer width. The Red Fin era had, after 18 short months, come to a close.

—*Mark Fragale*

10'8" X 21" X 14.5" X 9.75" X 3.125"

G&S HYNSON RED FIN GUN

Early notable big-wave gun makers Pat Curren and Mike Diffenderfer had perhaps the biggest influence on Hynson when designing these boards. Only about a dozen were made, and far less are known to still exist.

Tom Blake Hollow Boards

The surfboards ridden by the ancient Hawaiians were little different in essence than those still being surfed during the first two decades of the 20th century. Indeed, the surfers who helped bring about the revival of surfing at Waikiki in the early 1900s merely imitated the designs and dimensions of the solid wood boards, as did those who followed their lead in California after George Freeth introduced the sport in 1907 at Venice and Redondo, and Duke Kahanamoku gave demonstrations at Corona del Mar and Balboa in 1912. In those days there was little in the way of trial and error experimentation in surfboard design, except perhaps in testing the limits of length and thickness, because boards that were too short or too thin simply did not have the buoyancy to be paddled. That all started to change in 1926 when Tom Blake, a surfer, lifeguard and champion swimmer and paddleboard racer, began to figure out that surfboards and paddleboards would offer improved performance if only they were

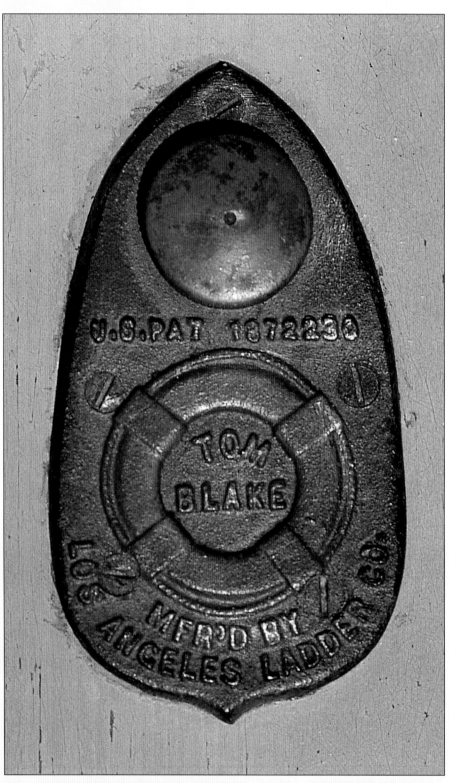

Although it looks like a military or law enforcement badge, this brass plaque is actually the mounting for a hollow board's screw-in drain plug.

13'6" X 23.375" X 5.875" X 18.5"

13'1" X 22" X 7.5" X 12.75" X 4.25"

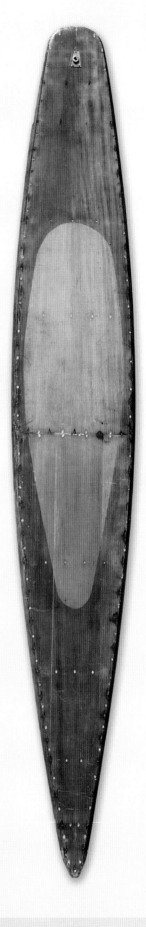

LORRIN HARRISON
HOLLOW BOARD

"Personal boards are always special. You can touch them and somehow reach out to the spirit of those countless hours the board's previous owner spent with it—in this case, a highly unique one: Harrison made this board out of redwood at the Pacific System Homes factory, then signed it personally," said board collector Fernando Aguerre.

TOM BLAKE
HOLLOW BOARD

In the mid-1920s, Blake developed a hollow paddleboard/surfboard that was later produced by several different manufacturers. The hollow design was a pivotal step toward lighter equipment. This example was produced by the Los Angeles Ladder Company, complete with a brass drain plug stamped with Blake's name and patent number.

TOM BLAKE
HOLLOW BOARD

The technique Blake used to create his hollow boards was inspired by how wood-framed aircraft wings were constructed, the result of his friendship with Gerard Vultee, an early aircraft designer and also an accomplished surfer of the 1920s in California.

lighter. As an experiment he drilled hundreds of holes through a 15-foot-long, four-inch-thick, *olo*-style board, sealing the openings with a thin sheet of wood veneer. It was a novel approach that apparently worked. Blake's board was reduced in weight from 150 pounds to a *mere* 110 pounds.

In 1928 Blake won the inaugural Pacific Coast Surfriding Championships on another such self-made board, this one only 9' 6" in length. He continued to tinker with surfboard design and construction, ultimately coming up with a series of hollow boards made around a wood frame and covered with a combination of mahogany planking and marine-quality plywood that was glued and screwed to the skeleton and varnished. He has said he got the idea of making boards in this fashion from Gerard Vultee, another avid surfer who was, like Blake, a member of the Los Angeles Athletic Club. Vultee was an engineer and aircraft designer for Douglas Aircraft (then called Douglas-Davis) and went on to found Vultee Aviation in 1936. The company reorganized in 1939 as Consolidated-Vultee and eventually morphed into Convair, along the way becoming one of the nation's most important builders of military aircraft. Blake credited Vultee with showing him how aircraft wings were made, thus inspiring the hollow board construction technique.

In 1932 Blake was awarded U.S. Patent No. 1872230 for his "Water Sled" and he contracted with the Thomas Rogers Company of Los Angeles, a maker of aircraft wings, to begin producing them commercially (and as do-it-yourself kits) in a variety of designs 10 to 14 feet in length. While some of the models were square-tailed boards designed specifically for surfing, others were made with paddle racing or lifeguard rescue work in mind, but action surf photos from the 1930s show that surfers rode waves on them regardless of the distinctions in purpose suggested by their designer. The Blake hollow boards, ranging from 45 to 85 pounds, were considerably lighter than the 75- to 150-pound redwood planks of the day, but they were notorious

for leaking, which soon added pounds to their heft and made them less buoyant, forcing surfers to make regular trips to shore so that a brass plug could be unscrewed in order to drain them. Still, during the next two decades Blake's hollow boards continued to be made under license by various companies including the Robert Mitchell Company (of Cincinnati, Ohio), the Los Angeles Ladder Company and Catalina Equipment, although many surfers of the day thought them better suited for rescue work and racing than for riding waves.

Even so, Blake's hollow boards made a huge impact on the sport. Their lightness made the hollow boards easier to transport and easier to manage for a wider range of people, opening the door to surfing for many who might never have been able to participate on bigger, heavier equipment. Furthermore, just the fact that they were innovative and came in a variety of outlines ushered in a whole new era of trial and error testing of new ideas during the '40s and '50s, leading to the now readily accepted notion of evolution in surfboard design and performance and having the right size and shape of board for the specific type of surf to be tackled. This was especially true after Blake began attaching a fin to his surfboards in 1935 and made fins a commercial option on his factory-produced boards and kits.

That Tom Blake was a genuine pioneer and visionary in the sport of surfing is evidenced not only in his work on the hollow boards and his first use of fins on boards, but in a slew of other innovations he conceived. He was, for example, an early surf photographer who designed and built his own waterproof camera housings. He also experimented with boards fitted with a mast and sail, an inflatable surfboard, a removable roof rack system for automobiles (ideal for the weekend surf warrior) and a host of lifeguarding and water safety equipment. Indeed, Tom Blake is a genuine founding father of today's surf lifestyle and industry.

—*Paul Holmes*

Catalina Equipment was one of several companies that had a licensing agreement to produce Tom Blake's hollow boards.

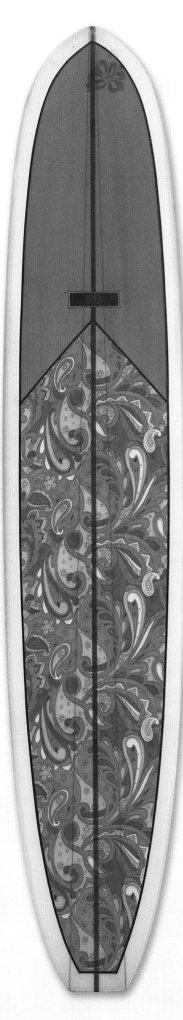

Benders and Stepdecks

The mid-1960s saw some very creative efforts made to advance surfboard design, with some surfboard manufacturers of the period likely enjoying their finest moment. Competition between board builders was keen, and, as an industry, the players may never have been stronger. That rivalry fostered an unprecedented stream of innovation and exploration toward new and better surfboards.

Among the most imaginative and novel pursuits of the day was that of flexible surfboards—one that purposely allowed the surfboard to bend and change its rocker. It was the crew at Harbour Surfboards, located in Seal Beach, Calif., who first envisioned the concept, then set to work in the direction of making it a reality.

Recalls Rich Harbour: "It was some time around 1966 that our team rider, Steve Bigler, had been surfing up the coast at Rincon in Santa Barbara (Calif). While sitting in the lineup, he caught sight of one of Reynolds 'Renny' Yater's Spoon model boards with a stepdeck. Steve got the chance to ride the board and was immediately won over. Bigler raced back to our Seal Beach shop all fired up with ideas and anticipation. His enthusiasm was contagious. Soon, Dean Elliott, Mike Marshall, John Graye and myself joined in and lent our own individual interpretations to Bigler's observations of Yater's surfboard. Except for Bigler, none of us had ever seen a Yater Spoon before. This allowed for a fresh approach to create what would become the Harbour 'Cheater.'"

The Harbour Cheater was the company's new and innovative beachbreak model. Dimensions of the early boards varied somewhat, but ultimately tuned in at 22.375 inches wide, with a 16.5-inch nose and a rather broad, 16.25-inch tail when measured on a 10-foot example. The surfboard weighed in close to mainstream standards of the day and featured a dished-out stepdeck in the forward portion of the board. In theory, the thicker area aft of this "stepped" section was set to create a

WEBER PROFESSIONAL
Attempting to follow in the success that the Weber Performer model experienced, the Professional was a flex board with both a stepdeck and dished tail. Unfortunately, the board would come nowhere close to attaining the same selling numbers as its Weber predecessor due in part to the birth of the shortboard revolution.

stressed flex point. This "hinge spot" allowed the rocker in the forward portion of the board to dissipate and bend into a flat planing area when the rider's weight was positioned forward on the nose. Carved from Walker Foam blanks, the model utilized a foam T-band stringer, composed of a one-inch foam strip bordered by a pair of one-eighth-inch redwood sticks. Depending on early or late production times, the model carried two distinctively different fin setups. Early models featured a fiberglass, routed-in speed skeg; later boards were appointed with a molded, fixed-position, non-removable polypropylene skeg.

With the boards' ability to flex, "I found myself 'Steering 10,'" claimed team rider Steve Bigler.

Adds Bigler, "I figured, let's find a way to maintain the rocker when it's needed but release it when the rider's weight is levered out on the tip to create a flatter planing area. By setting the step four inches forward of center, a cantilever point was created, allowing the Cheater to flex and surrender much of its rocker while noseriding." Bigler continues, "I was already a noserider by reputation. On the Cheater, sustained time on the nose at places like Malibu and Rincon was nothing short of remarkable. I found myself 'Steering 10,' that is, while precariously perched out on the nose, I could lean on the outboard rail while streaming in full trim and extend my tip time."

Unofficially, the Cheater was Bigler's baby, his model (Harbour Surfboards preferred to offer categorical models over signature models: Mark Martinson was the team rider aligned with the "Trestle Special"; Rich Chew was associated with the "Banana" model). Bigler favored tinted color schemes, and a variety of shades helped define the Cheater. It was a requisite that the model be finished in a full color glass tint or clear finish only.

The Cheater found a warm reception in the marketplace and additional "bender" surfboards soon came from a variety of sources. Hansen offered a model called the "Powerflex." Surfboards Hawaii unveiled the "Model A," which was promoted as an all-around, high-performance, small-wave board, but in reality it was an unabashed noserider. Dave Sweet Surfboards offered the "Flexer" and stepdeck, both employing a pliant fiberglass stringer. Steve Boehne's entry was the "Equalizer" model, featuring what the company dubbed "variable camber." Gordon & Smith's "SS" model was surprisingly similar to the Surfboards Hawaii A, differing primarily in template and thickness flow. Dewey Weber Surfboards rendered the "Professional," a thinly foiled flex board with both a stepdeck and dished tail. Con later offered the "Classic," a Bigler design. Others in the industry offered still more deviations on the theme. By 1967, the proposition first ventured by Harbour Surfboards of a flexible, relatively lightweight, diminishing rocker surfboard was now well in place and fully acknowledged.

Undeniably, few grasped and developed the bender concept further than East Coast surfboard builder John "Jack" Hannon. In conjunction with his head shaper, Bruno Huber, the two developed what was likely the ultimate contorting platform— the "Brute." Available exclusively in standard issue, black-bordered, yellow tint format, the Brute gained its own unmistakable identity.

Hannon's distant vantage point, far from California's West Coast epicenter of bender development, may have worked in his favor. Comments Hannon, "I was 3,000 miles away from where the hub of activity was taking place. My customers had differing performance requirements, and our assorted models met that need, all keyed in

for East Coast conditions." Throwing caution to the wind, Hannon elected to explore the outermost limits of benders.

Hannon's interpretation of both flexible and diminishing rocker was undoubtedly influenced by his years spent snow skiing. An accomplished skier, Hannon understood the dynamics of snow skis navigating upon uneven, earthly terrain, not all that terribly different from the surfaces of waves. Hannon figured, why place the stressed flex area within the forward section of the surfboard when it might otherwise be configured midship, further enhancing the concept of a flexible platform? Within the strange world of benders the Hannon Brute was the only surfboard that bent at both ends.

The Hannon Brute featured a "saddle" shaped into (or dug out from) the middle of the deck. This saddle spanned 16.5 inches on a 10-foot board, occupying just short of 15 percent of the deck expanse, and was far more than just a hinge point, dispersing the board's rocker at both ends while noseriding. Additionally, the saddle provided a surprising degree of comfort when sitting in the lineup between sets. Moreover, these benefits carried over into paddling; while laying prone to paddle, the surfer was allowed a relaxed posture within the recessed deck area.

Physically, the Brute was an exceptionally thin surfboard. Depending on board length, beam widths reached as high as 23.5 inches, the nose area measured in consistently close to 19.5 inches, with an ample 15.75-inch tail. To gain such breadth from standard Clark Foam blanks of the day, a two-inch foam stringer, bordered by .125-inch balsa strips, was incorporated to add width. The surfboard was so lightly rockered in its natural state that it was capable of exhibiting negative rocker during extreme duress in the water.

Hannon continues, "When we first constructed the board, we did not know how well it would work, yet it performed brilliantly, and its attrition rate was not all that different from other boards of the day. I'm not sure if you could duplicate the board with today's contemporary materials. During the era that the Brute was fabricated, foam and fiberglass were much stronger than they needed to be. The chemical industry was advancing, but the materials we operated with remain quite different from those utilized today. The period foam we were using permitted us to shape deep into the blank without the consequence of over shaping, jeopardizing that fine balance of strength to weight in the finished product.

"We had blueprinted then built the board upon faith and intuition. The prospect of the board displaying such torsional stress while remaining structurally sound remained a genuine concern. Once we got deeper into production and ongoing trials in the surf, any fears I held as to the board's durability were quickly allayed."

What is important to consider is that the Hannon Brute and the multitude of benders offered before and after it were constructed during a time when longevity and strength in surfboard construction were seen as paramount. Earlier in the '60s, these very same surfboard builders often based their entire company reputations upon the sturdy staying power of their finished products. The trade-off of durability versus performance was only now becoming realized. For the first time since the inception of the balsa wood Malibu Chips, the aspect of performance became the most highly revered quality a surfboard builder could offer a potential purchaser. The benders may have been a relatively short-lived trend, but they contributed significantly toward a surfboard that was built to perform over one that was built to last—a difficult axiom for both the board builders and surfers of the time to accept. In retrospect, it is arguable that benders were the dividing line, marking a sweeping change in which the surfboard industry acknowledged that performance was king.

Essentially, the benders were compromised noseriding boards. Although they slowly perished with the advent of shorter, high-performance surfboards, the concept of flexibility has remained fresh and vital, and it continues to be incorporated into surfboard design in new and different ways.

—*Mark Fragale*

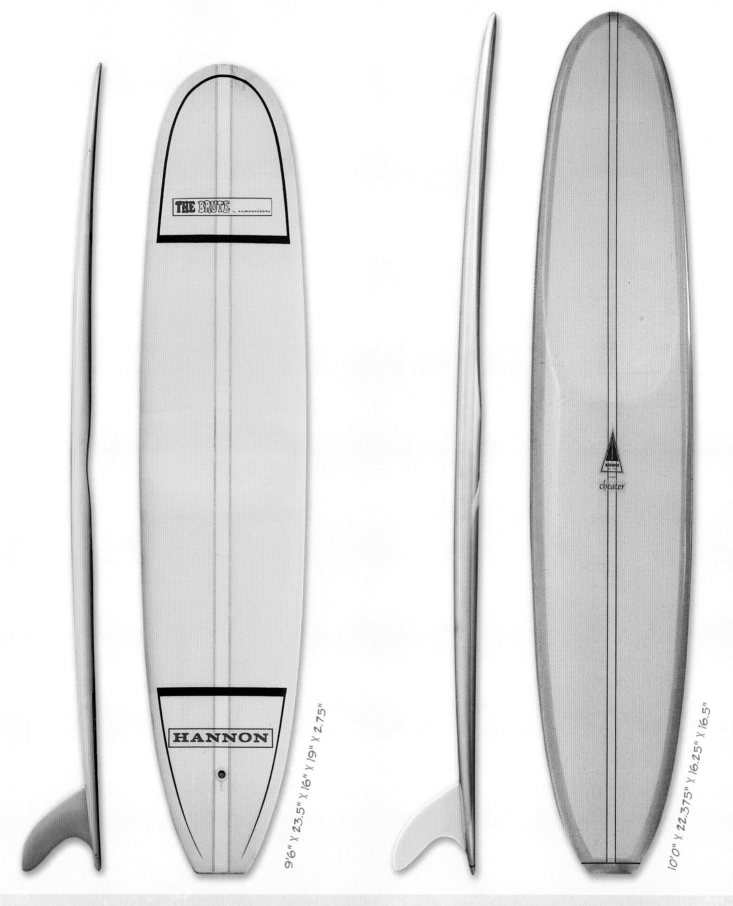

9'6" X 23.5" X 16" X 19" X 2.75"

10'0" X 22.375" X 16.25" X 16.5"

HANNON BRUTE

Boldly and defiantly contrived in Gilgo Beach, N.Y., the Brute redefined the "bender" concept and ran the blueprint of the existing standard to the extreme. Shaper Jack Hannon incorporated a "saddle" in the middle of the board so it would flex at both ends.

HARBOUR CHEATER

Although the very existence of the Cheater was premised on the Yater Spoon, this was the first surfboard to flirt with the concept of diminishing rocker. Envisioned by Steve Bigler after riding a stepdecked Spoon at Rincon, then implemented by the team at Harbour Surfboards, the design was a period milestone.

1960s Vee-Bottom

Although exact names and dates surrounding the early stages of the shortboard revolution are a tad murky, most pundits agree that California-born George Greenough set the stage sometime in 1964. During his first of many extended visits to Australia, his radically progressive style of riding waves while on a self-made 4' 10" scooped-out, spoon-like kneeboard influenced his host—local shaper Bob McTavish—to begin thinking about shorter equipment. Or more succinctly, what it would take for a stand-up surfer to emulate Greenough's fluid carving movements up and down the wave face and critical positioning near the curl, which until then had never been performed successfully on a consistent basis on traditional equipment.

This revelation led McTavish to begin experimenting with slightly shorter, thinner boards than were the norm with his main test pilot, Nat Young. But it wasn't only the equipment that was different, it was the whole mindset; the duo sought a more "involved" approach to surfing that focused on pumping the board in order to gain speed and turning in the steepest and most critical sections of a wave as opposed to merely trimming and riding the nose, which at the time was the pinnacle of surfing. In his book, *The History of Surfing,* Young explains the shift: "In chasing the curl we had begun to experiment with the power of the wave, getting involved in it as a means of self-expression."

Within a year Young won the 1966 World Surfing Championships in San Diego on "Sam," a board still over nine feet, but featuring thinner rails and a Greenough-made fin (which were based on the tail and second dorsal of a bluefin tuna), effectively announcing to the surfing world that change was not only in the air, but imminent.

The next year McTavish unveiled the "Plastic Machine"—his first vee-bottom board that featured a pronounced "V" shape rising off a rather wide 23-inch squaretail. Within months, lengths were shorn down nearly two feet from the original 9' 0" to 7' 6". The design promoted turning like no other board before it since Dale Velzy's Pig, which was

8'8.5" X 23.875" X 19.25" X 18" X 3"

KEYO
PLASTIC MACHINE

The Plastic Machine was a product of Aussie experimentation with deep vee, largely influenced by George Greenough's innovative kneeboard and fin designs. This type of board was ridden by Bob McTavish in the Duke Kahanamoku Invitational at Sunset Beach in 1967 and was a major step toward the "shortboard." The board weighed 23 pounds.

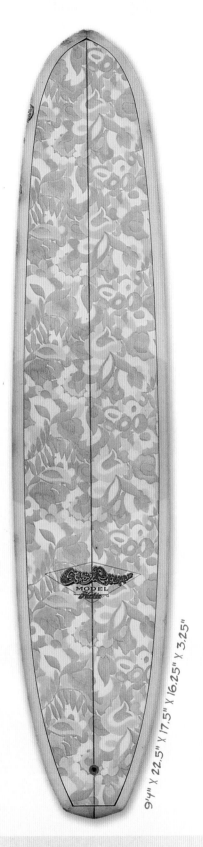

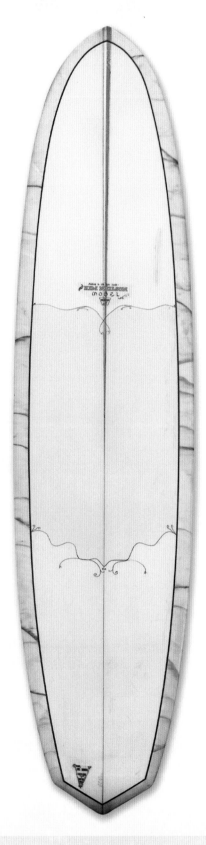

9'4" X 22.5" X 17.5" X 16.25" X 3.25"

HOBIE GARY PROPPER MODEL

The GP model was one of the biggest sellers in history, taking on several forms in its design since debuting in '66 as a noserider and being promoted by the East Coast's hottest performer. This is the precursor to the GP Wedge done with East Coast surfboard maker and marketing ace Dick Catri.

CAMPBELL SURFBOARDS

With its psychedelic design and pronounced vee-bottom, this Campbell board is a perfect example of the typical goings-on of the era when the surfboard industry was packed with shapers trying to find their niche with a plethora of board shapes to work with.

HOLMESY SURFBOARDS

This Kim Neilson model was shaped by Bill Holmes during the latter part of the '60s in the wake of the Bob McTavish-inspired vee-bottom.

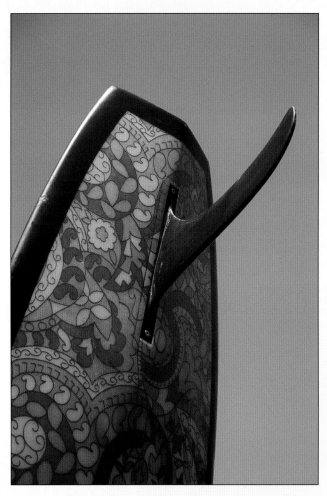

The very pronounced vee of the earliest examples quickly gave way to less radical versions as surfers battled with the boards' propensity to "track."

Returning to the winter of '68 and that historic Honolua Bay session, one of the participants that day was a young Dick Brewer. Right around the same time that McTavish and his crew were Down Under experimenting with the vee-bottom, Brewer was living on Maui working on what would later be known as the "pocket rocket" or mini-gun. These too were in direct contrast with what most shapers were doing back then. After seeing how well the shorter boards performed, Brewer cut as much as two to three feet off of the length of his boards, drastically pulled in the width of the tail and turned down the rails, making a medium- to big-wave gun design that aesthetically at least is still familiar to today's surfer.

—*Sean Preci*

especially radical considering tipriding was all the rage in the early to mid-'60s. Yet, as McTavish and Young soon found out, the vee-bottom did not work well in large Hawaiian surf—the ultimate proving grounds of the day. Not giving up on the boards, McTavish and Young took them to Maui's Honolua Bay, where in perfect six- to eight-foot waves the vee-bottom truly shined.

The session was recorded by Australian filmmaker John Witzig and included in the movie *The Hot Generation* released in 1968 and subsequently shown all over the world. By 1969 the radical vee-bottom was abandoned due to a phenomenal surge in surfboard design in search of the next big breakthrough. That same year, Witzig's follow up film, *Evolution*, had solidified not only the new approach to surfing, but also marked the first time that Australians broke from following the California lead and came up with their own original ideas in surfboard design.

While the radical vee-bottom was quickly superseded, the bottom contour concept survived in various reiterations.

Yater Spoon

*I*t's certainly debatable as to which mainstream film that featured surfing in the story line or as a subplot drew the largest audience. Was it *Gidget*? *Big Wednesday*? *Fast Times at Ridgemont High*? Or was it *Blue Crush*? For what it's worth, you'd be wise to put your money on *Apocalypse Now*—director Francis Ford Coppola's unforgettable Vietnam War epic. Nominated for several Academy Awards in 1979 (it earned two), *Apocalypse Now* quickly became the standard by which all other Vietnam War-inspired films were measured. It also gained the notoriety of introducing one of the most bizarre characters to ever grace the big screen. Thanks to co-scriptwriter John Milius (who also directed and wrote the screenplay for *Big Wednesday*) it just so happened to be a surfer.

In a film chockablock with memorable characters, Col. Kilgore—who was portrayed by Robert Duvall (and the only actor in the film nominated for an Academy Award, as Best Supporting Actor)—will forever be remembered as the bomb dropping, Wagner playing, napalm loving lunatic who took out an entire Vietnamese village in order for him and his men to catch some waves. All of this despite the pleas of one of his more rational peers that the beach he planned on taking the next morning was "Charlie's Point," or heavily guarded by Vietcong soldiers. Kilgore heeded these warnings by uttering perhaps the most memorable line ever accredited to a surfing character in cinematic history: "Charlie don't surf!"

Yet, other signs of Kilgore's seriousness about the joys of riding waves were his overt displays of loyalty—not only did Kilgore call for his beloved 8' 6" Yater Spoon as part of the preparation for the bombing mission, but he sported a Santa Barbara Surf Shop T-shirt at the barbecue where the scheme was hatched.

In 1959, after receiving ample tutelage in Southern California during the mid- to late '50s from Dale Velzy and Hobie Alter—two innovators of

YATER SPOON

This board was one of the 90 limited edition *Apocalypse Now* boards that Reynolds "Renny" Yater made. Each sold for $3,000 apiece. In the 1979 film the board belonged to the Col. Kilgore ("Charlie don't surf!") character.

modern surfboard design and construction— Reynolds "Renny" Yater moved to Santa Barbara, Calif., opened Santa Barbara Surf Shop and started Yater Surfboards. He quickly became famous up and down the coast for his quality surfboards. In keeping with the "quality over quantity" credo, Yater purposely kept his operation small scale as opposed to the mega-surfboard manufacturers of the early to mid-'60s such as Dewey Weber, Greg Noll and Hobie.

By the time Yater introduced his now-famous "Spoon" model in 1964 he was already a highly regarded shaper and respectable member of the local surfing community, founding and serving as the first president of the Santa Barbara Surf Club. Reflecting on the time period, Yater notes: "The boards back then [the early '60s] were heavy and hard to turn." After some thought, Yater came up with a way to simultaneously trim the weight and increase maneuverability. "I asked myself, 'What good does the nose of the surfboard do?' so I got rid of the weight by scooping out the nose." This reduces the "swing weight," making the board turn easier.

There was also an added benefit Yater had not originally thought of: "Not only were they good turners, but you could work the nose better while noseriding—since it stood lower in the water the board was easier to control [while riding on the front one-third]." Another aspect of the Spoon that made it so different, and coincidentally where its name originated, was its George Greenough-inspired cutaway fin. Most period fins were glassed all the way to the board's tail, often hanging over

Reynolds Yater, sitting with typical equipment of the day, looks out at empty waves breaking at The Ranch. Photo: John Severson.

the edge a couple of inches. Watching his Santa Barbara neighbor in action, going places on waves never imagined before, Yater moved his Spoon's fin forward and cut away the back segment, making it resemble the bluefin tuna-influenced fins that Greenough based his design on.

With this final adjustment, the Yater Spoon became recognized as *the* board of choice at spots like Rincon (where most of its test runs were administered), Hollister Ranch and Malibu. According to Yater, "the Spoon was designed for point surf and hollow waves, it didn't work well below Malibu." One Malibu legend in particular could attest to this. Soon after the Spoon came out in the spring of 1964, Yater gave one to Miki Dora to try out. Dora loved it so much that he continued to ride his Yater Spoon even after Greg Noll Surfboards came out with his "Da Cat" signature model. Other Spoon supporters included Joey Cabell, filmmaker Bruce Brown and Gordon Clark of Clark Foam.

As further proof of Yater's dedication to finding that perfect ratio between a surfboard's weight and strength, in the 1990s he was one of the first renowned shapers to endorse epoxy-composite surfboards. Since then, Yater has taken the process one step further by making epoxy-composite Spoons featuring wood veneer and handcrafted abalone cutouts of sea creatures done by artist Kevin Ancell. Plus, bringing one more aspect of the Spoon full circle, Yater released a very limited number of replicas of Col. Kilgore's board featured in *Apocalypse Now*. Except now, thanks to globalization, in some cases Charlie does surf.

—*Sean Preci*

Malibu Chip

By the end of the 1940s, a handful of Southern California surfboard builders was embarking upon a quest for better performing surfboards. Design and construction had changed little during the two decades before World War II, and the solid wooden plank-style boards that were standard issue for those who did not favor Tom Blake's hollow boards had, in fact, changed little since the days of the turn-of-the-century surfing revival in Waikiki.

The post-war surfboard makers were still very few in numbers at a time when there was no big market, and most of them had been shaping and re-shaping old planks and, in the process, were beginning to discover how changes in outline, bottom contours, rocker and rails could change a board's performance characteristics. As fiberglass became commercially available, surfers quickly adapted the new material to board building, in turn giving rise to the use of balsa wood as a surfboard core that was easier to shape than redwood, lighter and, once wrapped in fiberglass, more durable.

Santa Monica-based Joe Quigg turned out a state-of-the-art series of balsa and fiberglass boards in the late '40s that were intended for a group of young female surfers at Malibu.

"I'd been building girls' boards since early '47," recalls Quigg. "It helped the girls to leave the tails wide. I'd put what I called easy-rider rocker in them. They were real easy to ride. A lot of girls learned how to surf on those boards in just a few months."

One of the first such boards that Quigg made went to Darrylin Zanuck, daughter of Hollywood movie studio mogul Darryl F. Zanuck, who owned a house on the beach at the Malibu Colony. As it happened, Darrylin was dating local lifeguard and accomplished surfer Tom Zahn at the time, and the better performing board, although still long at around 10 feet, was borrowed by Zahn and put through its paces at

JOE QUIGG

"This balsa board was shaped for a woman, but guys would get on it and start ripping. This is the first surfboard design that encompassed turning radius— it has all the design elements of a present-day longboard. This design was the forerunner of the Malibu Chip," recalled board collector Spencer Croul. The board weighed 32 pounds.

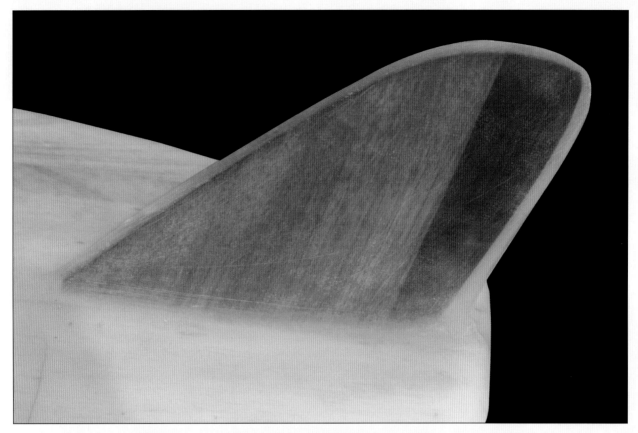

The Malibu Chip was notable for incorporating a larger fin than traditionally had been used in the past.

Malibu with rather impressive results. When the couple split up, according to local lore, the so-called "Darrylin board" had to be liberated from Zahn, so much did he like it.

But the Darrylin board was merely a precursor. As the decade drew to a close, Quigg and a group of other Malibu regulars including Matt Kivlin and Dave Rochlen went to Hawaii where they saw the locals riding the pointy-nosed, narrow-tailed Hot Curl boards, inspiring them once again to recognize how design and performance were related and how experimenting through trial and error could have a dramatic effect on surfboard handling.

Back on the mainland on the cusp of the '50s, as more and more female surfers began to take to the forgiving pointbreak waves at Malibu, Quigg made a series of balsa and fiberglass boards that had similar design features to the Darrylin board but were smaller and easier to manage for the women. Among them were some of the best female surfers of the day, such as Vickie Flaxman and the future Mrs. Quigg, Aggie Bane.

The boards featured more pointed noses and wide tails, added rocker, flatter bottoms, more egg-shaped rails and a large fin or "skeg." At around nine feet, lighter and better performing, the scaled-down designs were quickly adopted by some of the local male surfers, and opened a new chapter in the way surfers rode waves characterized by pivot turns, cutbacks and noserides. The quicker-turning boards were also much more suitable for surfing at fast-breaking beachbreaks, helping to increase the range of surf spots that could be successfully ridden.

"One day all of us Malibu guys, about three car loads of us, had taken a trip down to Windansea to go surfing," recalls Quigg of the Fourth of July weekend in 1950. "We'd arrived at night and taken all the boards out of our cars so we could sleep in there in case it rained. In the morning this local guy, Art Cunningham, sees our boards, which had rocker, and were curvy and were yellowish because that's the way the resin turned, and he sees our boards and says, 'Wow, look at those potato chips.' That's how that name got started."

Dubbed Malibu Chips, the balsa and fiberglass boards represented a milestone in surfboard design and a major turning point in design direction thereafter.

—*Paul Holmes*

Modern Fish

It's only fitting that one of today's most beloved shapes—the Fish—takes cues from a creature of the sea. After all, regardless of which school a waverider identifies with, shortboard or longboard, we're all essentially "fish out of water" when we jump into the ocean armed only with a hand-fashioned slab of foam. But seriously, bad jokes aside, the modern-day Fish has emerged as something of a common ground, embraced by riders from both ends of the spectrum. And like their namesake, these ubiquitous, small-wave speed machines come in an array of shapes and sizes, from stub-nosed twinners to pulled-in quad-fin rockets.

The Fish is a mutt.

So named for the shape of its tail, this one-time '70s throwback has emerged *en masse* thanks to the retro resurgence of recent years; and borrowing from a host of colorful innovators throughout surf history, fish have found new life with today's youth (and youthful at heart). Because truth be told, while popular amongst longboarders for their superior paddling power and float relative to the tri-fin thrusters they preceded, they were never intended for laid-back Sunday afternoon cruising. The idea was to produce a vehicle that allowed for

The classic twin-fin design provided riders a wider planing surface, which translated into increased speed in waves under six feet.

quick, radical direction changes and cutbacks impossible on a single-fin. And it was precisely for this kind of surfing that San Diegan Steve Lis earned his reputation.

Winner of the 1970 U.S. Championships in kneeboarding, Lis was widely credited with the development of the original fish-style twin-fin back in 1967. But as an underground hero who rarely strayed from his localized Sunset Cliffs stomping grounds, Lis has often been overlooked in the larger scheme of surfboard evolution. Presumably because, it appears, of the high-profile A-list who took up the reins and adapted the shape to stand-up surfing: David Nuuhiwa, Reno Abillera, Ben Aipa (with his fish-influenced swallowtail "Stingers") and, of course, four-time world champ Mark Richards. Each left his own unique stylistic mark on the Lis blueprint, helping to make possible the range of variations that presently fall under the umbrella. Once taken to mean a short, split-tailed twin-fin, the term "fish" nowadays refers to a loosely defined, amorphous family of shapes—almost a category of surfboards entirely unto itself.

Certain shapers like San Diego legend Skip Frye have kept alive the traditional wide-tailed, flat

LINDEN SURFBOARDS

In an effort to find alternative surfboard building materials, Gary Linden constructed this surfboard from agave and polyurethane foam. The two-tone color scheme represents the combination. The design itself is based on an early '70s Fish, complete with twin keel fins made of wood.

The "Speed Dialer" fin setup (shown here) was introduced by veteran Fish shaper Rich "Toby" Pavel.

rocker template of yesteryear. Citing tracking problems, many of today's retro enthusiasts, Joel Tudor and Tyler Hatzikian among others, have meanwhile issued their own subtle refinements. And hardly a boardmaker out there is without a fish shape of some sort. Many resemble shortboards with respect to thickness and overall dimensions, even making use of a third "trailer" fin, but nonetheless feature split-tails or swallowtails and wide, blunt noses; others are large, chunky and have more in common with a "big guy tri," yet still retain the defining characteristics of a fish. In spite of the seemingly endless rash of adaptations contemporary a-fish-ionados have brought about, the inherent purity of these ubiquitous boards remains. Incapable of holding in the wave face like a tri-fin shortboard, fish are not suited to particularly large or critical surf. Nor can one execute the wide, smooth arcs possible on a single-fin. What they are good for is fun—and lots of it.

—*Tristan Wand*

Pavel took two low-aspect ratio fins (which most traditional fish have) and split them into four high-aspect ratio fins.

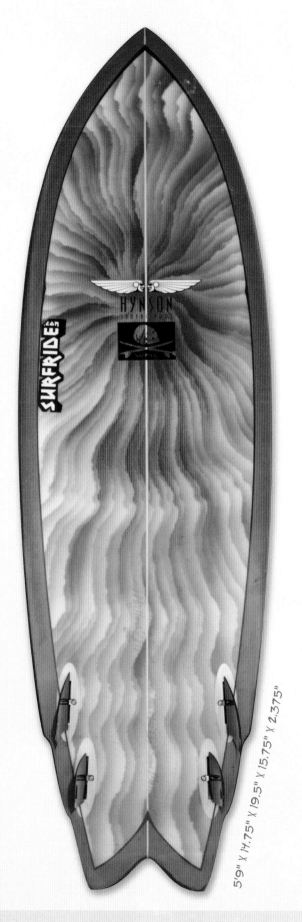

5'9" X 14.75" X 19.5" X 15.75" X 2.375"

MIKE HYNSON
HY STING

This model was shaped by Hynson himself. The quad-fin setup deviates from the Fish although still has the thickness and volume of a typical fish or retro board, but it's been adapted for riding in "juicier waves," according to owner Sean Mattison.

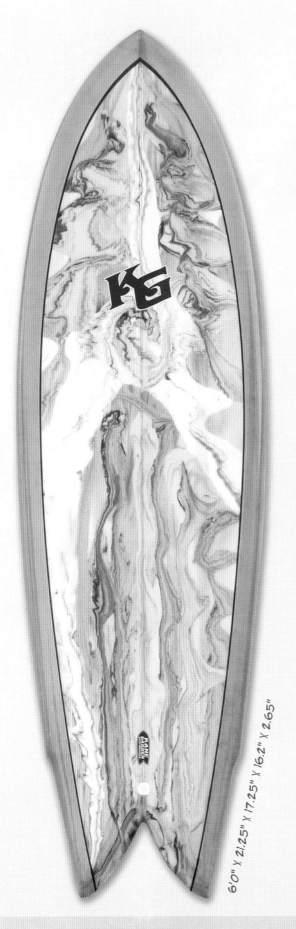

6'0" X 21.25" X 17.25" X 16.2" X 2.65"

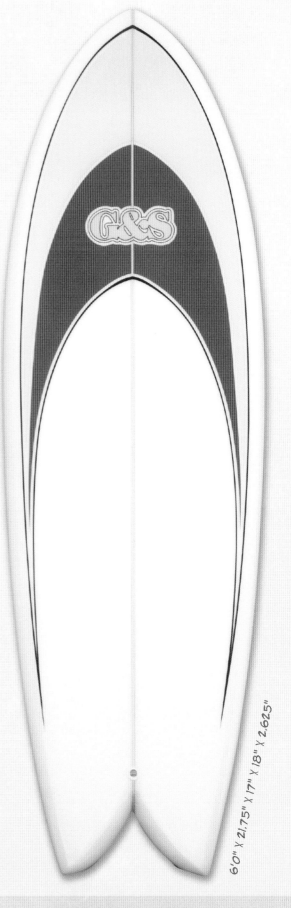

6'0" X 21.75" X 17" X 18" X 2.625"

KANE GARDEN TWINZER FISH

San Diego's Kane Garden Surfboards is just one among many SoCal surfboard manufacturers to offer variations on the Fish design. This twinzer model was shaped by Larry Mabile.

GORDON & SMITH

San Diego-based Gordon & Smith Surfboards was a stone's throw from the epicenter of the Fish design's inception along Sunset Cliffs, making its fish models as relevant as anyone's.

Miki Dora Da Cat Model

Three blocks inland of Southern California's Hermosa Beach Pier, during the spring of 1966, Greg Noll—one of the most powerful and respected surfboard manufacturers of the time—found himself deep in negotiations with the sport's then most controversial figure, Miklos Szandor Dora III. The objective of the bargaining session was for Greg Noll Surfboards to begin making a model that was officially designed and endorsed by the top-name surfer. It was a late start for such a project—Noll was among the very last in an exceedingly competitive field of high-volume builders to do so. Nonetheless, the tardy entry into this specialized aspect of surfboard merchandising went on to deliver unanticipated rewards, partly because both the new surfboard model and the personality associated with it were far from ordinary.

Noll's success in collaborating with Miki Dora to create a signature model was an amazing accomplishment, as Dora's repugnance for commercial aspirations and endorsements in surfing were well known. But the two highly esteemed surfers had been friends for quite some time and their mutual respect factored heavily into the deal. If indeed Dora were to "sell out" (something that many of his diatribes in the surf media had railed against), whom better to do it with than Noll?

The countless escapades and sagas of the rogue

The decision to team up with Miki Dora under his Greg Noll Surfboards label proved to be a wise business move for Noll.

surfer who came to be known as "Da Cat" defy corroboration: Dora's unabashed contention to live life on his own terms, apparently with little or no concern for the results, earned him legions of loyal admirers, droves of vehement detractors and a multitude of diligent lawmen in hot pursuit. The Dora mystique (along with his uncanny ability to ride waves) was almost mythical, and his bad boy, outlaw image only added to the enigma—and to the appeal of his signature surfboard—lore that continues posthumously even today.

The story of Greg Noll Surfboards' Miki Dora "Da Cat" model is as much about an ingenious and cutting-edge advertising campaign filled with social and political implications as it is about the surfboard and Dora's affiliation with it. Noll and Dora had launched a decidedly different surfboard into the marketplace, and its entire package of promotion, replete with one-sided sentiments and controversial assertions, rendered quite a fuss in its day.

The model swiftly attained cult status with surfers of the day, based on its reputation as both a well-engineered waveriding tool and a weapon to fight off the masses clogging the wide-open wave fields that Dora once identified as his own. Through the grand illusion of the advertising, Dora at times focused the media blitz toward those special individualists who held the purity of the sport paramount above all else, giving the board an

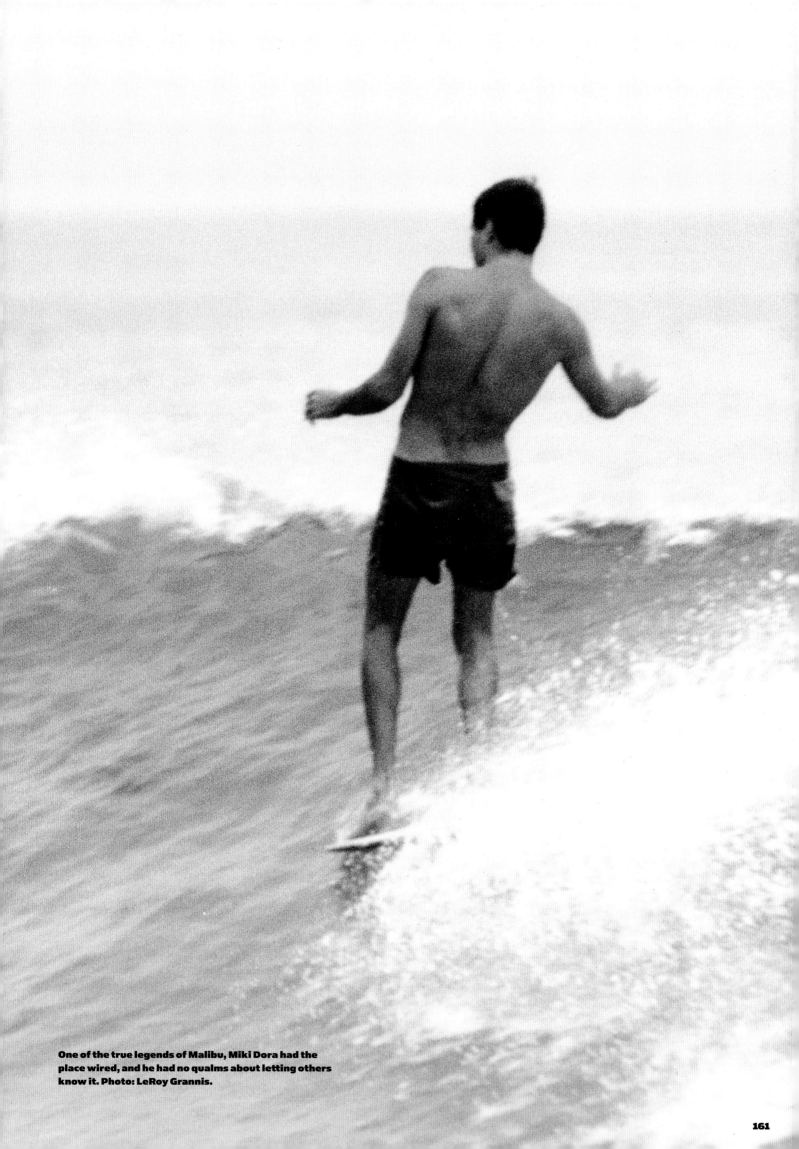

One of the true legends of Malibu, Miki Dora had the place wired, and he had no qualms about letting others know it. Photo: LeRoy Grannis.

underground identity that eventually made it an icon. A non-stop stream of surfing periodicals carried the message of Dora's musings in an extensive and well-funded campaign that was compelling at the time, and still is today.

Dora and Noll's creation hit the marketplace with unexpected intensity. Early installments of the well-known marketing campaign appeared in *International Surfing Magazine* and *Surfer*. One such ad appeared framed in a red background with a photo collage of Dora in and out of the water with the model, accompanied by images of the surfboard in production at the factory. By this time, Noll and company were in a new 20,000-square-foot Hermosa Beach, Calif., factory and ready to bang out product in volume.

Noll and Dora were like two mayflies, working tirelessly to produce the final version of the model in a short six- to eight-week period. Together they made about five prototypes before Noll, needing to check out the measurements on one of the boards, discovered that Dora had sold each of them after testing, pocketing the cash. Noll laughs off the episode: "The harmony and accord we reached during the R&D phases of the project would surprise most people; it surprised us, too. We saw eye-to-eye on the details of the construction throughout the venture. The only real point of contention between us during the entire task was the skeg. Miki envisioned the fin to be this full-blast, phallic-looking thing that likely lacked the necessary swept area to do the job. We settled on the narrow-based speed-fin that was unique to the model. It was a good thing."

When it came time to name the new creation, Noll and Dora put their heads together to think of an appropriate title. "Once we came to an agreement to launch the model," explains Noll. "We were sitting around doing our best to decide what best to name the surfboard. I came up with 'Da Cat,' as Miki was well known for his feline grace while surfing. Dora snorted, 'Oh great! Next thing you know they'll be calling me Puss 'n Boots.' But we thought about it and in the end Miki liked it. After that, the nickname really stuck."

The first series of Da Cat models began filling dealer inventories by April 1966. Its selling point was the distinctively sculpted deck, and that it was specifically designed to be shorter, wider and lighter than other surfboards of the day. The model's primary feature of a deep scooped-out area forward of center was quite different from other stepdeck surfboards of the time. A high center spine, bilaterally tapering into an evenly dished-out nose area on the deck defined the uniqueness of the board. Thin rails drawn high from the bottom in the forward portion of the board converged with lots of rocker flow, and the bottom contours allowed for a fine-foiled shape with discernible belly. The resulting scooped high-entry permitted clean ingress without pushing water.

Dimensions of a typical 9' 8" Da Cat measured in with a 17-inch nose, a wide point of 22.5 inches and a squared-off tail area of 16 inches. Thickness aft of center averaged 3.5 inches, further amplifying the progressively thinned and foiled nose area. The stringer design was a thin strip of .25-inch redwood that staved off unwanted weight and provided an excellent strength-to-weight ratio, though the double 10-ounce glass job more than made up for lost weight. The model featured its own distinctive skeg, an exaggerated speed-shape fin with an 11.5-inch base and a bell-shaped bottom 10 inches deep, routed into the stringer and glassed into a fixed position.

Early boards, using 10-ounce Volan cloth top and bottom, had either clear or pigmented lay-ups, employing panel designs of differing widths. The clear lay-up from the stringer to the tape-off where the color began ranged from 1.5 inches to 5.5 inches. The color then wrapped around the deck to the bottom of the board using the same border measurements utilized on the deck. The repetition of color schemes only added to the model's identity. Some of the more exotic designs included a black pigment version, thus called the "Black Cat." A precious few featured cat paw prints beginning at the aft-positioned logo and running all the way forward to the tip of the nose; others had fabric inlays.

Surfboard fabrication at Noll's California facility was accomplished under one roof. Raw materials

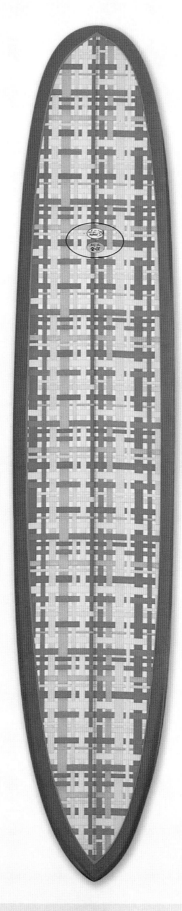

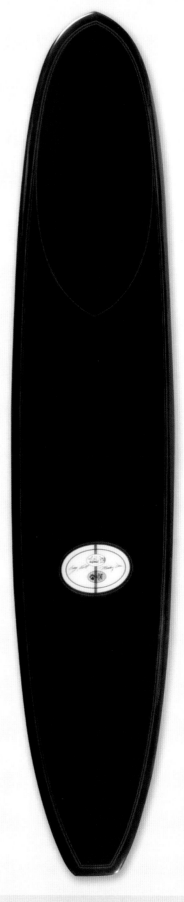

DA CAT

Surely at the top of anyone's "most popular" models list, Miki Dora's signature model was produced by Greg Noll Surfboards, and could be acquired for around $175 in 1966. It featured a scooped out area on the nose that intended to give more control when on the tip and make turning easier by reducing weight and volume in the forward third of the board.

PLAID CAT

The Da Cat model was produced in a variety of sizes and colors, all of which have become highly collectible. This pintail version, the second generation of the series, was available in some striking fabric permutations and with a removable ABS plastic fin.

BLACK CAT

Possibly the most highly desirable among collectors is this all-black version of Da Cat. Ironically it could be seen as a cynical marketing ploy since it was virtually impossible to keep wax on the deck of such a "hot" color except in the coldest of climates.

were delivered through one door and finished surfboards came out the other. Unlike the overwhelming majority of custom surfboard producers who bought their polyurethane foam cores through suppliers such as Clark, Walker and Foss, Noll blew his own foam. With the exception of Dave Sweet, who fostered the medium, Noll was the only other big name custom surfboard label of the time to do so consistently.

It wasn't long before the ad campaign gave way to more controversial proclamations for which the series is best remembered. Noll and Dora's creation was by now beginning to be perceived as a surfboard with an attitude. Noll granted Dora the control to wage the ad campaign as he saw fit. In doing so, Dora gained a media sounding board to espouse all that he saw as right or wrong with the state of surfing and the pop culture that rallied around it. Noll recalls, "More than a few had to be toned down to be made presentable for publication." The ads, however, were effective, as Noll gained a glut of newfound market share. During the ensuing years the company pre-sold almost every Da Cat surfboard it produced.

With so much energy generated by the enormously successful ad campaign, the surfboard took off. The non-conformist outlaw image became a symbol of a special kind of freedom, with no obligations to society's whims and dictates. The Da Cat model offered belief in escape from the ordinary. Dora reiterated the message with each new advertisement.

During the closing months of 1967 and leading into the early months of 1968, surfboard design was changing at a rapid pace. Surfboards had become lightweight, rails more foiled, rocker profiles refined and fins perpetually reducing in size. The culmination of all this condensed knowledge allowed for advancements so sweeping that select boards produced during those scant few months preceding the shortboard revolution arguably remain postmodern today.

It was in the spirit of these changes that Noll and Dora initiated a second-generation Da Cat by the fall of '67. The thickness, rocker and weight of the all-new pintailed version were substantially reduced. Average dimensions for a 9' 8" carried over a 17-inch nose, while beam width dropped to a slim 21 inches, and tail measurements decreased to 15 inches. The new aesthetic featured fresh positioning for the model's special logo laminate, now located forward of center on the deck, as well as a 10-inch-deep by 10.5-inch-base molded ABS plastic removable fin unit, which became standard in all Da Cats. Noll's fin system fared well, shortchanged only by the absence of any provision to adjust the fin fore or aft. Additionally, the model had the option of a channel bottom available—two concaved areas on either side of the tail. The liberal use of brightly colored fabrics added cosmetic appeal in the showroom and became commonplace during the second-generation run.

The Da Cat series sold especially well in California and found respectable sales at the company's Hawaii-based outlet. But no area in an otherwise fragmented marketplace embraced the Da Cat model more receptively or consistently than that of the East Coast, where, ironically given the board's Californian roots, the vast majority of Da Cat boards found their homes. Moreover, at a time when East Coast sticks were retailing for an average price of $160, Da Cats were pulling in just shy of $200, making them among the most expensive surfboards of the day.

Noll's success in marketing his product on the East Coast was predicated in large part on his ongoing relationship with a block of dealer networks that ate up entire drafts of his company's annual production. In New Jersey, particularly, Noll's lock on the market was extraordinary, and throughout the Garden State, Noll's agents sold Da Cat models in bulk. It is safe to say that there are more Da Cat model surfboards per square mile salted away in the sleepy beach town hamlets of New Jersey than anywhere else on earth.

When the first longboard epoch approached its inevitable demise with the advent of shortboards, Noll and Dora made no provisions for Da Cat to continue in production. The board belonged to another time and place, and its creators were astute enough to realize that fact.

—*Mark Fragale*

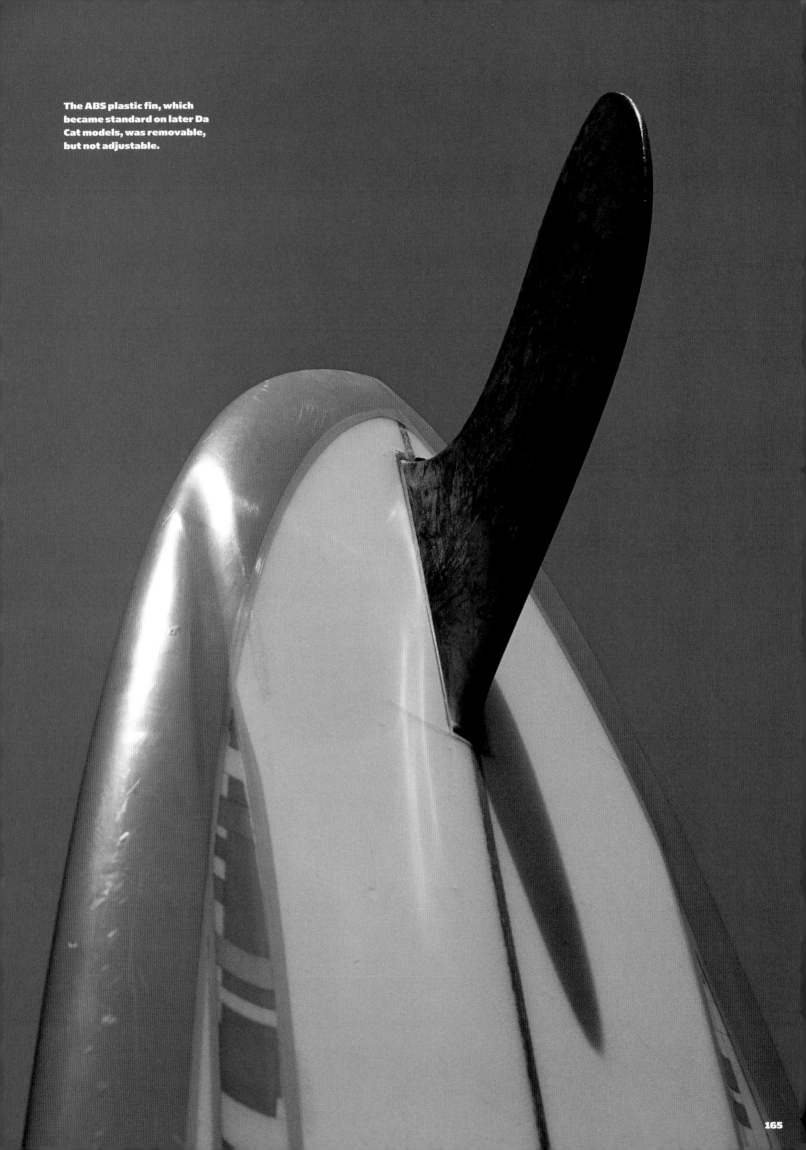

The ABS plastic fin, which became standard on later Da Cat models, was removable, but not adjustable.

Al Merrick Pro Boards

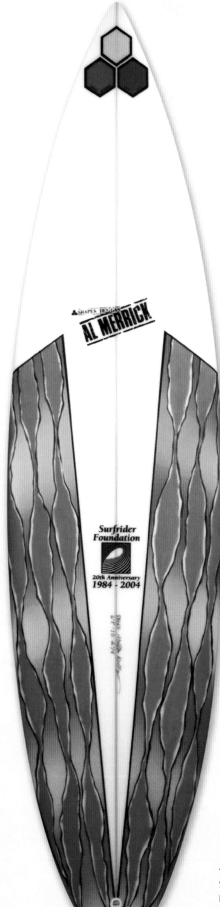

*L*ooking back now it appears rather innocuous—a backside air launched over a brownish, dumping closeout-section. But in 1992, the grand finale to the 130-second opening action sequence of Taylor Steele's film *Momentum* signaled the beginning of something big: the New School—with soon-to-be long-term dean, Kelly Slater—had officially opened for business.

Any discussion of professional surfing in the '90s begins and ends with Slater; it's as simple as that. Sure, elder statesmen Tom Curren, Mark Occhilupo, Damien Hardman and Derek Ho each captured a world title while in the limelight of their careers during the decade, but no one surfer did more for the sport or had more influence on the equipment people were riding than Florida's favorite son.

In an era that featured a full-on longboard surfing revival, an explosion of hospitable shapes ranging from the big guy tri to eggs and midlengths, as well as a resurgence in modified fish designs, the prototypical Slater "glass slipper" design could be found nearly everywhere. Typical measurements ranged from 6' 0" to 6' 4'" in length, 18.25 to 18.5 inches at the wide point and an astounding 2.125 to 2.25 inches thick, prompting the "potato chip" moniker given to period shortboards. But of note here is the fact that so few of its owners, *sans* professional and expert waveriders, could actually ride the things, prompting the famous footwear-alluding nickname.

Not since the '70s had so many surfers purchased and ridden the wrong board—back when seven-foot-plus ultra pinned-out, narrow guns with hard, down rails designed for Pipeline were being ridden regularly in Californian slop, back when Gerry Lopez was a god and his famed red Lightning Bolts defined a generation. Slater's boards were thin, narrow and shaped with so much tail and nose rocker that if you weren't constantly positioned in the wave's pocket the thing simply bogged down; in semi-flat, soft waves without a trough, forget about it. Selling these "K-boards" and others of their ilk in surf shops was like opening a Formula One racecar dealership across the street from the DMV.

AL MERRICK KELLY SLATER MODEL

This board is a replica of the one that then 18-year-old Kelly Slater won the 1990 Body Glove Surfbout on—the richest prize purse in competitive surfing at the time—to capture his first victory as a professional, ushering in an unparalleled chapter in surfing history.

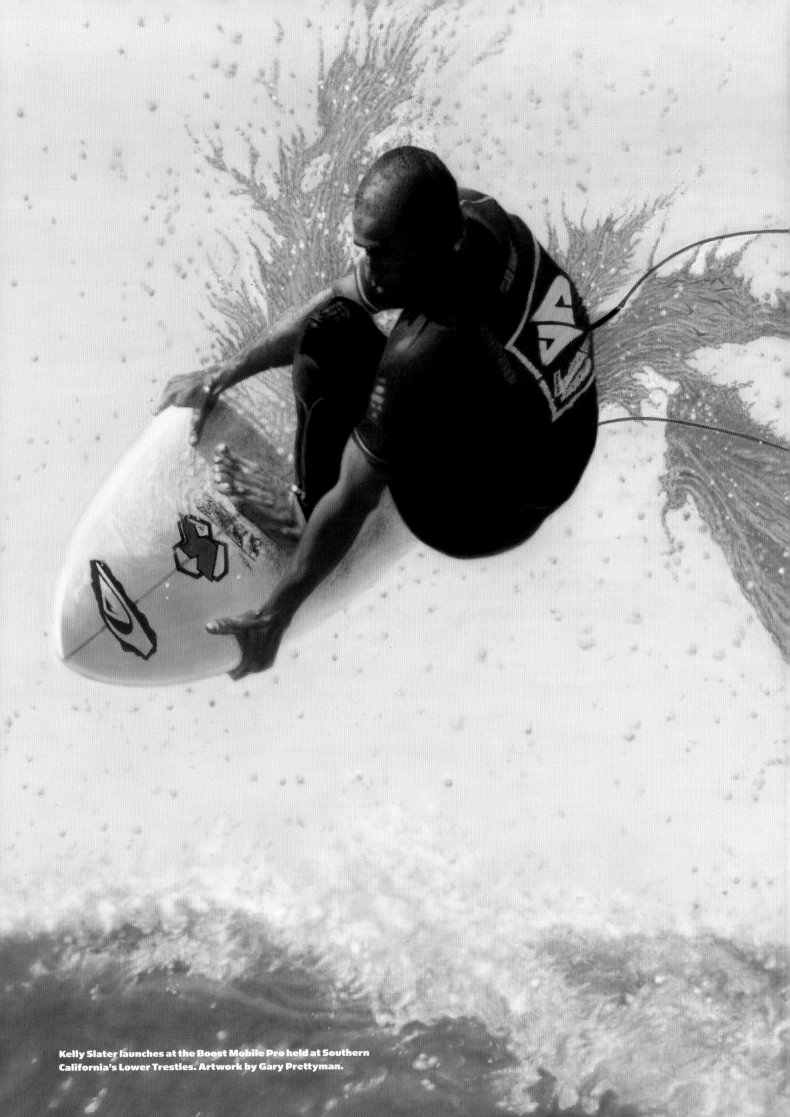

Kelly Slater launches at the Boost Mobile Pro held at Southern California's Lower Trestles. Artwork by Gary Prettyman.

And like Lopez before him, Slater's style, especially the equipment he rode, became the most oft-emulated in the land. Which is understandable, since between 1992 and 1999 Slater was considered by most as the best surfer in the world, period. The second best during any given year usually performed at such a lower level that most of them are remembered as mere asterisks or just a speed bump on the way to another inevitable Slater victory lap, except perhaps Rob Machado, who, during the unforgettable '95 Pipe Masters showdown, pushed Slater to an even higher level of waveriding. As close friend and peer Shane Dorian notes in *The Moment*—a film released in 1998 at the height of Slater-mania—"It's amazing that he can have no one to look to for an influence anymore, because he is far and away the best surfer in the world. So it's hard for him to look and go 'Gosh, what's Kelly doing?' because he is Kelly."

Kelly Slater surfing in the early rounds of the 1990 Body Glove Surfbout. In the finals he wore his now-famous "star shorts." Artwork by Gary Prettyman.

The one person Slater could look to for guidance was his surfboard supplier, Al Merrick, who's often referred to as the "shaper for the stars." The list of longtime Channel Islands team riders is illustrious. It includes Tom Curren, Kim Mearig, Lisa Anderson, Sophia Mulanovich, Slater—all of whom have won world championships, totaling 15 in all—Machado, Taylor Knox and Rochelle Ballard, among others. But no matter who the rider is, Merrick has the reputation for devoting meticulous attention to each surfboard he shapes, always logging exact dimensions for later refinements and listening intently to feedback. And the loudest feedback in the '90s came via Slater's actions—six world titles, five Pipe Masters crowns, six Surfer Poll Awards, 24 ASP-sanctioned event wins.

So whether the waves were two feet, 10 feet or 20 feet, the Merrick/Slater team proved quite dynamic, and usually unbeatable. In small surf the extra nose and tail rocker allowed Slater to push maneuvers to their extreme limit without losing control of the board. For instance, though Slater didn't invent the aerial, he was the first to implement it as a viable high-scoring maneuver during competition due to his knack for pulling them off with ease and regularity. The kick in the tail made the tail slides associated with the New School generation of surfers much easier because the fins wouldn't dig into the wave face as easily and track. And when the surf got bigger, these features helped the boards fit snugly into steep pocket sections and actually let surfers really pump their surfboard once inside the barrel. Also, pearling was less of a hazard than ever, especially when recovering from "big" moves and during late, critical takeoffs.

Of course it didn't hurt that by 1996 Slater was on top of his game, and it may not have mattered what equipment he rode. On the other hand, 15 combined world titles won by five different surfers over some 20 years on Channel Islands surfboards is probably no coincidence.

—Sean Preci

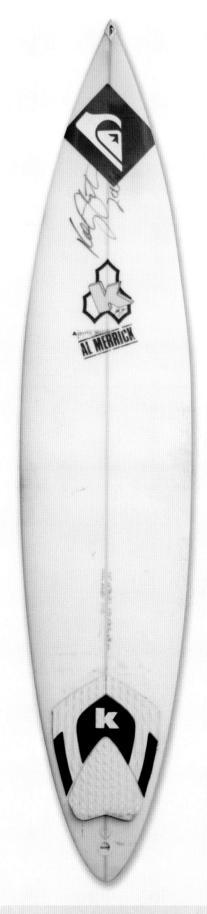

AL MERRICK
K-BOARD

In small to medium surf, boards like this were Slater's weapon of choice throughout his numerous title runs.

AL MERRICK
SEMI-GUN

Yet another one of Slater's personal boards. This one was designed to be ridden in solid North Shore waves, for which Slater has excelled throughout his career, from Bonzai Pipeline to Sunset Beach to Waimea Bay.

AL MERRICK
K-BOARD

Perhaps even more amazing than Slater's eight world championships was his complete dominance at Pipeline during the 1990s. This is a typical board ridden by Slater during his five Pipline Masters victories.

Tow-In Boards

It was a classic winter day in 1992, a massive north swell was pummeling the Seven Mile Miracle on the North Shore of Oahu, and longtime big-wave hellman Bill Sickler was sussing things out from a perch overlooking Sunset Beach. According to Bruce Jenkins's article "The Unridden Realm," which ran in *Surfer* the following year, what Sickler saw through his binoculars—and he couldn't have seen it without them—was nothing short of monumental. Laird Hamilton, Darrick Doerner and Buzzy Kerbox were carving up three-story-tall Outside Backyards like it was overhead West Peak; in fact, they were riding waves all the way through to inside Sunset. To place things in perspective, the outer reef at Backyards breaks more than a mile out to sea. Heavy water expert Dave Kalama may have put it best when he philosophized, "Unfortunately, with the group I'm traveling in, you have to put yourself on the line in order to have fun." Kalama's words were to some degree tongue-in-cheek. But when one considers the magnitude of the surf tow-in riders have since taken on, it's the notion of any sort of joke that becomes facetious.

Unequivocally, tow-in surfing has done more to change the big-wave arena than any development since the 1950s, when pioneering shapers such as Wally Froiseth, Pat Curren and George Downing set the initial blueprint for the big-wave gun with their 10- to 12-foot, Hot Curl-inspired balsa rhino chasers. Of course wood soon gave way to foam, rails and rockers were refined and both they and their successors went on to craft considerably sleeker and more maneuverable templates. But through it all, one thing that never changed was the big-wave surfboard's extended length—critical in facilitating the paddling speed needed to execute an early takeoff. And one thing that even the earliest gun shapers recognized was the existence of a size threshold (25 to 30 feet) beyond which paddle-in surfing was no longer physically possible. This aptly coined "unridden realm" was to remain unridden (successfully, at least) until the advent of the tow-in surfboard.

While paddle-in big-wave boards maintained a standard length and width (nearly 10' 0" x 20") in order to obtain the necessary paddling speeds, the tow-in boards were designed only for surfing. With the implementation of the personal watercraft (PWC) and tow rope, board sizes were drastically reduced, pared down to roughly 6' 6" with 15 inches of width. Borrowing ideas from windsurfing and snowboarding, the surfboards while being shorter were also heavier, and the fins

7'0" X 16" X 10.75" X 9.5" X 2.25"

GERRY LOPEZ
"This board was built for Jaws. Lopez says that it was the last board that he made for Laird," recalled owner Spencer Croul. He also added that to bookend his collection he now needs to get one of Hamilton's latest wave toys—the Hydrofoil Board. This board weighed 9 pounds.

Tow-in boards are like scaled-down versions of big-wave guns fitted with foot straps and a tight tri-fin cluster.

were thinner and stronger. Footstraps were added to increase leverage and balance to combat the added G-forces; the footstraps were also integral in keeping the rider with the board (similar to snowboarding) when enduring occasional "airs" from chop or during a drop-in. The straps also made it possible for riders to make turns and cutbacks, whereas paddle-in surfers could do little more than aim their large boards toward the shoulder and deep water.

While big-wave purists—those who insist on continuing to paddle into waves—claim that using horsepower-induced aid to catch waves places in question the soul of big-wave riding, the tow-in niche has certainly found its place in the surfing community. Whereas paddle-in surfing had reached its limit, tow-in surfing has taken the big-wave realm to previously unforeseeable levels. Since the birth of tow-in surfing, there have been continual advancements that have stretched the vastness of exactly what is *too* big. In Dana Brown's film, *Step Into Liquid* (2003), California's Mike Parsons was seen pulled into a 60-foot-plus wave at Cortes Bank—an open-ocean reef located 100 miles west of San Diego—virtually thrusting tow-in surfing into the mainstream media. Big-wave chasers have also been towed-in at many other breaks that before Jet Skis were totally unapproachable: Jaws (or Pe'ahi) on Maui, Belharra in Southwest France, Shipstern

Bluff in Tasmania, Dungeons off Cape Town, South Africa, and several others around the world.

While the tow-in surfing fraternity used to be limited to only the most qualified watermen, the recent media/sponsorship blitz has packed the big-wave, tow-in-only lineups. Billabong promotes an annual year-long contest, the Billabong Odyssey, providing a lucrative cash prize ($1,000 per foot of face height) to the biggest wave ridden.

However, of all those who have attempted to capture the big-wave prize, there remains one face at the forefront of big-wave tow-in surfing: Laird Hamilton. Of all the tow-in fanatics, Hamilton remains the foremost connoisseur of the extreme sport. He, along with his crew (Doerner, Ilima Kalama and his son, Dave) continue to push the sport to new limits, without the money-first mentality that many other big-wave surfers have adopted. Hamilton and crew continue to research and prepare for bigger waves (in the 100-foot-plus range) to conquer. Hamilton has even practiced being towed behind a helicopter, in the chance that he meets a wave that a PWC won't provide enough speed to catch.

With the technological advancements that have allowed for accurate swell forecasting, it seems only a matter of time before the envelope is pushed beyond belief.

—Chasen Marshall and Tristan Wand

Art Boards

Seeing that "surf art" is generally looked upon as nearly any drawn, painted or airbrushed illustration or sculpture depicting the act of surfing or its ancillary parts—waves, beachscapes and sea life—determining what constitutes an "art board" is not an exact science. In other words, whenever an artist (usually a surfer, but not always) uses a surfboard as a canvas to express him or herself, it's considered an art board. As with most art, the aesthetic quality of art boards is almost wholly dependent on personal taste and popular opinion.

With this in mind, art boards have been around for at least a century, with one of the most popular early examples being a surfboard dating back to the mid-1920s that was owned and ridden by Duke Kahanamoku himself. The balsa and redwood board depicts a life-size hand-painted portrait of a Hawaiian chief, which represents Kahanamoku's high standing within Island surf culture. Though the artist is unknown, the piece has been seen in numerous advertisements promoting Hawaiian products and tourism.

Another noteworthy wave in the personalization of surf equipment came during the

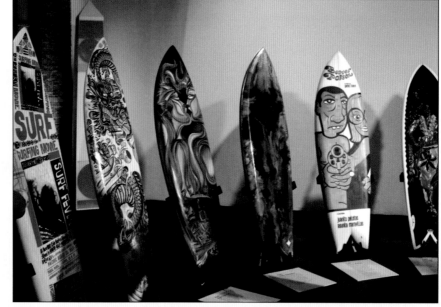

"Art for the Oceans"—the 2005 Surfrider Foundation fundraiser—brought together a half-century's worth of surf artists in one place. Photo: Robb Havassy.

'50s in the then-capital of West Coast surfing, the Los Angeles South Bay. Back then, and keeping with the somewhat jocund times following World War II, surfers commonly painted or drew pictures of their favorite cartoon characters onto their boards. Further bolstering his bawdy reputation, master craftsman Dale Velzy one-upped his peers by glassing a pair of panties from a current love interest onto the deck of his surfboard. Needless to say, once the girl caught wind of this, the relationship quickly ended.

Over the next two decades, airbrushing was the medium of choice for many surfers looking to add some color and individuality to their sticks. Reflecting the era, the subject matter often concentrated on psychedelic color swirls, dream waves and space scenes. Among the most memorable works of the time period came from surf artist/cartoonist and rock concert poster designer Rick Griffin, Australian surfer/shaper Terry Fitzgerald's airbrusher Martin Worthington and the always-stylish Mike Hynson. Later notable practitioners include San Clemente's Bill Stewart, whose subject matter ranged from the Soviet and American flags (commemorating the

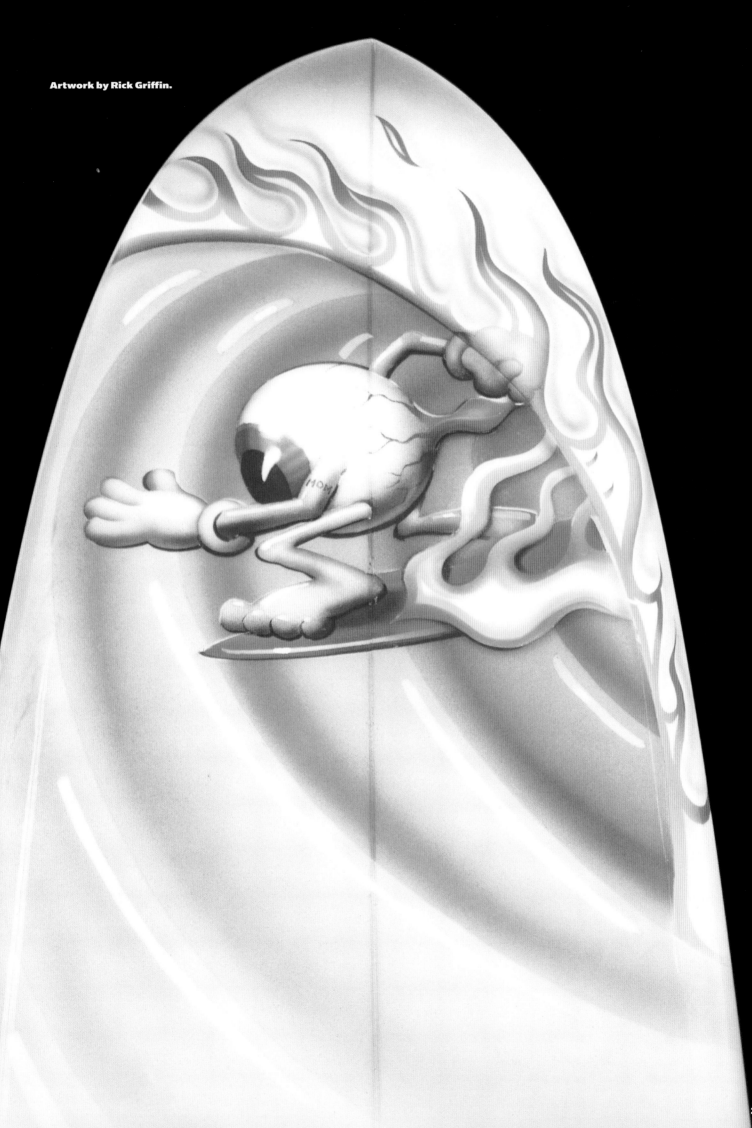

Artwork by Rick Griffin.

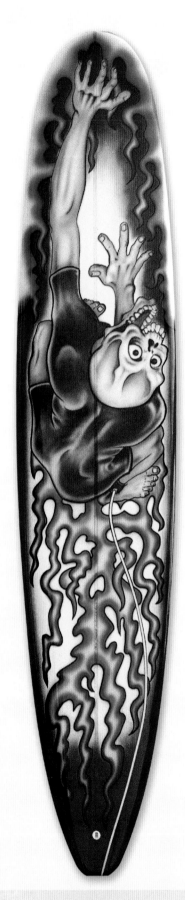

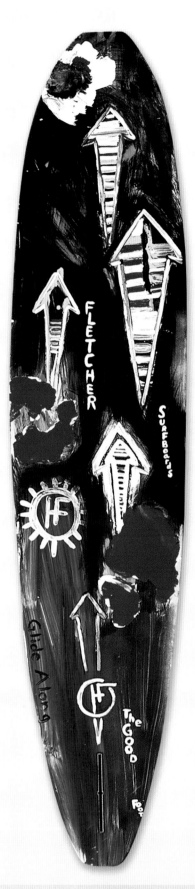

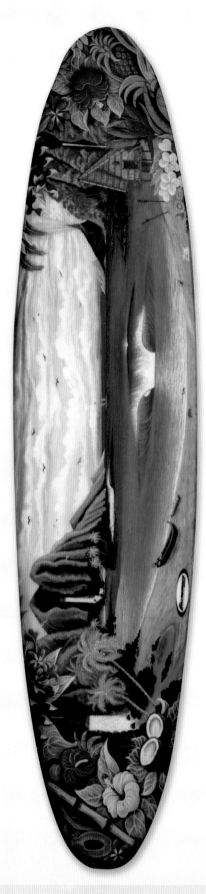

ARTWORK BY
BILL STEWART

ARTWORK BY
HERBIE FLETCHER

ARTWORK BY ZOE

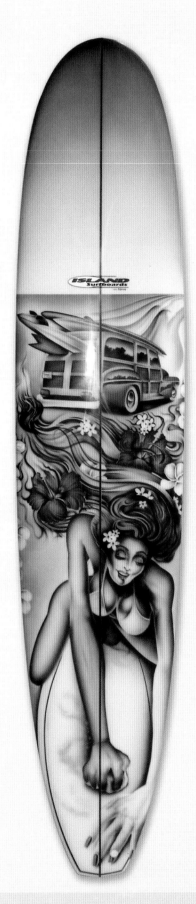

ARTWORK BY IVAN
MCMAHON

ARTWORK BY
RICK RIETVELD

ARTWORK BY
PAUL CARTER

end of the Cold War) to Yoda, the green Jedi guru of the "Star Wars" sextology.

The decade of decadence, the '80s, ushered in a new movement in surf art as artists like Rick Rietveld, Peter Schroff and Shawn Stussy reflected the neon, techno-pop culture through a variety of mediums—both on surfboards as well as on surf apparel. Yet, for the most part surfboards of the era featured somewhat simple designs with a stronger emphasis on color treatments (the louder the better in many cases).

These Al Merrick-made fish show the most recent phase in art boards; surfboards are viewed as canvases, and no longer as surf crafts. Photo: Robb Havassy.

But it wasn't until the 1990s that a major shift in art boards took place. Before then, surfboards—regardless of what pictures, designs or depictions they displayed— were intended to be ridden. The surf collector's boom that began in the early '90s and exploded by decade's end put the functionality of surfboards that featured artwork into question (with the exception of professional surfers' boards that were sometimes personally decorated with the help of paint markers, *a la* Kelly Slater). Suddenly, now that a market existed, art boards became just that, pieces of art that served a purely aesthetic purpose and therefore hung on the wall.

A few of the artists that emerged and benefited from this change in stance toward art boards was Julian Schnabel (who is also a feature filmmaker), Kevin Ancell (who later went on to work with Santa Barbara surfboard maker Reynolds Yater in producing beautiful shell inlay surfboards), Dibi

Fletcher (wife of Herbie) and Drew Brophy (though much of Brophy's early work was featured on surfboards that were indeed surfed, and surfed hard), among many others.

Today, art boards are as integral a part of surf and surfboard culture as signature models, except that they are often exceptionally more valuable monetarily. Probably the most memorable indication of this fact took place in 2005, when the Surfrider Foundation, the core surfing environmental group, organized "Art for the Oceans." The Surfrider-sponsored auction, which was held at a trendy New York City art gallery, brought together perhaps the most well-established group of surf artists ever assembled, all with one mission: to raise money for Surfrider's many ocean-oriented protection programs. The majority of the artists— which included *Surfer* magazine founder John Severson, famed seascape and sea life artist Wyland, longtime artist/surfer Billy Al Bengston, surf artists Kevin Short and Robb Havassy, surf filmmaker Thomas Campbell and *The Endless Summer* movie poster designer John Van Hamersveld, as well as previously mentioned people like Rietveld, Schroff, Schnabel, Ancell, Fletcher (both Dibi and Herbie) and Brophy—used the exact same canvas: an Al Merrick-shaped 6' 2" twin-fin fish, thus successfully marrying fine art with the art of shaping surfboards.

—Sean Preci

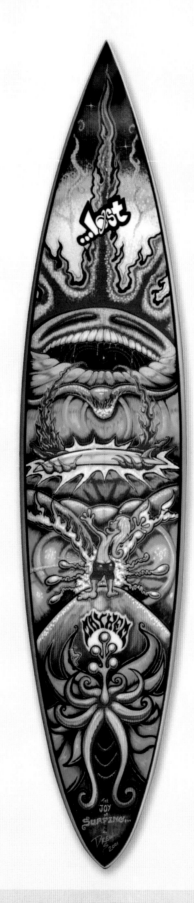
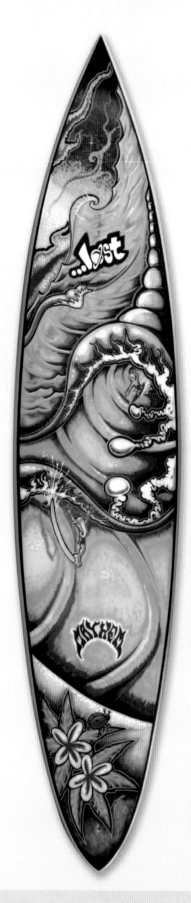

TRIPTYCH ARTWORK BY DREW BROPHY

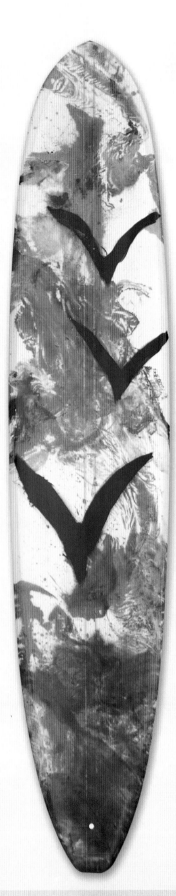

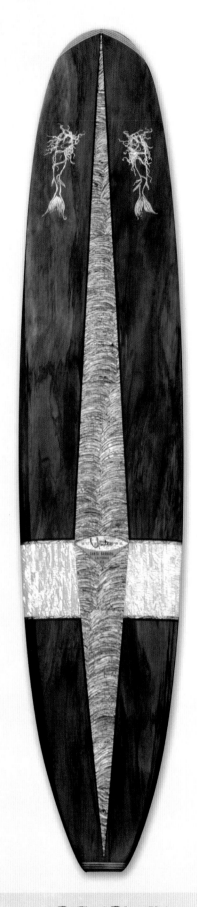

ARTWORK BY
JULIAN SCHNABEL

ARTWORK BY
JULIAN SCHNABEL

ARTWORK BY
REYNOLDS YATER &
KEVIN ANCELL

Logo Art

Much like album covers, or some paintings, surfboard logo art has the capacity to capture entire eras—to impart a very real sense of the time, place and prevailing vibe from which a given board originated. In fact, surf historians and surfboard collectors are often able to date boards by the style of the manufacturer's logo—the late '60s was a very different landscape than a mere several years later, much less several decades.

Considering that visual symbolism predates written language by thousands of years, the momentous impact of surfboard logos within surf culture should come as no surprise. It could even be argued that to many surfers, laymen in particular, the miniature piece of thin paper that lies beneath the sheet of resin-soaked fiberglass is the most important design feature of their surf craft. Even today's most seasoned surfer rarely rides equipment bereft of its maker's logo.

As may be expected, surfboard logo art, at least as modern surfers know it, was originated by perhaps the most influential surfboard designer of the 20th century, Dale Velzy. The ever entrepreneurial shaper from Los Angeles' South Bay first introduced the surfboard brand laminate around the late 1940s. The round logo consisted of a surfer riding a board on a blue background with the words "Designed by Velzy" and bordered by rope. Though Velzy changed his logo soon thereafter to an oval that read "Surfboards by Velzy," he was one of only several shapers to include lam art in the coming decade.

Up until then, the only prime example of any sort of logo reappearing on commercially produced surfboards was done by Pacific System Homes—the Los Angeles-based home building outfit that ventured into the surfboard making industry (if you could even call it that at the time) during the first part of the 1930s. Early on, the company offered a "Swastika" model, which came with a swastika often literally branded into the pine and redwood deck of the board. Shortly after Germany invaded Austria in 1938, Pacific System Homes discontinued the model for obvious reasons.

Even dating back to the ancient Hawaiians, surfers would personalize their surfboards by carving, writing or painting their names or the surf club they belonged to on them. The implication of what Velzy did was to shift the emphasis from the individual surfer to the craftsmen who actually constructed the board. This shift coincided with the advent of the use of fiberglass and polyester resin, hence the name laminate.

Once other shapers realized the potential for free advertising the laminates depicting their brand's logo had (they were often the last name of the shaper who begat the company—Surfboards by Velzy, Hobie Surfboards, Bing Surfboards, to name a few early examples), there was really no turning back. Now, nearly every new board produced has some type of logo displaying its maker's company, brand name or trademark.

Laminate art has always said something about the generation in which it was produced. From the clean, classic designs of the '50s and early '60s to the acid-tinged psychedelia of the counterculture movement to the '70s lightning bolt to the '80s neon fleck to the understated look of the '90s, a shaper's logo continues to be the final signature touch prior to glassing.

—*Sean Preci*

In the 1970s, the lightning bolt insignia was among the most recognizable symbols in the water; the top surfers of the era were riding the boards: founder Gerry Lopez, Mark Richards, Shaun Tomson, Jeff Hakman and Rory Russell, among others.

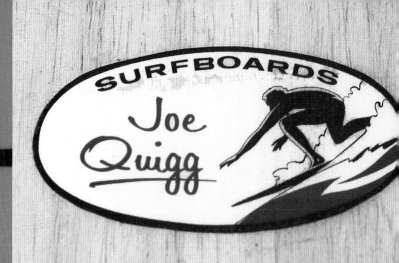

Phil Edwards
Honolulu

SURFBOARDS
Joe Quigg

HAP JACOBS
Surf Boards

Hand Shaped
by
Lance
COLLINS

MALIBU
CUSTOM SURFBOARD
malibu plastics
1864

PAT CURREN
NEWPORT BEACH

SHAPES AND DESIGNS BY

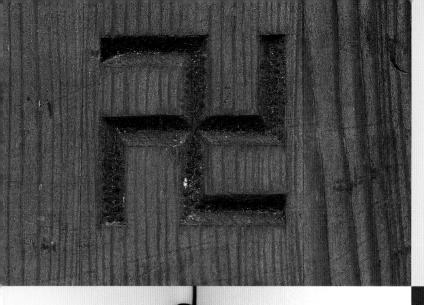

Surf Boards by Dewey Weber

plastic fantastic SURFBOARDS

JACOBS

JACOBS SURFBOARDS
Donald Takayama
Step Deck Model

MARK MARTINSON
MODEL
Robert August
SURFBOARDS

BING SURFBOARDS
Pintail
LIGHTWEIGHT

VELZY
SURFBOARD OF CHAMPIONS

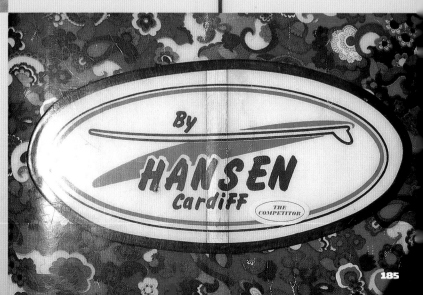

NEWPORTER
CHAMPIONSHIP SURFBOARDS

VAGABOND
custom
SURFBOARDS

RENTAL
By
HANSEN
Cardiff
50-50

WARDY
SURFBOARDS

Bill Hamilton
Custom Surfboards
Hanalei Bay, Kauai

REEF
3702 503
SURFBOARDS

HYNSON and COMPANY
Mike Hynson Model

HAWAIIAN ISLANDS
SurfBoards, Calif.

SANTA BARBARA SURF SHOP

custom surfboards

eliminator

BY GREEK

GREG NOLL Surfboards
BUG

bh
blue hawaii
s u r f

Maurice Cole
just Surfboards

LYMAN

bing

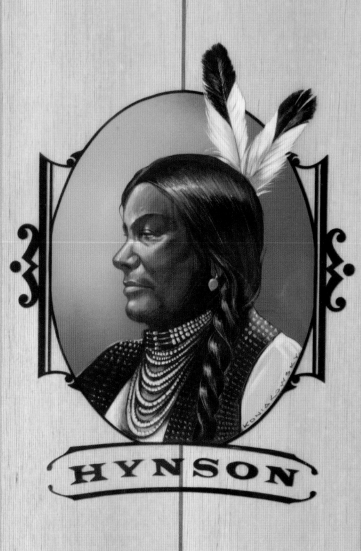

HYNSON
SURFBOARDS

Nat Young

EATON

Gary Propper
MODEL
Hobie

VELZY

SURFBOARDS
BY
Scott Dillon
COFFS HARBOUR AUSTRALIA

066 · 536536

Dick
Brewer
Surfboards

THE
POACHER

Anderson Surfboards

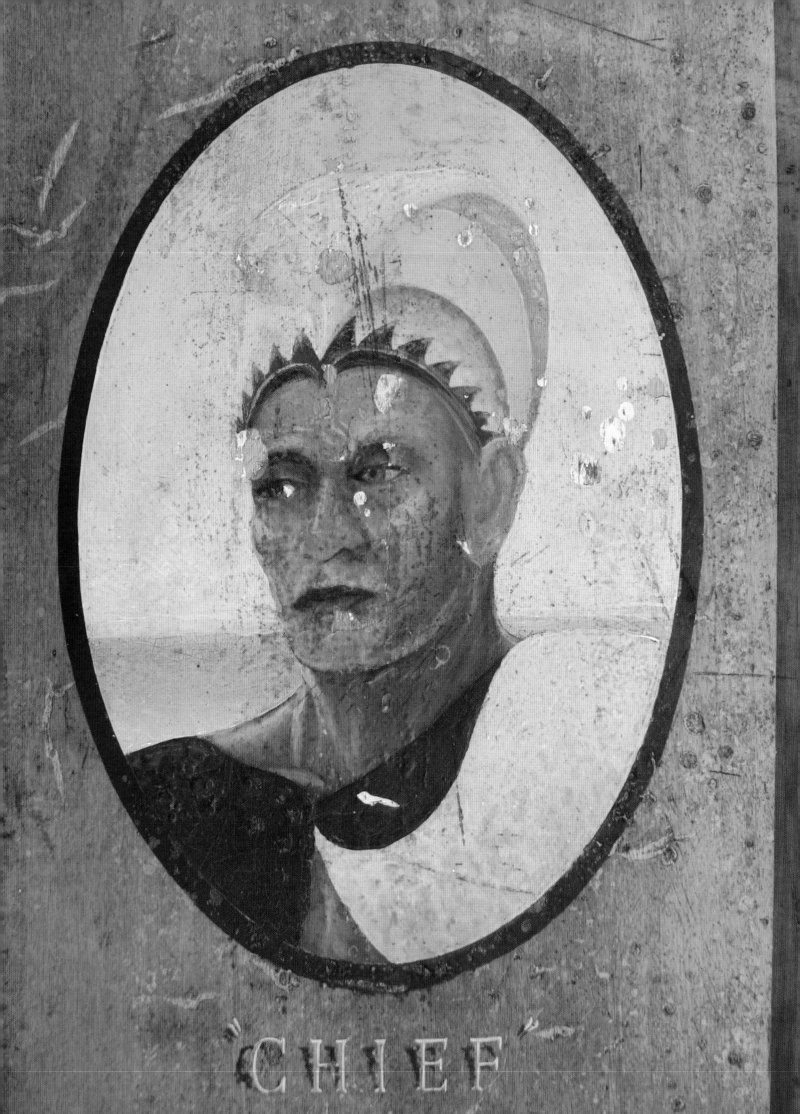

CHIEF

Contemporary Surfboards

hether it be the Foster's ASP World Tour pro charging the Banzai Pipeline or the beginner down at the local beachbreak catching his or her first wave, today's surfer has more choices of what type of surfboard to ride than ever before. And despite the fact that the three-finned or Thruster shortboard remains the top-selling surfboard on the market, no two aspects best describe the most recent phase of the contemporary surfboard as new technology and the alternative board movement.

From the time of the ancient Hawaiians up to the then cutting-edge surfboard builders of the late 1940s and early 1950s, surfboards were mainly constructed of wood. Although polyurethane foam replaced balsa wood as the modern surfboard's core material in the late '50s, there were no significant changes in the way mainstream surfboards were built or materials used until near the turn of the century, employing the same basic process: 1) a foam blank is cut into its rudimentary outline either manually or with the aid of a computer-programmed shaping machine; 2) the rocker, rails and bottom contours are then fine-tuned by hand with a sanding block; 3) a sheet of fiberglass is laminated onto the foam blank with a mixture of polyester resin and catalyst; 4) another layer of resin, known as the "hot coat," is applied in order to make sanding easier; fins, fin plugs or fin boxes are usually added at this stage; 5) the board is sanded one more time, and then a final "gloss coat" is added, which, when polished, gives the board a shiny finish.

With the continued experimentation of expanded and extruded polystyrene (XTR and EPS)—lighter, more dense foam—computer numeric cutting (CNC), thermal compression lamination, exotic composite skins (from carbon fiber to wood

veneer), an assortment of epoxy resins and other techniques in the late '90s and into the following decade, manufacturers and consumers were confronted with viable substitutes for traditional surfboard manufacturing for the first time in four decades.

Though surfers and shapers—notorious for their resistance to change—were slow to accept some of the new technology, several of the innovations gradually gained market share. The goal for these new boards was two-fold. First, to create a superior product to traditional polyurethane boards, one that is stronger and more durable, as well as an accurate reproduction of original designs. Second, to make the production process more streamlined and therefore more efficient, though it sometimes meant outsourcing the bulk of the production overseas due to cheaper labor costs and more relaxed environmental policies. While these types of surfboards hadn't necessarily threatened to supplant more traditional surfboards at first, everything changed on Dec. 5, 2005—the day Clark Foam closed its doors.

Citing continued pressure applied by several different agencies—including the EPA and OSHA—owner Gordon "Grubby" Clark shut down his factory without warning. Clark Foam, which was founded in 1958 with the help of surfboard manufacturer Hobie Alter, held a virtual monopoly on polyurethane foam production within the surf industry ever since its inception, pumping out between 350,000 and 400,000 blanks per year. Not only did the bombshell send the domestic surfboard manufacturing industry into a panic, but its ripples could also be felt all over the world as U.S. board makers almost immediately arranged for foam to be imported from Australia, South Africa and Brazil.

As solutions were being sought in earnest—a

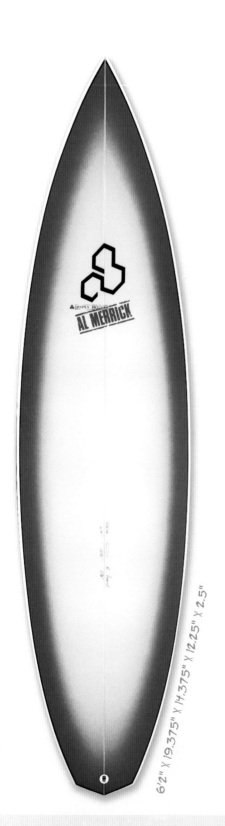

6'2" X 19.375" X 14.375" X 12.25" X 2.5"

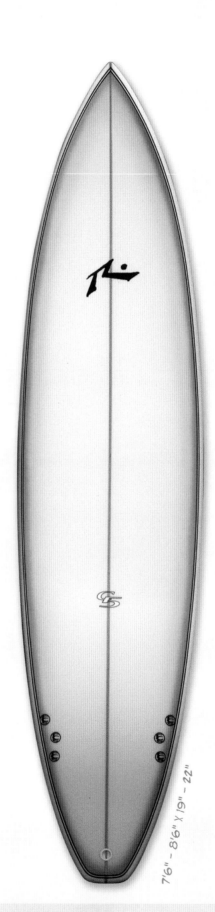

7'6" – 8'6" X 19" – 22"

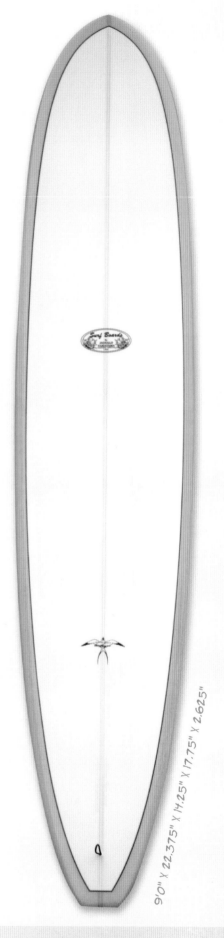

9'0" X 22.375" X 14.25" X 17.75" X 2.625"

CHANNEL ISLANDS SURFBOARDS

The K-Small is Kelly Slater's small-wave contest board shaped by Al Merrick. It features a diamond tail, which works to shorten the rail thus tightening the turning radius.

RUSTY SURFBOARDS

The Desert Island C-5 model is a shorter, wider version of the original Desert Island design, with the C-5 fin setup (which provides extra speed and power). Rusty Preisendorfer introduced these "big guy tri" boards to the public as odes to his personal surf craft.

HAWAIIAN PRO DESIGNS

This "Beach Break" model was hand-shaped by Donald Takayama for Jeff Hakman. It's believed to be the master shaper's most "progressive and innovative" high-performance design to date; it features hard, down rails and extra rocker to fit into steep waves. Like most of his boards, it comes with a T-band stringer.

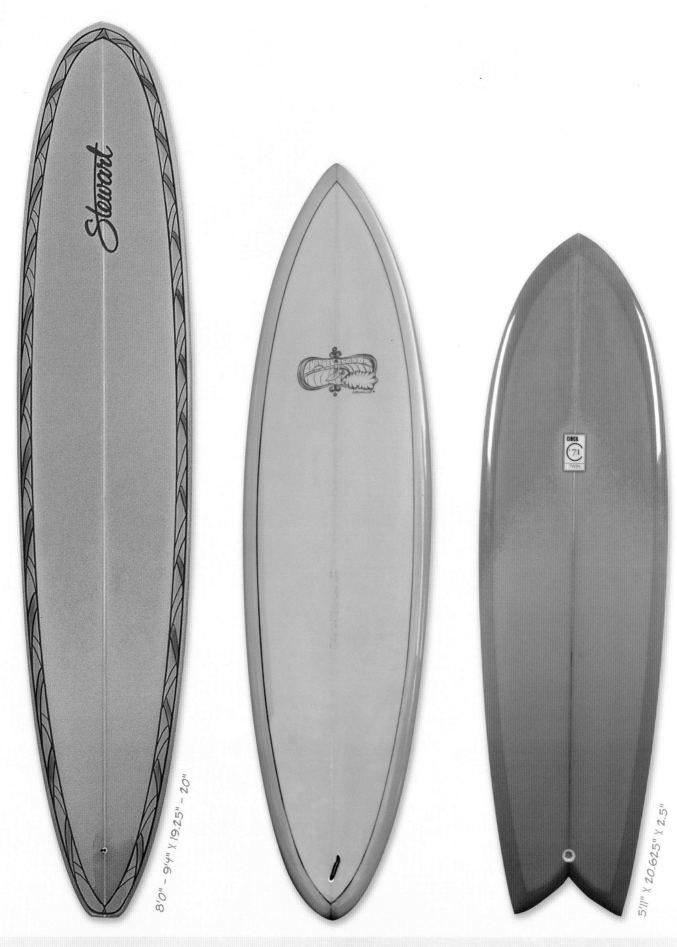

8'0" – 9'4" X 19.25" – 20"

5'11" X 20.625" X 2.5"

STEWART SURFBOARDS

The Hydro Hull was one of, if not the top-selling board for San Clemente's Bill Stewart. The board holds widespread appeal by pros and newcomers alike. The speed boat-inspired beveled rails and unique bottom contours allow the board to ride well whether on the nose or tail, though it is mostly recognized as a high-performance longboard.

CHANNEL ISLANDS SURFBOARDS

Al Merrick worked with team rider Rob Machado to come up with this retro single-fin design, the MSF G2 (second-generation single-fin), with a modern twist. It features a spiral vee in the tail, low rocker throughout and a variety of resin tints. The logo was designed by Thomas Campbell specially for these models.

HOBIE SURFBOARDS

Dubbed the "Circa '71" this model harkens back to the dawn of the twin-fin split-tail fish designs of Steve Lis. The board also comes with glassed-in keel fins.

10'0" X 20" X 10.5" X 10.25" X 3.375"

9'4" X 22.75" X 14.75" X 18.125" X 3"

FREELINE SURFBOARDS

This big-wave gun was shaped by Santa Cruz's John Mel for his son Peter, who emerged as one of the premier surfers at Maverick's once the spot became public in the 1990s.

BIC SURFBOARDS

Better known as a producer of pens than surfboards, BiC made the transition while managing to make agreements with various well-known shapers and surfers to mimic models using their CTS technology, which combines extreme durability with many of the same characteristics of standard surfboard construction. Above is the Nat Young model.

...LOST SURFBOARDS

Always a hotbed for young, talented surfers, San Clemente has also given rise to its fair share of influential shapers. Matt Biolos—who officially launched ...Lost in the early '90s—now shapes for a whole slew of professional surfers, most of whom are considered on the cutting edge of modern high-performance surfing.

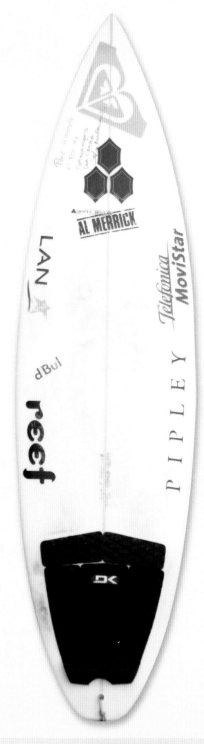

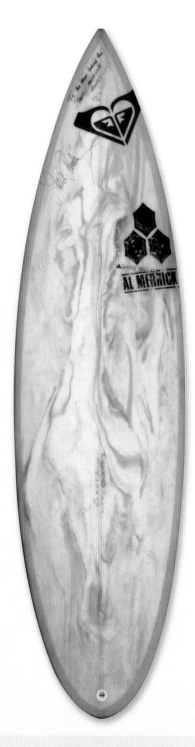

JS SURFBOARDS

Gold Coast shaper Jason Stevenson rose to prominence when his boards began making regular appearances on the ultra-competitive World Championship Tour (WCT)—now the Foster's ASP World Tour—in the early 2000s. Andy Irons rode this board on the way to one of his three consecutive world titles.

CHANNEL ISLANDS SURFBOARDS

Peru's Sofia Mulanovich literally burst onto the women's professional scene at the age of 21 by winning the ASP world championship in 2004 on this board.

CHANNEL ISLANDS SURFBOARDS

This is one of Lisa Anderson's personal boards. In the mid-1990s, Anderson became the poster child for women's surfing, winning four consecutive world titles (1994-97). She even graced the cover of Surfer magazine in 1996 (the first woman to do so in some 15 years).

whole slew of foam producers sprouted following the incident, and those that coexisted with Clark ramped up their production—surfboard manufacturers specializing in new technology were thrown into the spotlight.

The most successful proved to be Surftech, who, in the years leading up the incident, became the largest producer of surfboards in the world. This was the result of a combination of factors. Firstly, Surftech's success in incorporating the world's top shapers to launch their product, including Dale Velzy, Reynolds Yater and Donald Takayama. Soon after, such top-flight shapers like Al Merrick, Rusty Preisendorfer and John Carper also signed on. Secondly was its revolutionary approach to materials utilizing epoxy resins and EPS foam in a unique lamination process.

The thruster setup is perhaps the most refined surfboard design ever; these carbon-fiber fins provide added strength and flex.

Ironically, the ground-breaking process in the surfboard manufacturing industry largely came about as a natural progression from techniques in use in the sailboard industry for more than a decade. In 1992, Santa Cruz, Calif., resident Randy French founded Surftech based on his experience with his first company, SeaTrend—at one time a shaping and glassing shop and later a sailboard manufacturer at the forefront of cutting-edge technology. Building on these methods, French and company developed Tuflite technology, a surfboard produced by a 10-step process.

Instead of using polyurethane foam blanks that require shaping, Surftech blows its own EPS foam blank within a mold of a desired shape based on the template of one of its numerous established shapers. Then a sheet of PVC foam is heated and wrapped completely around the EPS foam, without any seams. Next, both sides of pre-formed PVC sheet foam are laminated to the EPS blank with a layer of fiberglass and resin. This step produces a hard-shelled blank, to which the fin boxes and leash plugs are installed into blocks of high-density urethane foam and capped with fiberglass/epoxy. Only after this step is the entire blank sealed. The bottom and deck lamination takes place in a vacuum seal for curing. The vacuum presses the lamination directly to the blank. At this point the board has a perfectly smooth surface. Then a very thin sand coat is applied. According to Surftech this provides a reduction in dead weight. Next the board is sanded by hand and machine. Then primer and finish paint are applied during a multi-staged catalyzation process. Last, the decals are added and the complete board is top-coated with clear and finish polishing.

The final product is considerably lighter than a typical surfboard. According to Surftech, their average board is two to six pounds lighter. And because of the multi-staged lamination process and reinforced fiberglass, Surftech claims that their boards are approximately 20 to 30 percent stronger. Not only are the materials and the technologies groundbreaking, the entire production process transcends the traditional boundaries of the industry. Surftech became the first surfboard manufacturer to move all of its production offshore to Thailand. While this decision gave detractors more cause to criticize the company, it allowed Surftech to mass-produce exact replicas of the most popular shapes designed by numerous master craftsmen faster than any number of hand-production shops. But French's dream is to go beyond: "Our goal isn't just to clone good shapers' boards and make them more durable, which we

8'0" – 9'0" X 19" – 23"

7'6" X 21.938" X 15.375" X 16.938" X 2.813"

BUNGER SURFBOARDS

Based out of New York, Charlie Bunger has been manufacturing surfboards since 1962.

BRUCE JONES SURFBOARDS

Though Bruce Jones founded his own label in 1973, he shaped for such big names as Hobie, Vardeman and Gordie throughout the '60s. This is an example of a contemporary longboard with a nod to the past, thanks to a wooden tail block.

HARBOUR SURFBOARDS

The "Spherical Revolver" model is a re-make of the 1969 design of the same name; it even comes with the original logo. The wide surface area and overall elliptical shape promote easy turning and stability. It can be ridden as a single-fin or with a 2+1 fin setup.

5'8" X 20.75" X 16.375" X 15.875" X 2.875"

6'6" X 23" X 16.5" X 20.5" X 2.75"

9' 1" X 22.5" X 13.2" X 18" X 2.9"

SURFTECH

The "Soul Fish" is Randy French's take on the popular fish design. It comes with twin keel fins and a single/double concave bottom. This particular board features Surftech's signature wood veneer finish.

WALDEN SURFBOARDS

The "Superwide" design by Walden was meant to provide maximum performance, floatation and glide. Boards like these are prime examples of a "mini-tanker," a shortboard that noserides exceptionally well.

HYDRO EPIC SURFBOARDS

Some surfboard manufacturers, like Hydro Epic, decided to go way outside of traditional board-making materials. This board is constructed of carbon fiber, kevlar, aluminum and epoxy. Its hollowness makes it much lighter than traditional boards. Notice the plug near the tail—it's meant to release pressure that may build up due to heat.

203

The twin-fin setup that Mark Richards made famous during the late '70s and early '80s can still be found in most any lineup these days.

board is thermoformed between an epoxy-hybrid top and bottom outer shell. This shell is remarkably different in its appearance and consistency than a traditional surfboard or even that of a Surftech. The result, according to BiC, is 30 percent more durable than a standard polyester fiberglass board while remaining similar with regard to weight and stiffness.

Another modern surfboard company, Boardworks, utilizes EPS foam molding but uses a two-part molding process instead of all in one. Two halves of the board are hand-laid in the mold, beginning with the gelcoat paint, layers of glass, high-density sheet foam, another layer of glass and then the EPS core with extra-toughened epoxy foaming resin on the rails for extra ding resistance. The two halves are then connected and placed in a press, compressed and cured under high temperature. When the board comes out of the mold it is sprayed with the basecoat layers, clear coat and polished. On all boards over seven feet, Boardworks inserts an

are doing, but ultimately to make a board that will substantially outperform what is currently being done."

BiC Sports is another surfboard manufacturer at the forefront of EPS technologies that was inspired by innovations in practice within the sailboard industry. But unlike Surftech, BiC Sports—an offshoot of the successful pen and office-supplies company—began as a sailboard manufacturer, eventually moving into surfboard production. In the years following, BiC has established a working production process but has been less successful at recruiting big-name shapers to come aboard. Although some boards are modeled after signature shapes, like that of Nat Young, most are models designed by BiC's own team of designers.

BiC's patented CTS technology, which is used in their high-performance boards, utilizes EPS foam that is shaped to specifications then layered with epoxy resins and fiberglass cloth. Then the

Regardless of the message the surf world tries to convey, longboards like this one, featuring a 2+1 fin setup and an extra-long leash, are found at most beaches worldwide.

5'6" – 12'0"

10' 6"

10'2" X 23.375" X 14.375" X 18.25" X 3.875"

SURFTECH SOFTOP

To help mitigate the safety-risk beginners were forced to endure with glassed boards, Surftech along with other companies began producing a soft-top surfboard. Surftech has 13 different models that are durable, safe and wax free—and are typical of boards used at most every surf school.

LINDEN SURFBOARDS

Gary Linden shaped this big-wave gun with 25-foot-plus waves in mind. It's made from balsa so it won't flex as much as a foam board and is less likely to break when conditions get serious. Linden successfully went on to complete a trifecta on this board, surfing massive waves on it at Maverick's, Todos Santos and Dungeon's.

BOARDWORKS AIPA STINGER

Ben Aipa collaborated with Boardworks—an epoxy-composite surfboard manufacturer—in offering a copy of a design taken from one of his personal boards. The board takes his original Sting concept and applies it to a contemporary longboard.

7'10" X 21" X 14.25" X 14.25" X 3"

9'0" – 10'0" X 22" – 24"

7'6 – 9'0" X 22.75 – 23.25" X 14.5" – 15" X 17.5" X 3.125"

BEAR SURFBOARDS

Bear Surfboards has been around since the late '70s, after it was invented specifically for the feature film, *Big Wednesday*. This is a prototypical mid-range design, not quite an egg but not long enough to be considered a longboard.

SURFTECH TUFLITE

In conjunction with a number of classic shapers, Surftech released a series of veneer Tuflite boards. The veneer provided the boards with a wood-made appearance while maintaining the typical Surftech durablity and ability to perform.

HOBIE SURFBOARDS

A board designed for a wide variety of East Coast surf conditions, the Peter Pan Slug is a "funboard" design that's ideal for speed and swooping turns.

7'9" X 14.5" X 12.75" X 19.75" X 3.25"

7'6" X 21" X 14.5" X 17.5" X 2.75"

6'6" – 9'1" X 20.925" – 22.625"

SKIP FRYE
SWALLOW-TAIL

Though not the actual inventor, San Diego's Skip Frye was at the forefront of several revolutionary surfboard designs—the vee-bottom, the split-tail twin-fin fish and the contemporary egg design. Frye's boards are renowned for their trimming abilities and offering their riders an all-around smooth ride, regardless of length.

WALDEN SURFBOARDS

This particular Walden "Wahine" board was designed for female riders, a group that has become more abundant in the water over the past few years. The board is shaped slightly narrower and lighter without sacrificing performance.

SOUTH POINT
SURFBOARDS

South Point makes numerous models ranging from its 6' 6" "Time Bomb" to a 9' 1" "Bonga Replica." The company uses a unique three-phase epoxy construction.

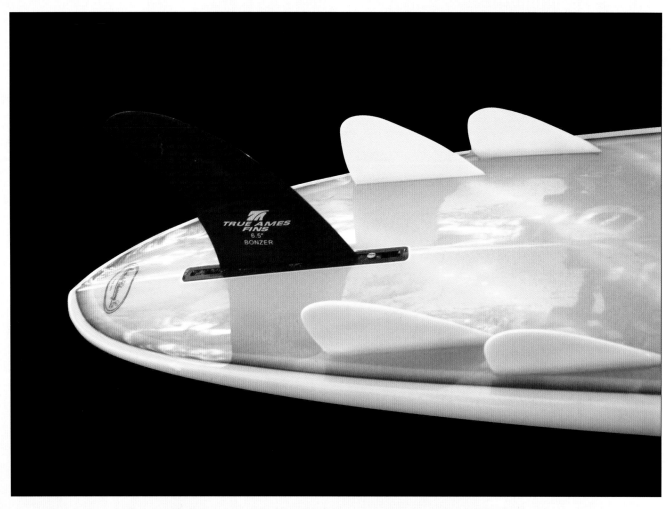

The modern Bonzer design usually features a total of five fins (as opposed to three on the original) to enhance its performance.

Epoxy Stringer System (ESS). This is a set of three 8 mm PVC stringers saddled in four-ounce glass bonds with the layer of four-ounce under the deck sheet foam to create extra support.

Like the discovery and implementation of technological advances within the surfboard making process, surfboard design has also taken steps forward in a natural evolution, though often only in slight improvements and refinements over time. The evolution of the surfboard had gone on this way for some time with the gaps between major design and construction breakthroughs becoming shorter and shorter, peaking in the decade and a half following the shortboard revolution.

In retrospect, it's barely comprehensible just how much frantic design evolution shapers inadvertently crammed into roughly a 14-year time span. From 1935, when Tom Blake placed a stabilizing fin on his then revolutionary hollow surfboards, up until 1966, there's no denying that

huge steps in surfboard design were taken—chiefly in the materials that were used to build surfboards following World War II. However, nothing compares to the myriad of design innovations that occurred between 1967 (the onset of the shortboard revolution) and 1981 (the introduction of the modern thruster).

Just a short list of the major designs introduced during that period include (in chronological order): the vee-bottom and what's now known as the egg by Bob McTavish; the mini-gun, or "pocket rocket" by Dick Brewer; the twin-fin fish by Steve Lis; the Bonzer by Malcolm and Duncan Campbell; swallowtail wingers and the Stinger by Ben Aipa; the twin-fin shortboard by Mark Richards; the "no-nose" single-fin by Geoff McCoy; and finally, the Thruster by Simon Anderson. For longboarding this era is often referred to as the "dark ages," seeing as the classic equipment of the '50s and early '60s was dismissed as archaic, if not completely ignored by

the surfing world. Nevertheless, the longboard would see a rebirth soon enough, and in essence become the first stage in what's now being called the alternative surfboard movement.

The alternative, or simply "alt." board movement is grounded in the desire by surfers and shapers to ride surfboards other than standard equipment, which had been the shortboard thruster, beginning in about 1982. Thus, longboards, which were all but forgotten for some 15 years, began to regain popularity during the mid- to late '80s—a period known as the longboard renaissance. Older generation surfers saw it as a chance to harken back to the lost era of their youth (and potentially catch more waves), while younger wave riders seized the opportunity to break away from the cookie-cutter program shortboarding was offering and at the same time take an almost forgotten art form and add an entirely new twist to it.

One early frontrunner in the rebirth of longboarding was Herbie Fletcher, whose surf shop slogan "The Thrill is Back" announced to the rest of the surfing world that the glide had indeed been resurrected. While other longtime surfboard manufacturers like Gordon & Smith never really quit making longboards, they had shifted much of their emphasis at the time to the then burgeoning skateboard industry. However, several other shapers began focusing (or refocusing in some cases) on nine-foot-plus equipment, including Donald Takayama with his Hawaiian Pro Designs label, Bill Stewart of Stewart Surfboards and Steve Walden of Walden Surfboards.

The significance of what these shapers did for longboards lies at the heart of the alt. board movement—they took old planshapes and outlines and applied modern elements, such as updated bottom contours, rail configurations, fin technology and new materials.

Yet it would take shortboard purists nearly a decade or more to go back in time as it were and revisit surfboard designs of the pre-thruster era. The resurgence of these so-called "retro" shapes should be viewed as a natural progression,

especially considering that the shortboard became more and more refined, limiting its rideability to the best surfers, and the fact that most people taking up surfing after 1981 were bred entirely on thrusters when it came to shorter equipment. Therefore, anything else—the fish and its siblings, quads and single-fins for example—were utterly foreign to a major segment of the surfing population … at least up until a few years ago.

All that changed when the universally recognized style masters of the sport—guys like Joel Tudor, Tom Curren and Rob Machado—illustrated what's possible on boards other than 6' 2" thrusters. Many, like Duncan Campbell of Campbell Brothers Surfboards—inventors of the bonzer design—felt that explorations of shapes from the past returned some of the classic style to surfing. Says Campbell, "I think [the alternative board movement] is good because it focuses on technique; surfboard design isn't just pro-driven anymore. It brought style back into surfing."

But it wasn't simply an issue of style; surfers and shapers alike realized that perhaps what came prior to the thruster might actually be worth resurrecting. Or, in the recent words of longtime shaper Scott Raymond Henry of Free Spirit Surfboards, "We went through design evolution so quickly the first time around—every three or four months we were onto something new—that we didn't fully develop the ideas, so now they're being revisited and fine-tuned." Henry is not alone in this belief. Fellow veteran shaper Gary Linden, founder of Linden Surfboards, agrees with the sentiment: "Nowadays [shapers] get a chance to reevaluate the old designs and see what's valid from a futuristic point of view; when things are progressing rapidly you tend to forget what basic design elements work."

To really get the movement going though, it would take several factors to work together simultaneously, and they would have to be in the public's eye for the entire surfing community to see. Enter Tom Curren. By the early part of the '90s, Curren had accomplished everything competitively he could ever wish for: three world

championships, two back-to-back and one via surfing through the trials all year long; a win in Hawaiian waters (the infamous 1991 Wyland Hawaiian Pro at Haleiwa in which he rode a board void of sponsors' logos); and countless victories against formidable opponents around the world.

The following year his major sponsor, Rip Curl wetsuits, sent a competitively burnt-out Curren on *The Search*—a seemingly endless journey to some of the world's most remote, exotic locales in search of perfect waves. Of course videograpers and cameramen went along to capture all the action, which led to the multi-volume *The Search* video series, culminating in the epic 1996 biopic, *Searching for Tom Curren*. This environment proved conducive to experimentation; toward the end of the run Curren began experimenting heavily with various surfboard designs, especially the fish, first on a

Coinciding with new innovations in contemporary surfboard construction was modern fin design—one such example is the Turbo Tunnel.

traditional stubby, twin-fin Skip Frye fish in small but clean waves at Jeffreys Bay then on a more pulled-in thruster fish at a huge righthander in Sumatra. Both of these sessions, which were included in the film, opened the shortboarding world's eyes to the possibilities of riding alternative boards, and just like that, surfers everywhere followed suit.

Since those historic sessions, nearly all the steps taken on the extremely divergent path sparked by the shortboard revolution—regardless if they ultimately led to a dead end or a pot of gold—

have recently been retread. Of course, some have been met with a warmer reception than others, the twin-fin fish and variations of it in particular, but nonetheless, a trip down to many of today's beaches will surely uncover revved-up eggs, downrailer single-fins, the occasional bonzer, the modern longboard and, of course, the traditional tri-fin thruster. Even in today's hi-tech world, the field of surfboard manufacturing is still wide open, and never before has there been so much divergence in the surfboard designs available to surfers.

—Sean Preci

6'10" – 9'6" X 2'" – 2.3"

11" – 12'6" X 26" – 32" X VARIED X VARIED X 5" – 5.5"

YANCY SPENCER BISECT BOARD

With the desire from surfers to travel the world in search of new and diverse breaks came the notion of a travel-easy surfboard. Any surfer who has had to check a board can attest to the difficulty and concern upon handing over his or her equipment. The bisect board made traveling with a board more convenient; the boards are often hollow and made of carbon fiber to make them extremely durable.

KEN BRADSHAW TOW-IN BOARD

This replica tow-in board was shaped by Ken Bradshaw for a Surfrider Foundation gala fundraiser. It is based on the board that he used to ride huge waves at Outside Log Cabins during a giant winter storm in 1998. The design is typical of the tow-in boards being ridden at the time by the likes of Laird Hamilton, Darrick Doerner and Buzzy Kerbox, among others.

STEVE BOEHNE STAND-UP BOARD

In attempts to reconnect to Hawaiian roots of surfing came the resurrection of the stand-up paddle board. With paddle in hand, the surfer remains standing at all times and paddles into waves. Its origins dated back to the '60s and '70s when Waikiki beachboy Leroy Ah Choy used a similar setup to shoot photos of tourists taking canoe rides and surf lessons.

Zack Howard

Matt Archbold

Glossary

50/50 rail, *n.* surfboard rail design in which the deck and bottom of a surfboard are attached by a smooth, elliptical section, offering little or no edge; also known as an egg rail; usually associated with classic longboard designs.

Acetone, *n.* chemical solvent used to clean polyester resin from glassing tools, as well as dirt or wax on a cured board.

Acid splash, *n.* typically a random mix of opaque pigments in the laminate coat that are spread across the board by using a squeegee.

Air compressor, *n.* a generator that pumps compressed air into an airbrush or air hose.

Airbrush, *n.* 1. air-compressed tool used to spray acrylic paint designs on foam or the sanded hot coat of a surfboard. *v.* 2. the act of using an airbrush.

Alaia, [Hawaiian] *n.* a thin, wide surfboard for quick-breaking surf made from koa or breadfruit; used by pre-20th century Hawaiian commoners and royalty alike.

Aloha, [Hawaiian] *inter.* hello, goodbye, love, compassion.

Backside, *adj.* when riding a wave at an angle the rider's back, heels and buttocks are facing the wave; also called backhand.

Balsa, *n.* wood from a tree usually grown in tropical climates of Central and South America; known for its porous texture, blond color and strength; most surfboards built in the 1940s and 1950s were constructed of balsa.

Barney, *n.* someone who doesn't surf very well. The term was derived from the Hanna-Barbera cartoon character Barney Rubble on *The Flintsones.*

Beachbreak, *n.* surf break in which the waves break over a sand bottom; beachbreaks generally offer shorter rides than other breaks.

Belly, *n.* slight convex rise on the bottom of a surfboard stretching from one rail to the other.

Betty, *n.* an attractive female. Derived from Betty Rubble, a character on *The Flintstones.*

Blank, *n.* the unshaped core material used to make a surfboard, usually made of foam or wood.

Blow through, *n.* an air bubble that goes all the way through the glass job that was caused by gas in the blank or too little resin.

Bonzer, *n.* surfboard design introduced by Malcolm and Duncan Campbell in 1972; one of the first surfboards ever to use a three-fin setup.

Bucket, *n.* a one-gallon container that a glasser uses to hold working resin.

Buffing pad, *n.* a soft backing disk that is used to polish a board along with rubbing compound.

Burger, *n.* a mushy (shapeless), uneven, bumpy wave. See Mushburger.

Burn through, *n.* when a hot coat or gloss coat is accidentally abraded to reveal fiberglass cloth, causing a weak point in the board.

Cant angle, *n.* degree to which the fin is not vertically aligned (90 degrees) to the bottom of the board at the point it is attached.

Catalyst, *n.* liquid chemical that is mixed with resin resulting in a hard, brittle material used with fiberglass to coat surfboards.

Channel, *n.* 1. area next to a surf break where generally no waves are breaking; often used by surfers while paddling out to avoid duckdiving, and by photographers to capture photos; thought of as a safe zone. 2. purposely carved-out portion of the bottom of a surfboard running parallel to the rails; thought to increase a board's speed while riding; come in sets of two to eight.

Chip, *n.* the name given to the first all-balsa-wood boards constructed in the late 1940s.

Closeout, *n.* a wave that breaks all at once or very quickly, offering little or no open face for a surfer to ride.

Concave, *n.* indented region on the bottom of a surfboard; placed under the nose on longboards to enhance noseriding and placed in the middle (as single concave) running to the tail (as double concave) on shortboards to enhance performance.

Crystallization, *n.* caused when moisture from acrylic paint is released during the catalyzation process and gets trapped in the resin to form crystal-like bubbles.

Cure, *v.* describes the catalyzation process of resin and fiberglass hardening around the surfboard's core material.

Cut lap, *n.* the visible cut line along the fiberglass cloth on the deck or bottom, close to the rail.

Deck, *n.* the top of a surfboard; the part a rider applies wax to and stands on.

Deck patch, *n.* an extra layer of fiberglass usually applied near the middle of a surfboard's deck to protect it against indentions mostly caused by knee paddling; generally associated with longboards.

Delamination, *n.* when a surfboard's resin and fiberglass covering begins to pull apart from its foam or wood core.

Ding, *n.* 1. damage done to the outer surface of a surfboard that usually affects the inner core as well. *v.* 2. the actual damage occurring.

Disc sander, *n.* a power tool used for sanding surfboards; also known as a power sander or grinder.

Downrail, *n.* type of surfboard rail configuration where the lower edge of the sloping deck is tucked under at an angle where the outer edge of the bottom meets; also known as the tucked-under edge.

Drainage *n.* a term glassers use when the laminate resin kicked too slowly and drained off of the board, somewhat exposing the texture of the fiberglass weave.

Duckdive, *n.* the act of a surfer pushing his/her board and body beneath an oncoming wave in order to make it out to the lineup.

Dude, *n.* a fellow surfing enthusiast, usually of the male gender. Females are sometimes known as dudettes. The word was popularized by the 1982 movie *Fast Times at Ridgemont High* by the character Jeff Spicoli (played by Sean Penn).

Egg, *n.* a surfboard in the mid-seven-foot range with an elliptical outline; sometimes called a mid-length or fun board.

Epoxy, *n.* a resin that is compatible with polystyrene foam; surfboards made of these materials are generally lighter and stronger than boards made of polyurethane foam and polyester resin.

Fiberglass, *n.* fine filaments of silica made into a yarn and woven into a fabric that is used as an outer shell on surfboards once mixed with resin.

Fillet, *n.* the resin and fiberglass support area at the base of a glassed-on fin.

Fin, *n.* stabilizing device attached to the bottom, rear section of surfboards to enhance performance; introduced by Tom Blake in 1935.

Fin rope, *n.* a rarely used material made of fiberglass strands woven into rope, which is applied for strength when glassing on fins. *See* roving.

Fin system, *n.* a generic term to describe the various removable fin setups using plugs or boxes.

Fire, firing, *v.* go off, going off. Another superlative to describe good surf: "Hey, Supers is firing on all cylinders."

Fish, *n.* surfboard design introduced by Steve Lis in 1967; the boards are usually short and stubby with a split tail and twin keel fins.

Flail, *v.* to make eccentric, often funny, arm and body movements; to surf in a clumsy manner.

Foil, *n.* 1. the overall proportion of thickness of a surfboard. 2. the thickness of a fin, measuring from its forward to aft edge.

Free lap, *n.* a lamination technique used with Silane cloth and ortho resin where the cut lap step is eliminated because the cloth is not visible under the resin.

Frontside, *adj.* when riding a wave at an angle the rider's face, chest and midsection are facing the wave; also called forehand.

Gaper, *n.* wide-open barrel.

Glass job, *n.* 1. the finished product of a surfboard's fiberglass and resin coat. *v.* 2. the process of applying the fiberglass and resin coat.

Glasser, *n.* the person who applies laminating resin and fiberglass on a shaped blank.

Gloss coat, *n.* a special, thin coat of resin brushed on after a board has been sanded, which is later polished, resulting in a shiny, reflective finish.

Going off, *v.* 1. when waves are consistent and breaking smoothly. 2. same as ripping, unreal, happening. 3. said when someone is shooting along in perfect surf.

Grommet, grom *n.* general term used to describe young surfers, both males and females, usually in their mid-teens and younger; also called gremmie.

Hairy, *adj.* scary, risky, or dangerous; something beyond normal limits, requiring nerve.

Haole, [Hawaiian] *n.* white, foreigner; comes from "ha" meaning breath of life and "ole" meaning not, or lack of.

He'e, [Hawaiian] *v.* to slide, to surf.

He'e nalu, [Hawaiian] *v.* 1. to surf, wave-sliding. *n.* 2. a rider of the waves.

Hips, *n.* the curved part of the outer, tail portion of a surfboard when viewed from above.

Hot coat, *n.* the layer of resin applied after the laminate coat has kicked, which makes a glass job possible to sand; also called sanding resin.

Hybrid, *n.* a type of surfboard that combines elements of both short and longboards, length, width and thickness in particular.

Insane, *adj.* really great, usually used to describe the surf.

Kahuna, [Hawaiian] *n.* a priest, sorcerer or expert practitioner.

Kai, [Hawaiian] *n.* the sea, sea water.

Keiki, [Hawaiian] *n.* child.

Kick, *v.* when resin is catalyzing.

Kiko'o, [Hawaiian] *n.* a very long surfboard, 12 to 18 feet, used in more challenging surf conditions.

Koa, [Hawaiian] *n.* a soldier, brave, a tree (Acacia koa).

Kook, *n.* most popular term in surfing used to describe other surfers (as well as nonsurfers) in a negative or derogatory way.

Laminate, *n.* 1. layers of resin and fiberglass applied to the shaped blank. *v.* 2. the act of applying resin and fiberglass.

Lay up, *n.* 1. a term to describe the materials used to laminate a board. *v.* 2. the act of applying fiberglass and resin to a surface. *See* laminate.

Log, *n.* a longboard that resembles traditional design concepts from the 1960s, especially in weight, rail configuration and fins (single); also referred to as a tanker.

Macking, *adj.* when huge waves roll in, big and powerful as a Mack truck.

Mask-off, *v.* the act of putting on masking tape to keep resin or paint off of a desired area.

MEKP, *n.* the abbreviation for Methyl Ethyl Ketone Peroxide, commonly known as a catalyst or hardener for polyester resins.

Mushburger, *n.* a shapeless wave, sometimes caused by unfavorable winds. In some cases, a spot that just doesn't have a good bottom contour and the waves are always mushburgers.

Nailed, *v.* to be wiped out badly, to get dumped on—happens after a surfer "closes the lid" on a coffin ride.

Nalu, [Hawaiian] *n.* wave.

Nose, *n.* the front, upper portion of a surfboard.

Noseguard, *n.* soft, rubber-like object applied to a surfboard's nose with adhesive in order to prevent injuries caused by a board's sharp point.

'Ohana, [Hawaiian] *n.* family, relatives.

Olo, [Hawaiian] a thick, long, narrow surfboard used in pre-20th-century Hawaii that was generally reserved for kings and chiefs.

Opaque, *n.* a non-transparent color pigment added to laminating resin, used to give a glass job any desired shade of color.

Orthophthalic, *n.* a commonly used polyester resin that has a crystal-clear finish.

Outline, *n.* the shape of a surfboard if viewed from above; also referred to as planshape.

Particle mask, *n.* small, light paper face mask used to keep out dust or air particles.

Pig, *n.* surfboard design introduced by Dale Velzy in the 1950s; Velzy moved away from popular designs of the time that featured parallel rails and instead placed the wide point near the tail, creating pronounced hips; the design is said to have made modern hot-dog surfing possible.

Pigment, *n.* a coloring substance that is mixed with resin before it is poured onto the fiberglass to give a surfboard coloration, usually the entire board; generally comes in translucent or tints, and opaque.

Pin air, *n.* air bubbles that are visible in between the weave of the fiberglass in the laminate coat, usually a sign of a bad lamination.

Pinline, *n.* a thin, decorative stripe of paint or resin, typically put over a cut lap or along the edge of a colored section on a surfboard.

Pintail, *n.* type of surfboard tail design that comes to a nearly sharp point; it is found on boards that are meant to be ridden in large or hollow surf because it helps the board stick to steeper wave faces.

Planer, *n.* 1. a power tool used to cut down the foam of a blank being shaped. 2. a hand tool (plane) used to cut down the wood stringer of a blank being shaped.

Planing surface, *n.* the part of a surfboard that actually comes in contact with water.

Plank surfboard, *n.* surfboard design used up until the 1940s; the boards were generally flat, varied in length and were extremely heavy because of their pure wood construction.

Pointbreak, *n.* surf break in which waves break along a section of land that forms a point; the waves created are usually extremely well formed and thus ideal for surfing.

Polisher, *n.* a person who performs the last process of a glass job by fine wet and dry sanding and then buffing out the gloss coat into a mirror-like shine.

Polyester, *n.* the most common type of plastic resin used in the surfboard industry, which works only with polyurethane foam blanks or wood.

Polystyrene, *n.* a lightweight type of plastic-based foam blank that works well with epoxy resins.

Polyurethane, *n.* the most commonly used foam blank since the late '50s; it is compatible with polyester resins.

Popout board, *n.* somewhat derogatory term used to describe surfboards that are made—usually mass-produced—in ways other than by using hand-tooled methods and materials.

Quiver, *n.* a surfer's personal collection of boards; generally each board is intended to be ridden in specific surfing conditions or at certain surf breaks.

Rail, *n.* the outermost, rounded edges or section of a surfboard; it connects the deck (top) with the bottom.

Reefbreak, *n.* surf break in which waves break over either coral (sometimes live) or rock reef; these types of breaks offer such varied waves that generalizations cannot be made.

Resin, *n.* general term for the liquid that is combined with catalyst and used with fiberglass to create a hard, outer protective surface.

Resin abstract, *n.* a resin design that uses mixed or unmixed pigments and then blends them together by using a squeegee in the lamination coat to create a desired design. *See* acid splash.

Respirator, *n.* a safety mask with carbon filters that helps reduce inhalation of resin fumes and dust particles.

Rocker, *n.* the curve in the bottom of a surfboard when viewed from the side; it is measured both in the tail and nose.

Roundtail, *n.* type of surfboard tail design that is elliptical or rounded; probably the most forgiving tail design offered.

Router, *n.* power tool used to route a groove or hole in the board to install a fin box, fin system or leash plug.

Roving, *n.* long strands of fiberglass used to support the base of a surfboard fin.

Rubbing compound, *n.* a diatomaceous paste used to polish the gloss coat.

Sanded finish, *n.* a board that has been sanded on the hot coat or gloss coat but has not been polished.

Sanding pad, *n.* a bited backing pad attached to a disc sander that is used behind sandpaper or a buffing mitt.

Shaping machine, *n.* in modern parlance, a computer-programmed machine that cuts foam blanks into almost finished surfboard shapes.

Shears, *n.* long, heavy-duty scissors used for cutting fiberglass cloth.

Silane, *n.* a fiberglass cloth with a clear finish that makes the weave undetectable when saturated with resin.

Single-fin, *n.* a surfboard with one fin, either glassed on or in a fin box.

Spoon nose, *n.* a surfboard with a wide, oval nose area that helps prevent the board from breaking the surface of the water, or pearling.

Squaretail, *n.* type of surfboard tail design that is squared at the end, with two distinct corners.

Squashtail, *n.* a variation of the squaretail, except with softer, or rounded, corners.

Squeegee, *n.* wide, rubber tool used to apply laminating resin.

Stepdeck, *n.* surfboard design introduced in the 1960s in which nearly half of the forward volume was shorn from the deck; it was implemented on surfboards intended for riding the nose.

Stinger, *n.* surfboard design featuring a break, or abrupt cut in the outline about one-third's distance up from the tail.

Stoke, *inj.* surfing's most enduring expression used to convey the feelings of joy, thrill and excitement that riding waves induces.

Stringer, *n.* wood strip that is glued into a surfboard blank to provide added strength.

Styrene monomer, *n.* toxic solvent added to resin to give it a wetter, thinner liquid form.

Swallowtail, *n.* type of surfboard tail design that is split, or shaped like the letter "W"; it was originally associated with the fish design, then the Stinger, but now appears on a variety of boards.

Tail, *n.* the bottommost section of a surfboard; it comes in a variety of shapes.

Tailblock, *n.* an added piece of wood or wood laminate attached to the end of a tail either for appearance or strength.

Tank, tanker, *n.* a heavy longboard. *See* log.

Template, *n.* thin piece of material, usually plywood, used to trace a board's outline onto a foam blank prior to cutting.

Tint, *n.* a transparent coloring added to laminating resin.

Toe angle, *n.* degree to which the fins chord varies from the stringer (side fins are usually "toed in" or pointed slightly toward the nose of the board; fins are never "toed-out").

Tri-fin, *n.* surfboard with a fin setup consisting of three fins of similar or exact size placed in a cluster; also known as a thruster after Simon Anderson's Thruster model introduced the design to the rest of the surfing world in the early 1980s.

Twin-fin, *n.* surfboard with a fin setup consisting of two identically sized fins.

Twinzer, *n.* surfboard with a four-fin setup in which the forward two fins are smaller (and closer to the rail) than the other two.

'Ukulele, [Hawaiian] *n.* flea; a small violin-like guitar.

Vee, *n.* a convex bottom contour rising off of the tail of a surfboard; introduced by Bob McTavish in 1967.

Volan, *n.* a fiberglass cloth that has a chromium finish, giving it a greenish, almost teal color.

Volume, *n.* a general term used to describe a surfboard's overall mass.

Wahine, [Hawaiian] *n.* female, women.

Wet and dry sandpaper, *n.* a fine grit sandpaper used with water in the final stages of sanding or in preparation for polishing.

Wipeout, *n.* a surfing mishap that either ends an ongoing ride or prevents the rider from ever starting one; wipeouts vary greatly in severity from minor and almost comical to extremely dangerous and lethal.

Acknowledgements

This book could not have happened without the help of the following friends and allies who share in common a passion for surfing, surf culture and, above all, surfboards of all shapes and sizes:

Mark Fragale is a longtime collector of vintage surfboards, specializing in big-wave guns, balsa boards and classic "signature models" of the 1960s. He is also a contributing writer for *Longboard Magazine,* specializing in surfboard design history and evolution. His magazine articles about the Hynson Red Fin, Weber Performer, Bing Pipeliner and Greg Noll "Da Cat" models were edited for those chapters in this book.

Spencer Croul had developed one of the best historic board collections in the world before he became a co-founder of the Surfing Heritage Foundation in San Clemente, Calif., and installed his treasure trove as part of its permanent exhibit. The Croul Family Foundation has published two definitive books about seminal figures in surfboard building: *Tom Blake; the Uncommon Journey of a Pioneer Waterman* and *Dale Velzy is Hawk.*

Dick Metz began his surfboard collection when he was the retail franchisee and dealer distribution chief for Hobie Surfboards in the early 1960s. By the time he retired from the surfboard business world, he had amassed some 250 boards, many of them both rare and historically significant. Metz is also a co-founder of the Surfing Heritage Foundation, a nonprofit organization devoted to the preservation of surfing's roots and culture.

Paul Holmes is a former Editor in Chief of *Surfer* magazine and a Contributing Editor to *Longboard Magazine,* where he made a specialty of writing profiles of key individuals in the development of surfing as a sport, lifestyle and industry, many of whom were surfboard makers. Holmes is also author of *Dale Velzy is Hawk,* the biography of the legendary Californian surfboard building pioneer who passed away in May 2005.

John Severson, whose artwork appears on the endpapers of this book, was founder in 1960 of *Surfer* magazine, often referred to as "the bible of the sport" of surfing. An artist and filmmaker as well as a publisher, Severson is now retired and lives on the Hawaiian island of Maui, where he spends much of his time surfing, playing golf and painting surf scenes in a wide variety of styles and media.

Randy Rarick is a longtime surfboard shaper and director of the Hawaiian Triple Crown series of professional surfing events on the North Shore of Oahu, Hawaii. He began his career during the mid-1960s as the ding repairer at Surfline Hawaii. Patching 10,000 boards, he says, made him something of a hands-on expert on classic boards of the era—useful knowledge when he stages his bi-annual Hawaiian Islands Vintage Surf Auction.

Ed Economy began his penchant for collecting as an ex-professional skateboarder who had hoarded memorabilia from his competitive career. A fascination with surfing collectibles began when he acquired a Duke Kahanamoku skateboard model, which led him to begin amassing all things relating to the "father of modern surfing" including boards, posters, letters, contest trophies and more, thus building the definitive collection.

Lee Nichol is a personal trainer by profession and a surfboard and surfing memorabilia collector by vocation. His 150-plus vintage board collection contains examples of all kinds of classic craft, but Nichol has also become something of a specialist in boards that feature printed fabrics in the laminate, a trend that was popular in the 1960s with traditional Hawaiian motifs and psychedelic patterns book-ending the era.

Allan Seymour began surfing during the mid-1950s and made a career in the lifestyle sport as a sales representative, contest promoter and all-around surfing impresario. As one of the first cultural observers to realize that a market was developing for surfing collectibles, in 1995 Seymour launched the Pacific Coast Vintage Surf Auction, providing an annual forum for buyers and sellers to trade boards, artwork, paper goods and more.

Gary Prettyman, whose photorealistic paintings have been used as action surfing illustrations on several pages in this book, is a lifelong surfer and artist. He is a regular exhibitor at the annual Laguna Beach Festival of Arts and his paintings have twice been featured in the art colony's Pageant of the Masters world-famous "tableaux vivants" extravaganzas.

Chasen Marshall is in the early stages of his young writing career but has made major strides in a short time. After freelancing for various Orange County newspapers, he was brought on as an intern at *Longboard Magazine* in May 2005 before taking time off to study in Europe and finish college. He returned to the magazine soon thereafter as a Contributing Editor and now serves as the publication's Managing Editor.

Tristan Wand is a former Associate Editor of *Longboard Magazine.* Wand currently lives in Los Angeles, where he's pursuing a Master's degree in Professional Writing (with an emphasis on screenwriting) at the University of Southern California. He hopes ultimately to write and direct a "surf noir" film that will appeal not only to mainstream moviegoers, but also to real surfers.

Sean Preci is a former Managing Editor of *Longboard Magazine* who has traveled extensively as a keen recreational surfer to outposts as far afield as South Africa, Madagascar, Ireland, France, Hawaii and several countries in Central America. Most recently he received his Master's degree in Rhetoric and Writing Studies from San Diego State University while working as a freelance journalist.

Index

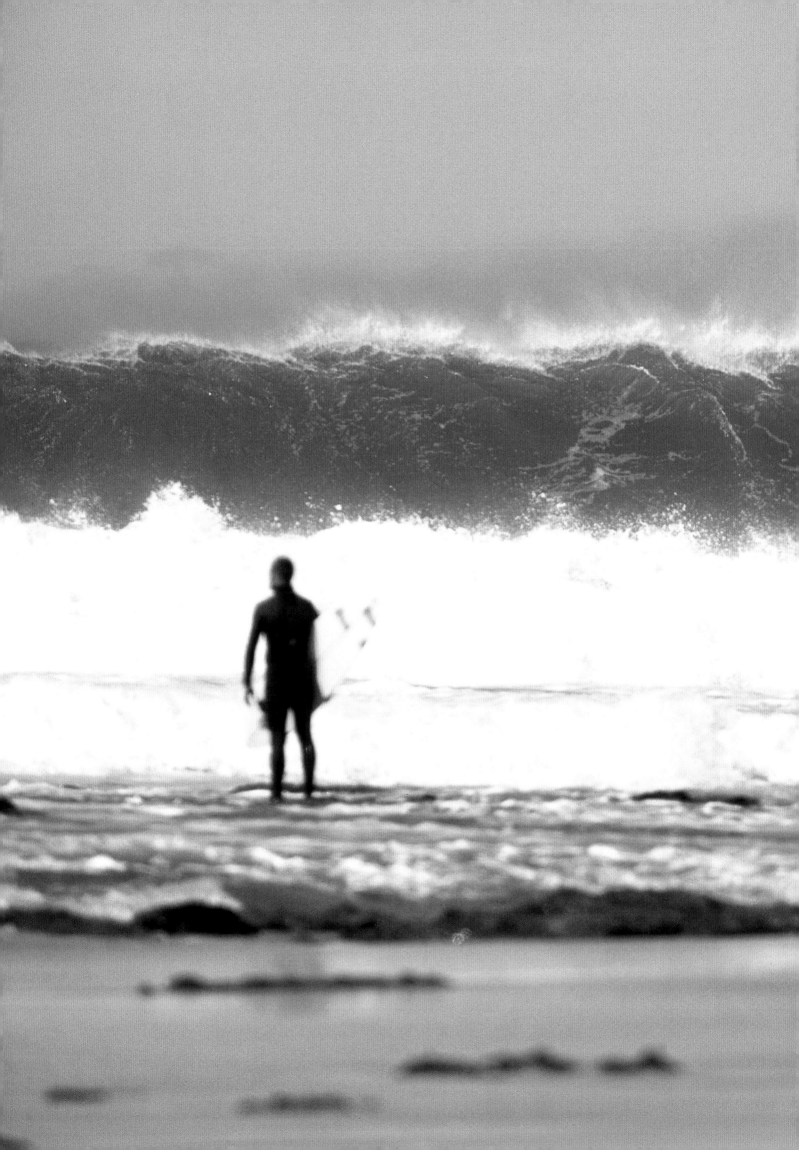

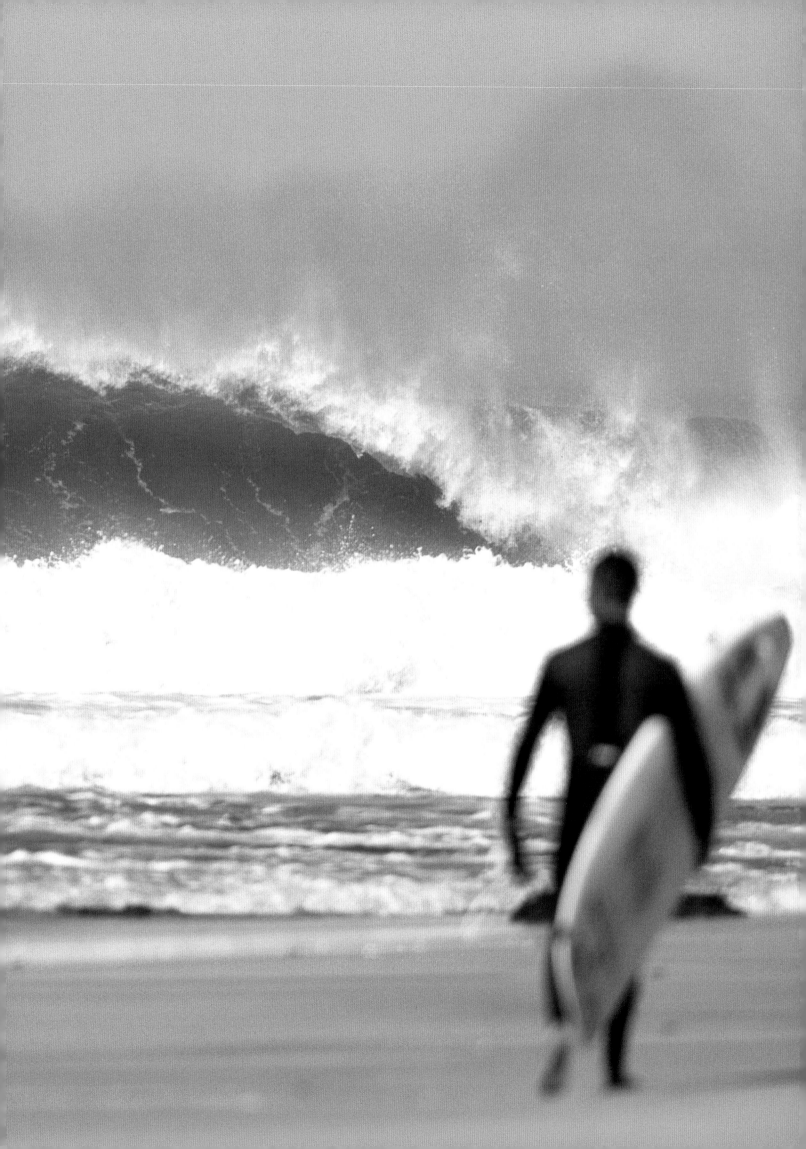

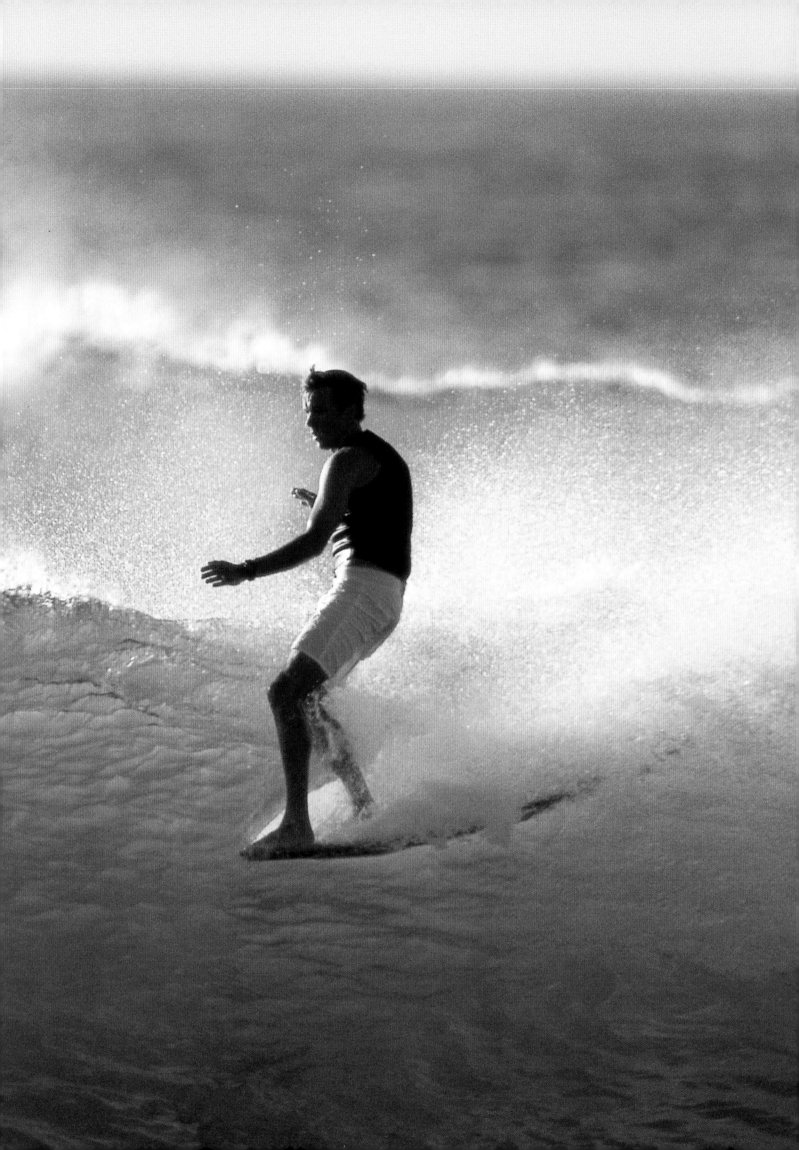